In the Mind's Eye: Dada and Surrealism

In the Mind's Eye
Dada and Surrealism

Dawn Ades, Mary Mathews Gedo, Mary Jane Jacob,
Rosalind E. Krauss, Dennis Alan Nawrocki, Lowery Stokes Sims

Edited by Terry Ann R. Neff

Museum of Contemporary Art, Chicago
Abbeville Press, Publishers, New York

In the Mind's Eye: Dada and Surrealism was prepared on the occasion of
the exhibition "Dada and Surrealism in Chicago Collections," Museum of
Contemporary Art, Chicago, December 1, 1984-January 27, 1985. The
book and exhibition were supported in part by the Museum's Contemporary
Art Circle; Borg-Warner Foundation; Parfums Ungaro; Christie, Manson
& Woods International, Inc. and were also made possible by grants from
the National Endowment for the Arts, a federal agency, and the Illinois
Arts Council, a state agency. *In the Mind's Eye: Dada and Surrealism* was
also funded by a generous gift of Arnold B. Glimcher, president, The Pace
Gallery, New York, and by the Robert R. McCormick Charitable Trust.

Library of Congress Cataloging in Publication Data
Main entry under title:
In the mind's eye: dada and surrealism.
 "Published on the occasion of the exhibition 'Dada and Surrealism in
Chicago Collections,' Museum of Contemporary Art, Chicago, December
1, 1984-January 27, 1985" — T.p. verso.
1. Dadaism — Exhibitions. 2. Surrealism — Exhibitions. 3. Art, Modern
— 20th century — Exhibitions. 4. Art — Collectors and collecting —
Illinois — Chicago — Exhibitions. I. Ades, Dawn. II. Neff, Terry Ann
R. III. Museum of Contemporary Art (Chicago, Ill.)
N6494.D315 1986 709'.04'063074017311 85-27331
ISBN 0-89659-596-X (cloth)
ISBN 0-89659-597-8 (pbk.)

Designed by Michael Glass Design, Inc., Chicago.
Typeset in Bodoni by Word City, Chicago.
Printed and bound in Japan.

Cover illustration: René Magritte, *The White Race* (see p. 168).

Contents

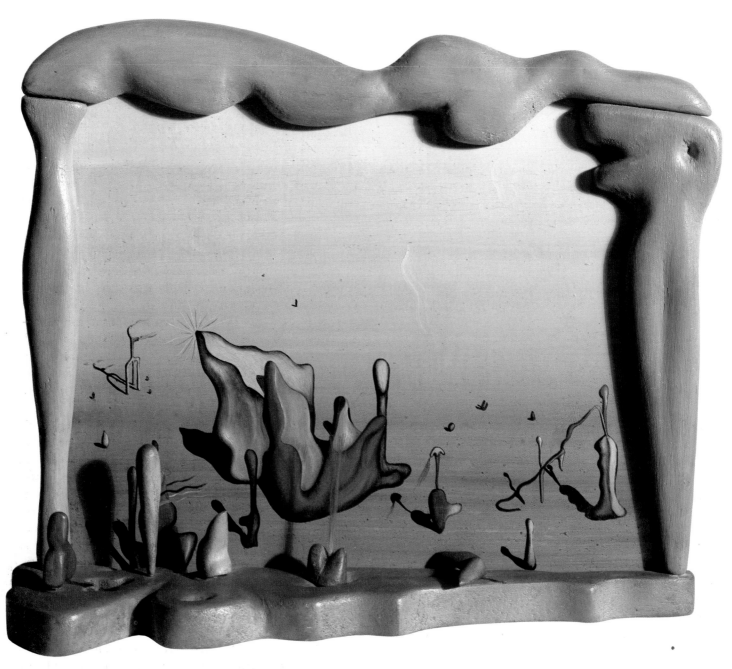

Pl. 1. Yves Tanguy, *The Certitude of the Never Seen*, 1933 (see p. 220)

Foreword

The cumulative impact of the exhibition "Dada and Surrealism in Chicago Collections" challenges written description. One may claim that it was virtually a survey of two great movements, with many areas of remarkable depth and numerous masterworks. But such claims sound so hyperbolic that the only verification was visiting the exhibition itself. To commemorate what has become a celebrated highlight in our exhibition history, we have this major publication as a document of what occurred and as a means of deepening our understanding of Dada and Surrealism.

The premise of the exhibition was that all works come from Chicago collections; the results were spectacular. How can so many riches be found in one city? Actually this is something of a Chicago tradition, and always accompanied by notable connoisseurship. At the turn of the century, great Impressionist and Post-Impressionist works were gathered here, and today there is extraordinary activity in the acquisition of contemporary American and European art. The history of Dada and Surrealism collecting in Chicago is elucidated in this publication by Chief Curator Mary Jane Jacob; and coorganizer of this exhibition, Associate Curator Dennis Alan Nawrocki, has annotated many of the works that were displayed.

An integral concept of the exhibition was to broaden historical knowledge and critical response about the art. This was achieved through a symposium and lecture; the research and interpretations of the internationally known participants are presented in this publication. Terry Ann R. Neff played a key role in conceiving this aspect of the exhibition, as well as editing this publication.

An unusual educational activity that recaptured the spirit of Dada was the presentation of a Dada Cabaret on five consecutive evenings. This project was researched and coordinated by Director of Education Naomi Vine and was performed under the direction of Robert Ivan Schneideman, professor of theatre at Northwestern University, Evanston, Illinois.

The ultimate purpose of an exhibition is bringing together people and art for the pleasure of enrichment. We are gratified to have hosted tens of thousands of visitors from the region, nation, and abroad. Part of this interest was due to the nature of Dada and Surrealism themselves: the artists associated with these two movements ignored the formalistic tenets of Modernism and, instead, focused on social and political issues and on the inner life — concerns shared by so many artists in recent years.

The Museum of Contemporary Art has many expressions of gratitude resulting from this exhibition. First and foremost, we salute the connoisseurship of the many collectors who so generously lent their holdings. Mary Jane Jacob and Dennis Nawrocki made the thoughtful selection of objects and, with Associate Curator Lynne Warren, they designed an extraordinary installation that respected and enhanced the art. Registrar Debi Purden oversaw with exemplary concentration and care the movement of 400 works of art.

Individual sponsors should feel great pride in what their support made possible. The Museum expresses its appreciation to the Contemporary Art Circle, which continues its outstanding tradition of support for major Museum exhibitions; the Borg-Warner Foundation; Parfums Ungaro; Christie, Manson & Woods International, Inc.; the National Endowment for the Arts, a federal agency; and the Illinois Arts Council, a state agency. Thanks are due to Pati H. Gerber and the Laz Chapman Foundation, in memory of Oscar Lewis Gerber, for their support of the lecture, symposium, and Dada Cabaret. This book was also supported by the Robert R. McCormick Charitable Trust.

Arnold Glimcher, director of The Pace Gallery, who previewed the exhibition, was so taken by what he saw, and felt so deeply the importance of documenting an extraordinary collection of works, that he made a generous contribution at that time in order to ensure that this publication would be a complete record. His enthusiasm was shared by our many visitors, and we hope this publication will rekindle the interest of those who saw the exhibition, and be a source of knowledge and pleasure for all who read it.

I. Michael Danoff, *Director*

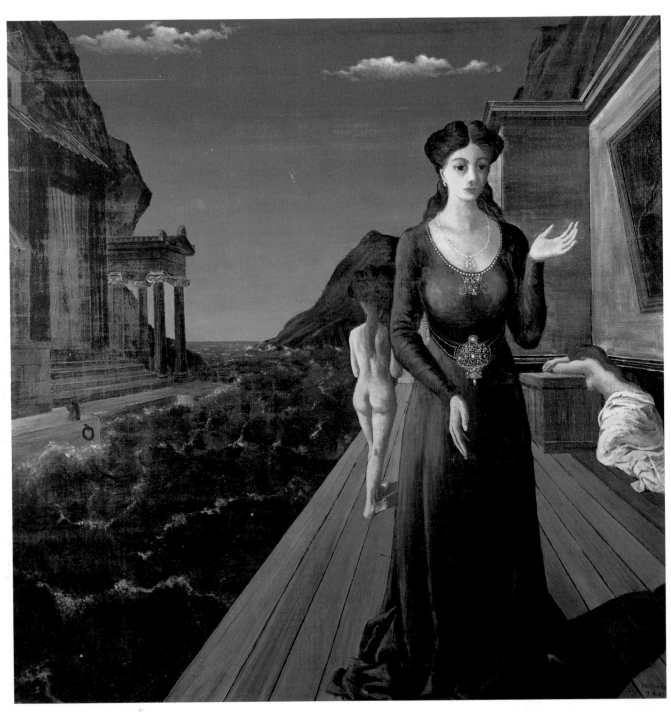

Pl. 2. Paul Delvaux, *Penelope*, 1945 (see p. 138)

Chicago: "The City of Surrealism"

By Mary Jane Jacob

Chicago's interest in Dada, and especially Surrealism, is not a new one; these movements have made their appearance here in exhibitions since the teens. Yet Chicago's involvement with Dada and Surrealism is a phenomenon mainly of the 1950s that continues today. It was the 1950s that saw the beginning of great collections of quality and depth that have had an impact on the role of modern art in the community and the direction that artists here have taken for nearly four decades. This exciting, formative period of activity coincides with the decline, if not rejection, of Surrealism by the New York art world, and parallels the development of a real art scene in Chicago: the emergence of an important group of young artists, the establishment of commercial galleries, the move of the city's art institutions into the field of modern art, and, of course, the spread of interest to many individuals who, influenced, began to collect. To arrive at an understanding of the growth of the extraordinary holdings in Chicago that constitute the exhibition "Dada and Surrealism in Chicago Collections," it is enlightening to look from this juncture around 1950 in both directions: to the waning of New York's interest in Surrealism, and to the rise of the Chicago art community.

From the start, the "first" and "second" cities were linked. New York's 1913 Armory Show that first introduced Dada to the United States then traveled to The Art Institute of Chicago. But it did not set off a wave of Dada collecting at that time (as was the case when in the 1950s Surrealism came to Chicago and the city was ready to join the ranks of advocates in full force). In fact, it must be pointed out that Chicago's interest in Dada, on the whole, seems but a corollary to Surrealism, its main focus. The primary supporters of Dada remained in New York: Katherine Dreier who in 1920 with the help of Marcel Duchamp and Man Ray created the Société Anonyme, and Louise and Walter Arensberg whose extensive holdings of Duchamp, Picabia, and Man Ray were seminal for a new generation of American artists in the 1920s. That is not to say that later exposure to Dada was absent in Chicago. The Arensberg collection was shown at the Art Institute in 1949 and, even before that time — in 1936 — there was displayed the collection of Chicago lawyer Arthur Jerome Eddy (which

contained works of Duchamp, Picabia, and Man Ray), while one-person exhibitions of Man Ray and Picabia were held at The Arts Club of Chicago in 1929, with the latter artist showing again three years later. The first Chicago exhibition devoted to the leading force in the Dada movement, Marcel Duchamp, was held at the Arts Club in 1937, but it was not until the retrospective organized in 1974 by the Philadelphia Museum of Art and The Museum of Modern Art in New York and shown at the Art Institute that the full range of this artist's work was seen here. Correspondingly, in Chicago collections one finds the work of only a few Dadaists, with the exception of a number of fine early works by Picabia and a group of important examples of Man Ray. Most clearly this lack of attention to Dada is reflected in the complete absence of major works by Duchamp in the city.[1]

One can date the beginning of American consciousness of Surrealism to 1931 with the first museum exhibition of this movement at the Wadsworth Atheneum in Hartford, Connecticut. While presented by Director Chick Austin it was, by and large, an exhibition organized by Julien Levy who had opened a gallery in New York that year. Realizing the great importance and prestige of a museum showing, Levy agreed to lend the works first to Hartford, exhibiting them in his gallery immediately following the close of the exhibition at the Atheneum. This keystone exhibition included the leading figures of the day as well as American Surrealist Joseph Cornell, Levy's own discovery, who made his debut in this show. It was Levy, the first American dealer to exhibit Surrealism, who beyond all others actively promoted the work of the great Surrealists during these early years, in group and one-person exhibitions.[2]

Levy was soon followed on the scene by dealer Pierre Matisse and by Curt Valentin's Buchholz Gallery in showing Surrealist art; and in 1936 The Museum of Modern Art's endorsement came with the exhibition "Fantastic Art, Dada, Surrealism," organized by Alfred H. Barr, Jr. Of commercial galleries in Chicago only Katharine Kuh showed the work of the Surrealists. Beginning in 1936 her exhibitions included Joan Miró (1938), Kurt Seligmann (1939), and yearly exhibitions of Paul Klee, but interest was negligible and there were

very few sales. While Surrealism was not her emphasis, Kuh was well acquainted with Seligmann, Ernst, Tanning, and the Mexican artist Carlos Merida, and she was the first to introduce Chicago to this style. Through her gallery, in operation until 1942, she also did much to familiarize Chicagoans with modern art in general, not only with her exhibitions, but also through the weekly classes that she offered in the back of her gallery (her main means of support in the early years), her publications, and her continuing curatorial work at The Art Institute of Chicago until 1959. During this same period and until the mid-1940s, The Arts Club of Chicago, always a pioneering institution in modern art, displayed Surrealism on nearly an annual basis. In addition to exhibitions of Man Ray, Duchamp, Picabia, and shows of Tchelitchew and Giacometti from the Levy Gallery, it showed de Chirico, Miró, Masson, Tanguy, Dali, Klee, Ernst, Matta, Lam, and Seligmann, with lectures on the subject by James Johnson Sweeney and Sidney Janis.[3]

While Levy had few clients in the 1930s, his gallery served as a meeting place for refugee artists who were then gathering in New York and whose presence contributed to the growing enthusiasm for their art. By the late 1930s and early 1940s, there was a feeling of great energy in the city, due in large part to these artists who brought to New York new ideas and a flavor of internationalism. This period was also marked by a sense of struggle as a new generation of Americans came into contact with these Europeans and, both influenced by and rebelling against them, sought to create an independent style which came to be known as Abstract Expressionism.

In the 1940s other New York galleries, notably those of Sidney Janis and Alexander Iolas, took up the work of the Surrealists. In 1942 Peggy Guggenheim opened her Art of This Century Gallery, guided into Surrealism by her husband, artist Max Ernst, and simultaneously by critic Clement Greenberg who supported the new wave of American Abstract Expressionists, chiefly Jackson Pollock. It was here that the ensuing dichotomy between the older Europeans and the younger American artists was given its most visible form and opportunity for dialogue. Though short-lived (Guggenheim divorced, closed her gallery, and returned to Europe in 1947), the activities of the gallery paralleled the exchange, influence, and conflict between these generations around the war years.

By the end of the decade, Julien Levy had closed his gallery, most of the Surrealists had left New York and returned to Europe, and Abstract Expressionism had fully emerged: with it came a ground swell of American chauvinism and prejudice against prior European modern art, including the Surrealists in spite of their established position in 20th-century art. Writing about this period in 1965, Levy said that Surrealism had been: "so long submerged, lost out of sight during that emotional storm of *Abstract-Expressionism* that carried away, like a tornado, everything else, good or bad, in its path as an international school..."; he made a plea that its place in history be restored.[4] The events that followed in the New York art world — the development of Pop Art and Minimal Art in the 1960s — only served further to banish Surrealism from the annals of contemporary art history. Not until William Rubin, The Museum of Modern Art's director of painting and sculpture, organized "Dada, Surrealism, and Their Heritage" in 1968 was there a major attempt again to put the work of these artists before the public and place it within a context.

In Chicago the history was very different. Just as the field of Surrealism was being abandoned in New York, its reputation as an important international movement dismissed, so Chicago took up the cause.[5] Building on the firm background established by the Surrealist exhibitions at The Arts Club of Chicago and occasional shows at Katharine Kuh's gallery, Kuh (now at the Art Institute), with Frederick A. Sweet, organized in 1947 the Institute's Fifty-Eighth Annual Exhibition of American Paintings and Sculpture, whose theme was "Abstract and Surrealist American Art." The exhibition included Baziotes, Dali, Max Ernst, Jimmy Ernst, Gorky, Kelly, Man Ray, Matta, Sage, Seligmann, Tanguy, and Tchelitchew; Seligmann also came to lecture.[6] Early exhibitions of developing collections of Chicagoans served not only to continue to bring Surrealism before the public eye but also as models that supported the notion of acquiring the works of the Surrealists. In the early years there was The Mary and Earle Ludgin Collection, shown in 1936 at The Renaissance Society at the University of Chicago, and The Joseph P. Winterbotham Collection at the Art Institute in 1947.

But it was not until the 1950s, Chicago's period of great development and commitment to Surrealism, that major collectors in this field came to the forefront — Joseph and Jory Shapiro, Morton and Rose Neumann, Barnet and Eleanor Hodes, and Edwin and Lindy Bergman. And with them, strong Surrealist dealers established their galleries in Chicago — Allan Frumkin and Richard Feigen. Meanwhile, to round out the sense of Chicago as "the city of Surrealism," a new generation of artists emerged from The School of the Art Institute of Chicago whose figurative style was interpreted as an indigenous brand of Surrealism.

If there is one reason to account for why Surrealism was so avidly collected in Chicago, it would undoubtedly be Joseph Shapiro. He was attracted, if not obsessed, by this style, and after having amassed in the 1940s a broad history of art in prints, the following decade he turned with great enthusiasm almost exclusively to Surrealist painting, sculpture, and drawings. It was perhaps Surrealism's intellectual side and literary affinities that appealed to Shapiro, but whatever the personal motivation, the commitment to this new passion was total. Moreover, his interest had city-wide impact because, from the start, he and his wife, Jory, openly shared their collection by making their home available regularly to visiting groups, and because Shapiro (although a lawyer and businessman by profession) worked as a curator, organizing

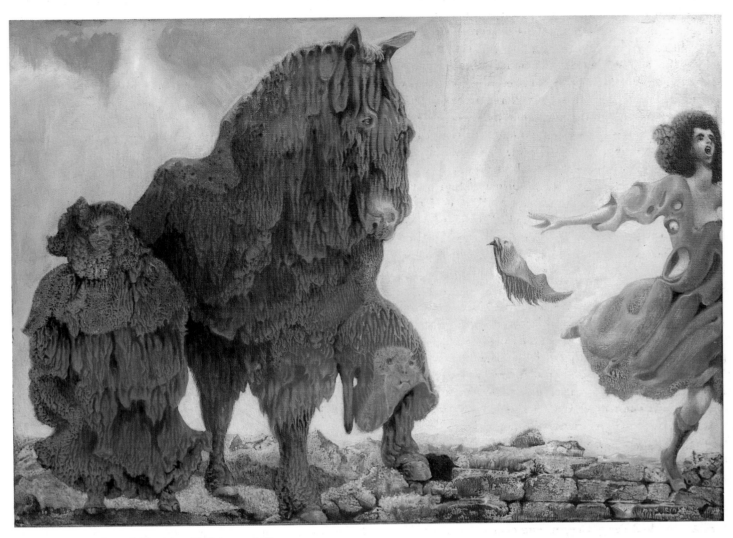

Pl. 3. Max Ernst, *Spanish Physician*, 1940 (see p. 147)

exhibitions in the field and as an educator, promoting Surrealism in his many lectures and talks, formal and informal.

As early as 1951 the Shapiros displayed selected American and European works from their collection at the Renaissance Society (including Surrealists Baziotes, Giacometti, Klee, Matta, and Miró). The Shapiros again showed their collection in 1958 at the Renaissance Society, but this time with an even stronger Surrealist direction, represented by Bellmer, Brauner, Cornell, Delvaux, Max Ernst, Giacometti, Klee, Magritte, Matta, Miró, Schwitters, Tanguy, Wols, and many others. Joseph Shapiro's organizing activities during this period led him to assemble four Surrealist exhibitions: "The Condition of Modern Man: An Exhibition of Modern Art" (1957) and "But... Is It Art" (1960), both at the Arts Club; "Pan American Art" at the Art Institute (1959); and "Surrealism Then and Now" at the Arts Club (1958). In 1966 Shapiro presented "Surrealism," a grouping of 17 works at the

Rosenstone Art Gallery, Bernard Horwich Center, Chicago, from the Shapiro, Bergman, Ruth and Leonard Horwich, and Mr. and Mrs. Herman Spertus collections. Highly influential for dealers and collectors alike, the most important of these exhibitions was "Surrealism Then and Now," which marked a turning point in the city's involvement in Surrealism. Proceeding from a personal interpretation of Surrealist tendencies, Shapiro presented forerunners: Redon and Chagall; key figures in the movement: Brauner, Cornell, Dali, de Chirico, Delvaux (see pl. 2), Max Ernst (see pl. 3), Magritte (see pl. 4), Matta, Miró, Picabia, Richier, Tanguy, Tchelitchew; and related artists: Bacon, Balthus, Dubuffet, Giacometti, Graves, Klee, and Picasso. In his thesis for the show, Shapiro stated that "by the exploration of unconscious imagery, the Surrealist discovered a new experience and revelation of psychic reality....Surrealism is the art of the ambiguous image, the symbol, the enigmatic presence, whose poetry is actually enhanced by its obscurity and mystery. This exhibition is

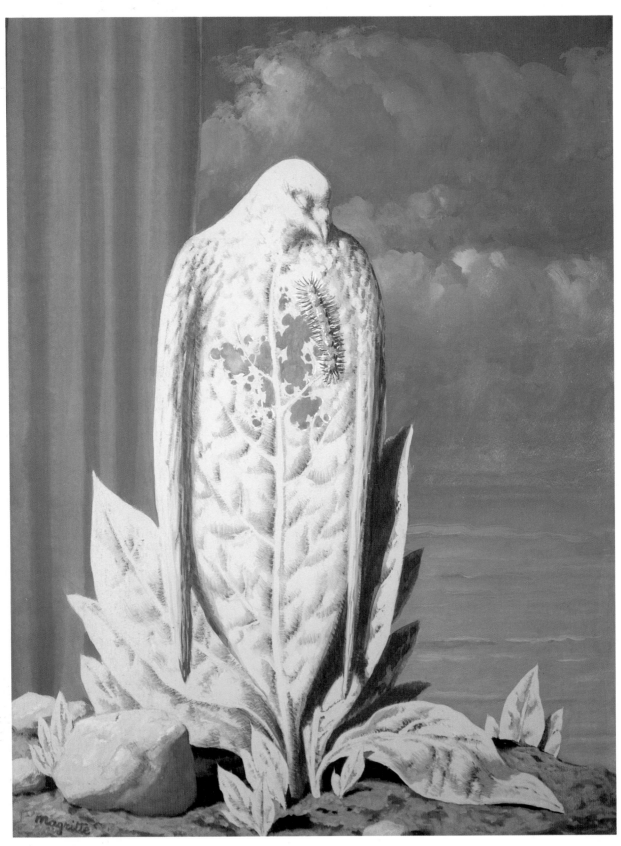

Pl. 4. René Magritte, *The Flavor of Tears*, c. 1948 (see p. 169)

selective rather than comprehensive and seeks to extend Surrealism beyond the limits of an historical art movement to include contemporary artists who are creating in its tradition or under its influence."[7]

The impact of the show was felt immediately as Richard Feigen selected for the second exhibition at his new Astor Street gallery many of the same artists to be on view concurrently with Shapiro's Arts Club show. Feigen had opened just the previous year and soon became identified with quality Surrealist art. The way had already been paved by Allan Frumkin who, having established his gallery in 1952, was the first Chicago dealer actively to bring classic Surrealist works to the city and to introduce its contemporary proponents, most notably Matta.[8] Shapiro quickly became one of both Frumkin's and Feigen's steady clients. With the decline of interest and the drop in the New York market, significant works could be secured by these astute dealers and made available in response to (and simultaneously fostering) the rapidly growing interest of Chicagoans.

Another important early Surrealist collector was Barnet Hodes. He was guided in his purchases by William Copley, for whom he had served as legal counsel in finalizing the latter's inheritance of the family newspaper business. Copley, a painter, collector, and owner of a gallery devoted to Surrealism in Beverly Hills, California, from 1946 to 1948, was especially knowledgeable in the field. From 1951 to 1964 Copley lived in Paris and came in close contact with the Surrealists; in his own painting he even called himself a Surrealist. Hodes had two special goals in assembling his collection: to own a work by each artist in the first Surrealist exhibition, and to have a gouache study for each of Magritte's major paintings (he acquired 53 in all). He accomplished these aims and, through Copley, also came to know the Surrealists and even represented Duchamp and Matta in legal matters.[9] Hodes and his wife also served on the board of directors of the William and Noma Copley Foundation established in Chicago in 1954 to provide grants to individuals in the fields of painting, sculpture, and music. These were determined by its board of directors that included, in addition to the Copleys and Hodes, Marcel Duchamp and composer Darius Milhaud, and were based on nominations from its advisers: Hans Arp, Alfred H. Barr, Jr., Max Ernst, Julien Levy, William S. Lieberman, Man Ray, Matta, Roland Penrose, and Sir Herbert Read — a veritable roster of "who's who" in Surrealism. While the awards and Foundation-supported publications were broad in scope, they did include books on Surrealists Hans Bellmer, Jacques Hérold, and René Magritte.

Influenced by Hodes, who was their neighbor across the hall on Chicago's south side, Morton and Rose Neumann also began to collect in the late 1940s/early 1950s. Purchasing a group of European modern masters from the leading Parisian dealer Henry Kahnweiler, they then became clients of Richard Feigen.[10] While not making Surrealism a focal point in their

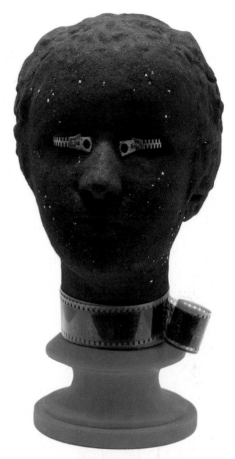

Pl. 5. Marcel Jean, *The Specter of the Gardenia*, 1936/72 (see p. 155)

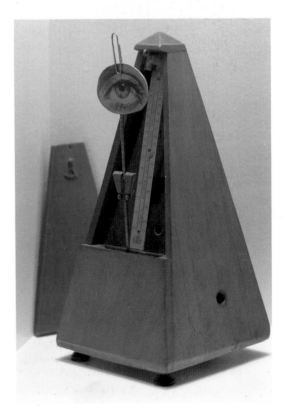

Pl. 6. Man Ray, *Indestructible Object*, 1923/58 (see p. 176)

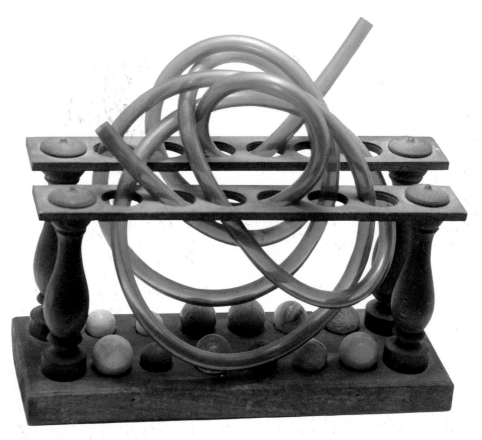

Pl. 7. Man Ray, *Smoking Device*, 1959 (see p. 181)

collection, the Neumanns did purchase some great examples of the movement, as well as acquiring the largest holdings of Dada in the city (see pls. 5,6,7).

Edwin and Lindy Bergman came seriously to collecting at the end of the 1950s. They were strongly influenced by the example of Joseph and Jory Shapiro whom they met through Chicago painter John Miller, who first arranged for them to go to the Shapiros to see the collection. Repeated visits, long hours of looking at art, and their own independent study of 20th-century art convinced them that they too wanted to collect. Their first purchases were from Allan Frumkin — German Expressionism and Surrealism — but they soon knew their affinity was for the latter movement. A pivotal moment for them came in 1955 when they made a trip to Cuba. They had been reading The Metropolitan Museum of Art's *Seminars in Modern Art* by John Canaday and were greatly impressed by Cuban artist Wifredo Lam's *The Jungle* (see Sims, fig. 1). When they inquired in a local Cuban art gallery about Lam, they were told that while this premier artist was not handled by the gallery, a visit could be arranged. This was the beginning of a long friendship between the artist and the Bergmans; eventually they also came to purchase a study for *The Jungle* (pl. 8). Lam came soon thereafter to Chicago to visit; during his stay at the Bergmans' home he enthusiastically told them about

the European art world and drew them a map of where they should go. Their first trip to Europe was made in 1959 and through Lam they met Copley, who in turn introduced them to Giacometti, Man Ray, Roland Penrose, and others. They made many subsequent trips, amassing perhaps the most comprehensive Surrealist collection in Chicago. In addition, they devoted special emphasis to American Surrealist Joseph Cornell (see pls. 9,10), whom they also came to know through Copley, who had shown his work in his California gallery; over the years the Bergmans have assembled the largest and most important private collection in the world of this artist's work.

Throughout the 1950s and 1960s, the increasing interest of Chicagoans in Surrealism was nurtured by Frumkin and Feigen.[11] During this period Frumkin showed Surrealists as well as new Chicago artists, while Feigen made Surrealism his focus.[12] Feigen became familiar with the artists, now back in Paris, through Matta, a charismatic and catalytic force who came often to Chicago, was a visiting professor at the School of the Art Institute in the mid-1950s, spoke English well, and inspired people about Surrealism. Matta introduced Feigen to Brauner, Bellmer, Max Ernst, and others in Paris, where Feigen was also able to acquire works from the William Rubin collection housed in his apartment there, and bring them to Chicago — Matta's *Earth Is a Man* (pl. 11) and Masson's

14

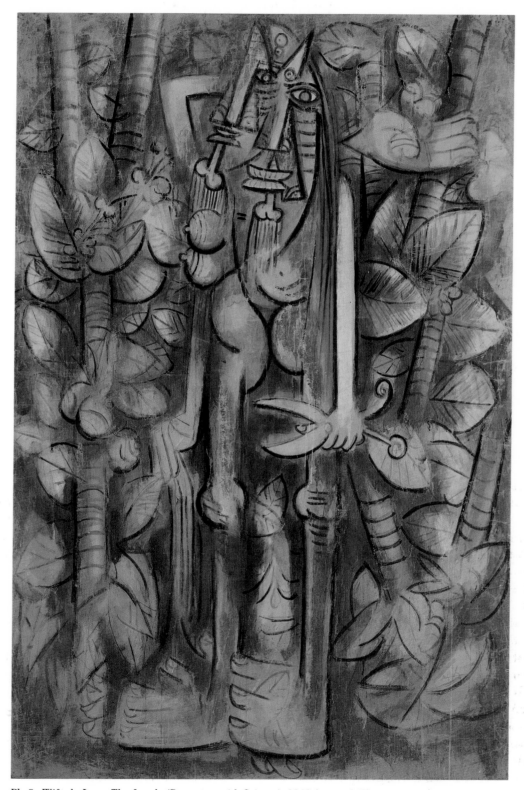

Pl. 8. Wifredo Lam, *The Jungle (Personage with Scissors)*, 1942 (see p. 161)

Pl. 9. Joseph Cornell, *La Bourboule*, c. 1933 (see p. 128)

Pl. 10. Joseph Cornell, *Rose Castle (Pink Castle)*, c. 1948 (see p. 129)

Pasiphaë (pl. 12) — which subsequently were sold to Joseph and Jory Shapiro and their fellow Chicago collectors Dr. and Mrs. J.H. Hirschmann, respectively. Feigen's Surrealist connection was further enhanced by the presence of Lotte Drew-Baer, the former assistant and secretary to Julien Levy, who was the director of his Chicago gallery. In 1965 she assembled at Feigen's a major exhibition of works from the Levy gallery, entitled "Poetry in Painting 1931-1947."

Surrealism in the city in the 1950s and into the 1960s was all-pervasive. The Arts Club continued to make it a strong part of its program.[13] The Art Institute also organized "Surrealism and Its Affinities: The Mary Reynolds Collection" in 1956, an extensive exhibition of artist-designed and self-published books and periodicals, many with covers by Mary Reynolds; the Institute also brought from The Museum of Modern Art, New York, exhibitions of Ernst (1960) and Magritte (1966). Another trend that continued and, no doubt, contributed to the dialogue within the collecting community itself, giving it a sense of identity, was exhibitions drawn from Chicago collections, some being selected by collectors themselves, notably Shapiro and Bergman.[14] The 1960s was also an important period in Chicago for the solidification of local interest in Surrealism because of the Art Institute's hosting of The Museum of Modern Art's "Dada, Surrealism, and Their Heritage" exhibition, which included not only examples from the Bergman, Neumann, and Shapiro collections, but in its broad up-to-date thesis, the work of Chicagoan George Cohen.

Influenced in part by the presence of Surrealism long after it had been submerged in the New York scene, the indigenous style of the "Monster Roster," that first emerged after World War II when Cosmo Campoli, George Cohen, Leon Golub, Theodore Halkin, June Leaf, Irving Petlin, Seymour Rosofsky, and H.C. Westermann entered the School of the Art Institute on the GI Bill, ran counter to the Abstract Expressionism of the day. Other sources can be cited for this development, such as the work of nationally known Chicagoan Ivan Albright, primitive artifacts readily available at the Field Museum of Natural History, and, of course, the artists' own stylistic predilections. But this new trend in Chicago art veered away from the national norm (i.e., that of New York) just as Chicago collecting took a distinct, uncommon route in its Surrealist focus, and it is not surprising that aesthetic affinities may be seen in both areas. This sense of independence continued into the 1960s and early 1970s. As Pop Art, then Minimal Art, held sway, Chicagoans remained devoted to Surrealism and the figurative tradition that was carried on by the new generation of Imagists or "Hairy Who," whose style departed from the mainstream of New York and, hence, was relegated for many years to the secondary position of a provincial phenomenon. This historical tendency was noted by Franz Schulze in 1966 when he wrote: "This 'subjective' Chicago pop, because of its concern for story and feeling, takes a cue less from New York pop than from surrealism, especially of the marginal, primitive, idiosyncratic kind that stands outside the mainstream of modernist tradition....At their best, they have displayed an ingeniously ferocious personality in their work, auguring a weird and fantastic new species of pop art or possibly a gamier kind of commercialized surrealism.... Fantasy grows out of alienation, and alienation from the mainstream has a long and interesting history in Chicago art, a history that apparently is still being written."[15]

Surrealism was kept before the public eye on an almost constant basis.[16] Importantly for the future growth and widespread collecting trend locally of this field, a spirit of friendly competition arose as collectors who knew each other in the community shared the belief that Surrealism was a significant modern art movement and that the works were good to own. In their enthusiasm they supported one another in purchasing bold examples that at the moment were not sanctioned by New York as the "hot thing."[17] This astute independence recalls the collecting of yet another avant-garde European movement — Impressionism — the only other modern movement that Chicagoans collected in such depth and quality. At the end of the last century, Berthe Honoré Palmer collected Impressionism before it was generally appreciated, and her vision and informed taste led to the serious building of an Impressionist collection in the city by many in the decades that followed. Similarly, Shapiro built the city's first great Surrealist collection and was a guiding force for the collecting of others at a time when it was not fashionable in New York. His influence, and that of the other pioneering collectors and dealers, may be seen in the collections of a hundred or so Chicagoans who have Surrealist works among their holdings or have made it an area of concentration. The existence of this resource in the city has had a profound impact on the course of modern and contemporary art in Chicago, by serving to sustain a Surrealist and figurative tradition, and also to continue an interest in the new, the avant-garde, as important collections of wide-ranging styles in contemporary American and European art are being formed today.

Practical circumstances assisted the growth of Surrealist collections in the city: the movement was not popular in New York and so it was available. Inspirational reasons were also present: proselytizing collectors like Shapiro and others not only encouraged but brought into fashion the collecting of this work. Unencumbered by the dictates of style that often come with being in the center, Chicago offered a geographical and psychological position of greater freedom to take risks, to step outside the norm and into new fields in which reputations can be made. This led to what may be called a Chicago community personality which was a positive force in fostering the growth of Surrealist collections: a Chicago independence in staking out its own territory, not following but challenging New York, making its own achievements and doing so with great enthusiasm, gusto, and vigor. Chicago knew that while it might remain "the second city," it could become "*the* city of Surrealism." And it did.

Pl. 11. Matta, *The Earth Is a Man*, 1942 (see p. 190)

Pl. 12. André Masson, *Pasiphaë*, 1943 (see p. 186)

Notes

1.

Duchamp is represented in Chicago only by his books in The Mary Reynolds Collection of The Art Institute of Chicago and in editioned material: *Boîte-en-Valise* (p. 141) in the MCA collection and *The Green Box* in The Mary Reynolds Collection.

2.

Levy's exhibitions included: Man Ray (1932, 1945); Max Ernst (1932, 1936, 1943, 1944, 1945, 1947); Lee Miller (1932); Pavel Tchelitchew (1933, 1934, 1937, 1938, 1940, 1942); Salvador Dali (1933, 1934, 1936, 1941); Roberto Matta (1940, 1943); Leon Kelly (1939, 1942, 1944, 1945); Dorothea Tanning (1942, 1944, 1948); Alberto Giacometti (1934); René Magritte (1936, 1938); Giorgio de Chirico (1937); Yves Tanguy (1936); David Hare (1940, 1948); Joseph Cornell (1932, 1940); Kay Sage (1944, 1947); Paul Delvaux (1946, 1948); Leonor Fini (1936, 1939); Frida Kahlo (1938); Arshile Gorky (1945, 1946, 1947, 1948); Victor Brauner (1947); as well as several group exhibitions of Surrealist photography. Levy also organized exhibitions from his gallery that traveled to The Arts Club of Chicago in 1935; these were Tchelitchew and abstract sculpture by Giacometti.

3.

These exhibitions at The Arts Club of Chicago included: de Chirico's recent work (1930); paintings by Miró from 1926 to 1929 (1931); André Masson's paintings selected by Pierre Matisse (1933); those of Miró, again from Matisse (1934), which served as the occasion for catalogue author James Johnson Sweeney's lecture on Surrealism; the work of Tchelitchew (1938); Tanguy (1940); Dali and Klee (1941); Max Ernst — who attended the opening — (1942); Masson paintings selected by Curt Valentin (1942); Miró (1943); Matta and Lam, selected by Matisse, and Cuban Painting Today (1944); and Seligmann (1946). Also see note 13.

4.

Julien Levy in *Poetry in Painting 1931-1949: From the Collection of the Julien Levy Gallery, New York* (Chicago: Richard Feigen Gallery, 1965), p. [3].

5.

Outside of New York and Chicago, the other main stronghold of collecting Surrealism from the early 1940s on was in Houston, where Jean and Dominique de Menil, following their immigration there from Paris, acquired in depth the work of Surrealists.

6.

It was the "Fifty-Eighth Annual Exhibition of American Paintings and Sculpture" at the Art Institute that Emily and Burton Tremaine cited as inspirational in leading them to collect. However, they were more attracted by the abstract work than that of the Surrealists.

7.

Surrealism Then and Now, text by Joseph Randall Shapiro (Chicago: The Arts Club of Chicago, 1958).

8.

The Allan Frumkin Gallery opened in Chicago in 1952 and during that decade showed Joseph Cornell (to whom Matta had introduced Frumkin); there grew an interest in Chicago for Cornell at that time that existed nearly nowhere else. Frumkin also had a one-person exhibition of Germaine Richier, and Surrealist group shows. In 1959 Frumkin opened his New York gallery but with far less Surrealist representation because he found there was no market there; instead he showed artists such as

Chicagoans Leon Golub and H.C. Westermann, as well as Maryan, James McGarrell, Philip Pearlstein, and Peter Saul, among others. Both establishments were operated simultaneously until 1980 when the Chicago branch became Frumkin & Struve. Richard Feigen operated his Chicago gallery from 1957 to 1971, having also taken up residence in 1963 in New York, where he opened a gallery in 1968. Feigen reopened his Chicago branch in 1983.

9.

The major portion of the Hodes collection was sold at auction at Christie's, New York, in November 1984. Also in 1984 the major photography collection of Arnold H. Crane, including extensive holdings of Man Ray, was sold to the J. Paul Getty Museum, Malibu, California.

10.

Feigen's first gallery was on Astor Street, his second on Division Street. When he moved again, to open on Ontario Street in the burgeoning gallery district, the Neumanns moved from their South Side apartment and bought Feigen's Division Street townhouse, where they still reside.

11.

Among the other key collectors who made Surrealism an important part of their collections during these early years were James and Marilyn Alsdorf, Ruth and Leonard Horwich, Arnold and Adele Maremont who were advised by Katharine Kuh, Katharine and Morton G. Schamberg, Harold Weinstein, and Claire Zeisler. Other galleries that have shown Surrealist works from time to time include: Alice Adam, Benjamin, Fairweather-Hardin, Findlay, Richard Gray, Hokin, B.C. Holland, Holland-Goldowsky, Kovler, and Worthington.

12.

While beginning first with an exhibition of German Expressionism, Richard Feigen turned to Surrealism by his second show. He pursued this course during his Chicago years (1957-71) with exhibitions of Brauner (1959); Cornell (1959); Bacon (1959, the first Chicago show of this artist who, while not a Surrealist, has affinities with the school); Masson (1961); "Poetry in Painting 1931-1949: From the Collection of the Julien Levy Gallery, New York" (1965); Dubuffet (1967, again not a Surrealist but a related artist); Gorky (c. 1968); "Drawings from the Julien Levy Collection" (1969); Leon Kelly (n.d.); "Max Ernst: From the Julien Levy Collection" (1971); as well as numerous group exhibitions.

13.

At The Arts Club of Chicago, Tchelitchew and Giacometti were shown (1953); Tchelitchew's sculpture and Miró (1954); Richier and, of course, Shapiro's "Surrealism Then and Now" (1958); Gorky (1963); and Richier (1966). Related activities at the Arts Club included Jean Dubuffet's seminal lecture "Anti-Cultural Positions" (1951) in conjunction with an exhibition of his work, while Dada artist Kurt Schwitters was given a major one-person exhibition organized by Sidney Janis who came to lecture on "Schwitters and Collage" (1952).

14.

Exhibitions of the 1950s to 1960s drawn wholly or in part from Chicago collections included: Miró and Arp sculpture at the Arts Club (1961), Klee there the following year; Matta organized by Joseph Shapiro at the Renaissance Society (1963); and Magritte (in large part from Chicago), assembled by Edwin Bergman for the

Renaissance Society (1964). In addition, those focusing on the activities of a single collector included The Arnold and Adele Maremont Collection shown at the Institute of Design in 1961, and "The School of Paris, Paintings from the May Schoenborn and Samuel A. Marx Collection" at The Art Institute of Chicago (1966). In 1967 "Fantastic Drawings in Chicago Collections," curated by Joseph Shapiro, was organized for the Museum of Contemporary Art which had opened that year; "Avant-Garde Chicago," an exhibition of contemporary art from local collections, was curated by Harold Rosenberg for the Renaissance Society (1968); and "Selections from the Mr. and Mrs. Joseph Randall Shapiro Collection" was held at the Museum of Contemporary Art (1969).

15.

Franz Schulze, "Chicago Popcycle," *Art in America* 54, 6 (Nov.-Dec. 1966), p. 104: Another indigenous, related group is "The Surrealist Movement in the U.S.," a Surrealist and Marxist group founded in the summer of 1966 by Franklin and Penelope Rosemont, who earlier that year had met André Breton in Paris. The group considered itself the only legitimate descendent of historical Surrealism linking the U.S. to the continued artistic and political aims of this movement internationally. From 1968 to 1972 they operated the Gallery Bugs Bunny at 524 West Eugenie Street which was devoted exclusively to the showing of Surrealist art. These shows included local and other contemporary figures, the best known being Gerome Kamrowski. They staged a show of 130 Surrealists and 40 other artists from 34 countries with over 500 works in "Marvelous Freedom, Vigilance of Desire: World Surrealist Exhibition" in 1976 at the Chicago alternative space, Alexas Urba Loft, renamed for this occasion Gallery Black Swan. The next year they held at the Hyde Park Art Center "Surrealism in 1977," which included 100 works by 24 participants in "The Surrealist Movement in the U.S." The group has also operated the Black Swan Press and published a journal entitled *Arsenal/Surrealist Subversion*.

16.

Among Chicago exhibitions since 1970 that included Surrealism were: "The New Curiosity Shop," curated by Joseph Shapiro for the Renaissance Society (1970); Miró sculpture, The Art Institute of Chicago (1972); "The Surrealist Experience," presented by Timothy Baum and Richard Gray at the Richard Gray Gallery (1972); "Modern Masters from Chicago Collections," Museum of Contemporary Art (1973); "Cornell in Chicago," Museum of Contemporary Art (1973); the retrospective of Marcel Duchamp, organized by the Philadelphia Museum of Art and The Museum of Modern Art, New York, at the Art Institute (1974); "Max Ernst Inside the Sight," from the de Menil collection, the Art Institute (1974); "Alberto Giacometti: The Milton D. Ratner Family Collection," the Art Institute (1975); "Photographs from the Julien Levy Collection Starting with Atget," the Art Institute (1975); "Man Ray Photographs," Museum of Contemporary Art (1975); Picabia, Richard Gray Gallery (1982); and "Max Ernst Books and Graphic Works," The David and Alfred Smart Gallery of the University of Chicago (1982).

17.

For a view of the period of the collecting of Surrealism and an assessment of Chicago's involvement in the field, see the February 1970 issue of *Art Gallery* in which Jay Jacobs stated that Chicago is an "artistic backwater; its public taste...hasn't progressed much beyond surrealism, the last fully validated style that employs recognizable content."

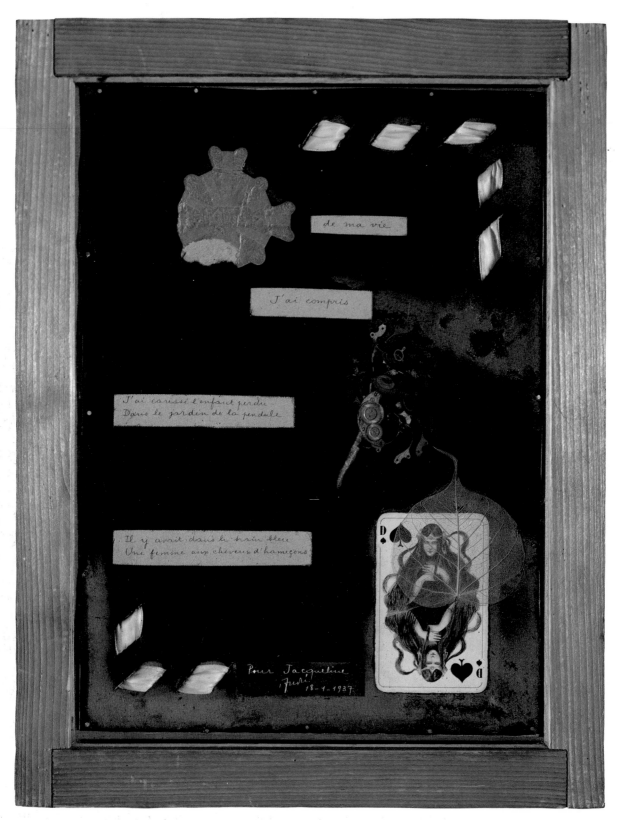

Pl. 13. André Breton, *For Jacqueline*, 1937 (see p. 126)

Between Dada and Surrealism: Painting in the *Mouvement flou*

By Dawn Ades

This paper originated in an attempt to answer some questions about Max Ernst's painting *Pietà* or *Revolution by Night* (fig. 1). This highly charged, enigmatic image, whose importance for Surrealism has never been doubted, was painted in 1923, only a matter of months after Ernst's arrival in Paris from Cologne in September 1922. Strictly speaking, it belongs, therefore, not to Surrealism, which was not founded as a movement until 1924, but to that indeterminate period following the end of Dada in Paris, when the group led by André Breton (see pl. 13), which was to form the nucleus of Surrealism, was gathered round the ex-Dada review *Littérature*. It was to this group that Ernst immediately gravitated, and one of the first questions that might be asked is what kind of context this "hiatus" between Dada and Surrealism could provide for Ernst's painting, and, further, what importance the painting had for the still questing *Littérature* group.

For André Breton *Revolution by Night* possessed the character of revelation. He accorded this character to Ernst's canvases of 1923-24, mentioning specifically *Revolution by Night* and *Two Children Menaced by a Nightingale,* and to Joan Miró's paintings of 1924 (see pl. 14), like *The Tilled Field* and *Harlequin's Carnival,* and said that nothing equaled them until Salvador Dali's visionary and poetic first Surrealist canvases of 1929 (see pl. 15).[1] Once before, in 1921, at the time of Dada, Ernst's work had struck Breton and his friends with the force of revelation. His collages (see pls. 16, 17) had arrived in Paris for an exhibition — without their maker, still unable to move from the occupied Rhineland — and in them Breton had perceived, as he wrote in the catalogue preface, a principle of organization comparable to the poetic image, based on the juxtaposition of "two widely separate realities... and drawing a spark from their contact."[2] In the group of paintings to which *Revolution by Night* belongs — and of which it is the most haunting image — the collage principle had lessened considerably in favor of a more visibly oneiric structure, an image somehow condensed and complete, but still highly mysterious.

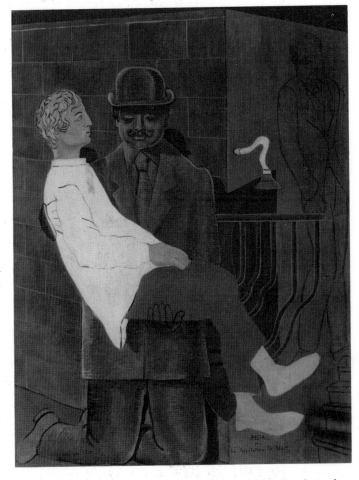

Fig. 1. Max Ernst (German-French, 1891-1976). *Pietà* or *Revolution by Night,* 1923. Oil on canvas; 116 x 89 cm. The Tate Gallery, London.

The special character of this group of paintings by Ernst has nearly always been explained by historians in terms of what was to come — in other words, in terms of Surrealism as it was constituted in 1924 with Breton's *Manifesto of Surrealism* and the ideas and practices put forward in the first Surrealist review, *La Révolution surréaliste.* William

Rubin called these paintings proto-Surrealist, and treated them as "the sole direct link between Dada and Surrealism."[3] John Russell went further, suggesting that in *Revolution by Night*, Ernst "got quite free from the arbitrary undirected aesthetic of the *sommeils*,"[4] and, moreover, that it would not be much of an exaggeration to say that the whole subsequent history of Surrealist painting could be inferred from these two paintings (*Revolution by Night* and *Of This Men Shall Know Nothing*).

However, for several reasons this does not seem quite satisfactory, for it begs a number of questions about the relations between Dada, Surrealism, and the unnamed period between them, and accords relatively little interest to this period in its own right. Further, to place *Revolution by Night* at the head of all Surrealist painting overlooks the fact that the paintings and drawings produced by, for example, Miró and André Masson (see pl. 18) under the immediate impact of the first *Manifesto* and the current of ideas it summed up were very unlike *Revolution by Night* in their emphasis on the automatism of the mark. Masson's drawings were seen as the true equivalent of automatic writing, as the source of "finds" of unexpected images, while the paintings produced at least the illusion of total spontaneity. Moreover, the kind of "dream painting" that took de Chirico as its model came under attack in the very first issue of *La Révolution surréaliste*. When Ernst returned from a journey to the Far East in the autumn of 1924, it was to find Surrealism established, with automatism as the rule. The displacement of "dream painting" may have been only temporary; however, it does suggest that to understand the context in which Ernst's painting acted as a "revelation," we need to look carefully at the period preceding the formation of Surrealism. We need to examine the appeal of "dreams" at this time and what they might have meant for the future Surrealists; the status of an interest in Freud; the factors that contributed to the displacement of Dada values; the context in which the term "Surrealist" came into use, and the way in which it acquired its new and special meaning.

The period between 1922 and 1924, between the crumbling of Dada and the formation of Surrealism as a movement in 1924, is usually treated as a somewhat formless transition between Dada and Surrealism, its relationship to either movement dependent upon the particular bias of the historian or critic.[5] This period does seem to have effected a complete reversal of Dada values: the transition from primal anarchy, the refusal of commitment, the exteriority and aggressive gesture of Dada, to the relative fixity and commitment of Surrealism, with its set of theories and principles, its belief in psychic automatism and the poetic image. It was a period of uncertainty, a switchback between hope and despair, expectation succeeded by demoralization, but always characterized by an extraordinary receptivity (*disponsibilité*) — a receptivity or openness to the new which often makes it appear directionless. It was more than a

breathing space, and not simply a reaction against Dada. For those few ex-Dadaists involved, it was a peculiarly intense experience. As Breton said in his *Entretiens*: "I think I can say that we put into practice the total collectivization of our ideas. Nothing was kept back from the others You would have to go back to the followers of Saint-Simon to find anything comparable"[6] The image that is used again and again to describe this experience is that of a ship or a voyage of discovery, indicating an experiment without a clear idea of a goal. The same metaphor is implied by Louis Aragon in the title of his account of those years, "Une Vague de rêves" (A wave of dreams).

These years are known variously as the "*époque de sommeils*," the "*époque floue*," or the "*mouvement flou*," although Breton left it unnamed. Aragon described the origin of the term "*mouvement flou*" in his preface to *Le Libertinage*: ". . . we imagined, one day when four or five of us were gathered at André Breton's, that the Dada movement had been succeeded by an absolutely new state of mind which we amused ourselves by calling the *mouvement flou*. Illusory, and for me marvelous expression. It gives an account of a world and will never be in the public domain"[7] *Flou* means hazy, out of focus, indistinct (it is particularly used in connection with photography, or landscape, or images generally). As a qualification of "movement," it is clearly a problematic adjective — how can one have a movement (which implies something formed, with rules and principles of action) that is formless? But this, with all its contradictory implications, was what those involved chose to call it. "*Epoque floue*" seems to be a rationalization by historians.[8] The substitution of "epoch" for "movement" removes the paradox; it is perfectly possible to accept, as William Rubin did, this term to describe a transitional period in which the features of some future "form," in this case Surrealism, are as yet perceived only indistinctly; Rubin also suggested "uncrystallized" as a translation for "*flou*."

The "*époque de sommeils*," period of trances, or "sleeps," or "*expérience de sommeils*," as Breton called it,[9] should not be confused with the period as a whole. It was a quite specific and relatively brief period toward the end of 1922, when the group began experimenting with self-induced hypnotic trances. How significant an experience these trances were, both for the ultimate direction the group was to take and for Ernst's *Revolution by Night* in particular, will be discussed below. The kernel group of this "saintsimonian" collective consisted of Aragon, Breton, Eluard, Ernst, and Péret; to this group another was fused: Baron, Crevel, Desnos, Morise, and Vitrac. Gala Eluard and Simone Breton also were present, as was the mercurial ex-Dadaist Francis Picabia. (Marcel Duchamp, whose name was frequently invoked, was for most of this time absent in the United States.) Insofar as the activity of the group was made public, it was in the new series of the review *Littérature* (March 1922-June 1924); the painters Ernst and Picabia also exhibited at the annual salons. Important

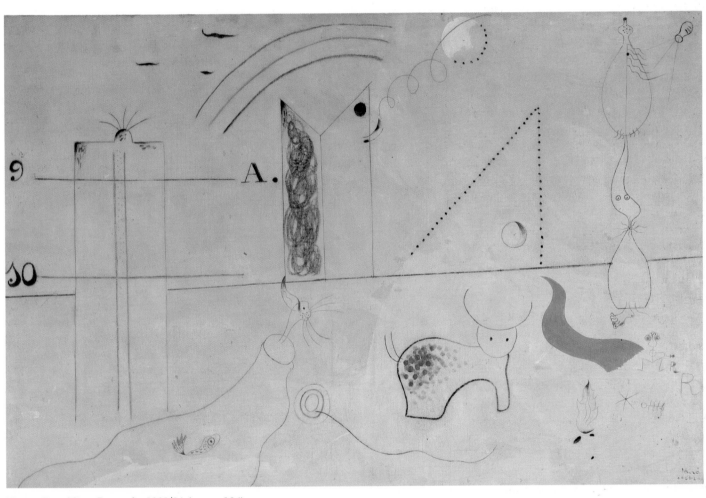

Pl. 14. Joan Miró, *Pastorale*, 1923/24 (see p. 196)

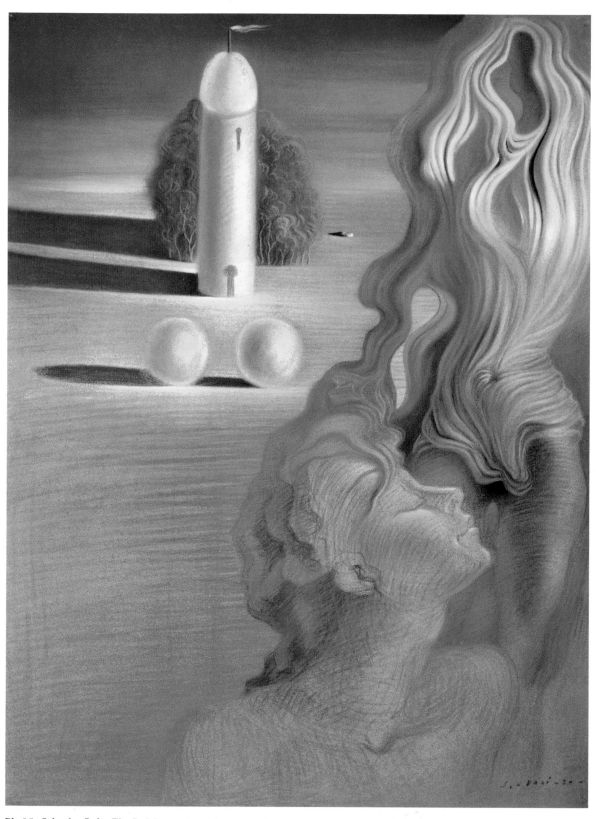

Pl. 15. Salvador Dali, *The Red Tower*, 1930 (see p. 131)

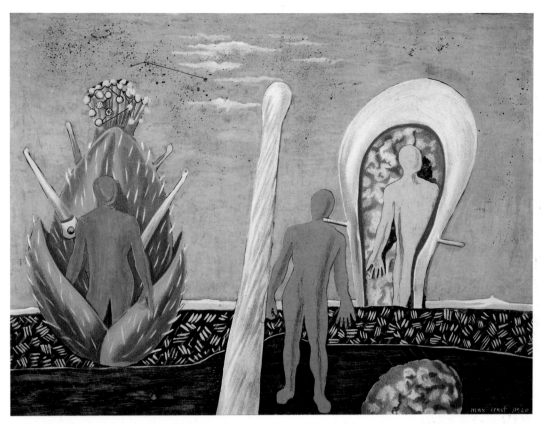

Pl. 16. Max Ernst, *Dada Gauguin*, 1920 (see p. 142)

Pl. 17. Max Ernst, *The Massacre of the Innocents*, 1920 (see p. 142)

Pl. 18. André Masson, *Man*, 1924/25 (see p. 182)

too was the collection of texts, written between 1918 and 1923 by Breton, that he published under the title *Les Pas perdus* in the spring of 1924 (some of which had already appeared in *Littérature*). These were selected and arranged to demonstrate a particular trajectory, with the question of Dada at the center. Placed first is the most recent text, "La Confession dédaigneuse," written at the beginning of 1923, and marking a low point in the discouragement and demoralization from which Breton suffered following the apparent failure of the trances and of his hopes for a real collective activity, and combined with a deep distrust, fueled by Dada, for conventional modes of literary activity. In part a memoir of his friend Jacques Vaché, who committed suicide just after the armistice — a Dadaist event *avant la lettre*, a poet whose greatest luck, Breton had written earlier, was to have left nothing behind — it ends by saying "I love only unaccomplished things" Several of the texts are directly concerned with Dada: two Dada manifestoes are followed by "Pour Dada," which Breton wrote for *La Nouvelle Revue Française* in 1920. This emphasizes the freedom brought by Dada, its refusal to form a "school," and also, significantly, discusses the possible role of the unconscious in spontaneous poetic creation, instancing Guillaume Apollinaire's use of the term *surréaliste* to describe the "finding" of images like "lips of coral." Between the manifestoes and "Pour Dada," Breton placed a text on the Comte de Lautréamont, whose *Poésies* had been published in *Littérature* in April 1922. If any text sets the mood for the next two years, it was this one: "Leave everything/Leave Dada/Leave your hopes and your fears/Leave the substance for the shadow/Leave if need be an easy life, . . ./Set out on the road."

In "Clairement" (*Littérature*, Sept. 1922), Breton adopted a slightly gentler tone toward Dada, allowing it some influence in the creation of the group's new state of mind: "It will not be said that Dada served any other purpose than to keep us in the state of perfect receptivity in which we now are, and from which we will now move away with lucidity toward that which calls us." This text also formulates an idea that lies at the heart of the *mouvement flou*: "I think that poetry, which is all that has ever smiled at me in literature, emanates more from the life of men, writers or not, than from what they have written . . . life, as I understand it, being not the ensemble of acts in the end imputable to an individual . . . but the manner in which he seems to have accepted the unacceptable human condition."

It was this resistance to a separation between art and life, between poetry and life, that was a major element of the hesitancy in taking up a literary "career." Part of Marcel Duchamp's attraction for Breton at this moment was the unity of his attitude to his life and his work. For Duchamp, whose name was a "true oasis for those who are still *searching*," and who seemed to arrive more quickly than others at the "*critical point* of ideas," "the question of art and of life . . . is not posed." Breton spoke out on behalf of life: "Plutôt la

vie," as he called one poem.[10] In the last text in *Les Pas perdus*, "Caractères de l'évolution moderne et ce qui en participe," which was a lecture given at Barcelona in November 1922 on the eve of an exhibition of recent work by Picabia at the Galeries Dalmau, and which marks one of Breton's frequent attempts to enumerate, if not define, the elements of the "modern spirit," Duchamp and Picabia were given a central position: ". . . It may seem strange that I speak of two painters, but, from my point of view, the activities of Francis Picabia and of Marcel Duchamp, the one complementing the other, appear to me as truly inspired. Their vigilance, which has not lessened for a moment in a dozen years, has several times prevented the fine ship which carries us from sinking And let it be understood that it is not a matter here of painting"

What Breton so valued was a continuation of certain elements of the Dada spirit which he redefined in a new context: the refusal to conform to accepted practices within a literary or artistic métier, mobility in the realm of ideas, and a continued receptivity (*disponibilité*). The danger of accepting a new set of conventions for the old — the trap that Dada seemed to have fallen into in 1921 in Paris and which led both Picabia and Duchamp to break with it — is a leitmotif of the *mouvement flou*. In choosing to conclude *Les Pas perdus* with this lecture, Breton ended on an open note: there is still no name for their new direction, but at least it counters the demoralized mood with which the anthology opened.

Littérature may have seemed directionless in its new series, but what its sole editor, Breton, chose to publish was certainly not arbitrary. For example, the very diversity in the few illustrations included demonstrates the positive aim of keeping all avenues open, as well as the negative one of avoiding a school. It is also to be stressed that the illustrations were understood to be no less a part of the complex of ideas and attitudes of the group than were the experiments with language and poetry.

It would be worthwhile to list the illustrations in *Littérature* and comment briefly upon them, before going on to consider the respective roles of the two major participants in terms of the visual arts: Ernst and Picabia. In the first issues of the new series, de Chirico's *The Child's Brain* is reproduced, a painting of primary importance for Ernst's *Revolution by Night*. There is then a gap until the fifth issue (October 1922), which contains two photographs: one by Man Ray of dust breeding on Duchamp's *Large Glass* (but not identified as such) with the caption "This is the domain of Rrose Sélavy / How arid it is — how fertile it is / how joyous it is — how sad it is — view taken from an aeroplane by Man Ray, 1921." The second is one of Eugène Atget's haunted views of Paris shop windows, a butcher's shop with decorated carcasses.[11] The sixth issue contains a color reproduction of Picabia's *Phosphate* (fig. 2), one of his recent highly reduced abstract works. This is followed in the next issue by a new kind of

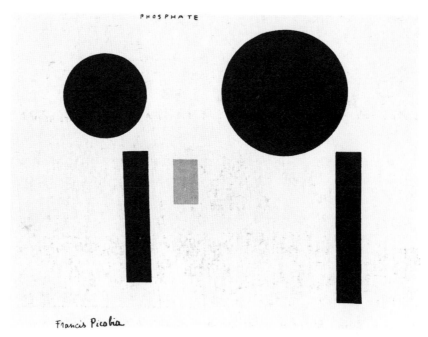

PHOSPHATE

Francis Picabia

Fig. 2. Francis Picabia (French, 1879-1953). *Phosphate*, c. 1922. Ink and watercolor on composition board. Photograph *Littérature* n.s. 6, 1 (Nov. 1922).

Fig. 3. Robert Desnos (French, 1900-1945). *The City of Nameless Streets*, 1922. India ink on paper. Photograph *Littérature* n.s. 7, 1 (Dec. 1922).

drawing altogether, which as we shall see relates to the *sommeils* — a rough drawing by Robert Desnos entitled *The City of Nameless Streets* (fig. 3). Two drawings by Ernst in the next issue (January 1923) hark back to his collages of 1920-21. *The Sea, the Coast, and the Earthquake* (fig. 4) relates to his "alterations" of plates from geology textbooks; the other, untitled, of a man holding a dirigible/cucumber/ lampshade on a tasseled string foreshadows the type of collage construction Ernst used much later in *The Hundred Headless Woman*; the staircase, though, reappears in several paintings of this period. In the ninth issue appears a rayogram by Man Ray, *Mister..., Inventor, Constructor, 6 Seconds* (fig. 5). This technique, of exposing objects placed on sensitive paper to

light ("6 seconds") was developed by Man Ray after he moved to Paris in 1921. It is a technique using chance — a process to which both Dada and Surrealism in various ways had recourse, here used to create new beings and new objects. *Littérature* 10 (May 1923) contains a reproduction of an untitled Cubist painting by Picasso, whom Breton always firmly dissociated from the other Cubists. It is a recent work, in Picasso's Cubist manner, exemplifying how the broken syntax of Cubist painting could create an extraordinary series of visual metaphors as well as an unprecedented formal inventiveness. Throughout the next issue (October 1923) are scattered little drawings by Max Ernst, several of them the first hints at images he was later to develop more fully — such as the veined eye

Fig. 4. Max Ernst. *The Sea, the Coast, and the Earthquake*, 1923. India ink on paper.
Photograph *Littérature* n.s. 8, 1 (Jan. 1923).

which is the basis for one of the most remarkable of the later frottages (figs. 6a, 6b, also see fig. 7). The final issue published Man Ray's photograph *Ingres's Violin*, a subtle interpretation of title and image. Picabia was responsible for the covers for all issues from September 1922; in his new "Neoclassical" style, they move effortlessly between the erotic and the sacrilegious (figs. 8-10).

It has been suggested that when Ernst appeared on the scene, first through his exhibition of collages in 1921, and then in person the following year, he was welcomed by Breton as a worthy successor to, but quite different from, Picabia, who, in this argument, is seen as too closely linked with Paris Dada in the public eye to be a useful ally in their private, post-Dada world. However, it is clear from Picabia's regular contributions to *Littérature*, not just visual but including texts and poems, from the tone of Breton's references to him in *Littérature*, and from the letters they exchanged through 1922-23, that his participation was desired and solicited.

At the beginning of 1922, Picabia was still engaged in his characteristic baiting of the public, with a renewed range of visual provocation. He sent in three works to the Salon des Indépendents: *Dance of Saint Guy*, *The Merry Widow*, and *The Straw Hat*.

The Merry Widow was rejected because it contained a photograph and the Indépendents refused to accept photographs; *The Straw Hat* was banned because of the potential obscenity in the inscription ("*m — pour celui qui regarde*"). The committee said they could not risk the government's taking the Grand Palais away from them. So, ironically, only the *Dance of Saint Guy* was shown, an empty picture frame laced with string, aesthetically the most provocative of them all. Originally intended, it appears, as part of a living installation that was to have included white mice, it still seems of clear Dada inspiration.

But Picabia's art was soon to change again radically. He and Breton reunited early in 1922 during the fiasco of the Congress of Paris — a congress whose leaders included representatives of the major avant-garde groups of artists, including Léger for the Cubists, Ozenfant for the Purists, Delaunay, and Breton for the Dadaists. The "International Congress for the Determination of the Directions and the Defense of the Modern Spirit," as Breton announced it (January 3, 1922), failed in a flurry of recriminations, and Picabia congratulated Breton on playing a thoroughly devious Dada game: bringing together all these people, Dada's old enemies, in order to demonstrate the futility of such an attempt at unification.[12] This was almost certainly not what Breton had intended; nonetheless, it provided the basis for two years of collaboration between the two men. The point is that Picabia was as disenchanted with Dada as Breton was, but for different reasons. Breton was incapable of sustaining the negative posture of Dada (as it was manifested in Paris, at least); he was not, as Picabia put it, *brut*, and he was also sick of Dada's relentless exteriorization; these two years were marked by a turning inwards. Picabia, on the other hand, scented a danger of even Dada's becoming stereotyped — a repetitive formula.

The radical changes in Picabia's art in 1922 cannot be ascribed to any particular influence of Breton and his circle, but nonetheless mark a parallel break with the past. The new abstract works (oddly prophesied by the *Dance of Saint Guy*) like *Phosphate* are based on the simplest and most reduced forms: lines, rectangles, circles. As always with Picabia, they represent a highly idiosyncratic response to the painting of his contemporaries — Malevich or Mondrian, for instance. But it is clear that they do not signify pure aesthetic or spiritual experience. For one thing, Picabia emphatically lettered on titles, like "Phosphate," that suggest that he was still favoring a symbolic meaning. The lines and circles relate back to the

Fig. 5. Man Ray (American, 1890-1976). *Mister...*, *Inventor, Constructor, 6 Seconds*, 1923. Rayogram. Photograph *Littérature* n.s. 9, 1 (Feb.-Mar. 1923).

Fig. 6a. Max Ernst. Drawing for poem "Interdit de séjour" by Max Morise, 1923. India ink on paper. Photograph *Littérature* n.s. 11, 15 (Oct. 1923).

Max Morise

INTERDIT DE SÉJOUR

A la dernière corrida
une très belle dame m'aborda
amoureuse de l'espada
et maîtresse d'un duc
elle me disait tout bas
SOL Y SOMBRA Y SOL Y SOMBRA Y SOL Y SOMBRA Y SOL

Lévriers
sur la poussière équatoriale
mes beaux chiens de luxe
je vous choisis pour sépulture.
Vous serez joyeux de me dévorer
et moi je serai fier
et bien abrité du mal.
Mais surtout gardez-vous de m'éveiller.

Le sommeil
l'argent
l'arc-en-ciel
les fèves
le cœur
le sable
et l'oiseau-mouche
retourneront en poussière.

Fig. 6b. Max Ernst. Detail of figure 6a.

Dada machine paintings (see pl. 19), but in certain compositions have a new and different association, with astronomy, astronomical instruments, star charts. Star patterns and planetary movements were a potentially fascinating source of imagery, basically abstract but superimposed with a humanly constructed figuration. It is interesting that around the same time, Ernst based several works on charts of the heavenly bodies: the 1920 collage *Pleiades*, for example, or the black-ground painting of 1923, *Victory of Samothrace*.

Simultaneously with these works, it seems, Picabia was developing a new figurative style: *The Spanish Dancer*, which he sent to the Autumn Salon of 1922, is slyly Neoclassical, not exactly parody, yet clearly opposed to the revival of classicism in the early 1920s. *The Spanish Dancer* plays with negative/positive, black/white effects, as does *Conversation* of 1922, which more obviously owes a debt to Duchamp's experiments with optics, and is thus part of a long and fruitful visual dialogue between them. Picabia's covers for *Littérature* are endlessly inventive within this new style.

One reason at least to emphasize Picabia's place among the *Littérature* group at this time is that it demonstrates during the *mouvement flou* how far in reality Breton was from adopting any given program. Certain things seem to have been important — the need for an activity to be undertaken *in common* by a group of like-minded people, an openness or freedom to new ideas and new forms in poetry or the visual arts, but with the emphasis always on the freedom itself. For Breton the "imperious need" for activity was matched only by the absence of any resolution to the problem, at one time posed by the Dada veto, of avoiding capitulation to the demands of the métier. The poems in *Claire de terre* were written just before the most extreme moment of demoralization, when Breton announced in the *Journal du Peuple* that he would write no more.[13] No wonder Duchamp's decision in 1923 to "go underground," leaving "definitively unfinished" his *Large Glass* in New York, should have so profoundly disturbed Breton that he was to write in the *Second Manifesto of Surrealism*: "It was not open to Duchamp to abandon the game he was playing round about the war for an interminable game of *chess* which gives perhaps a curious idea of an intelligence for which servitude was repugnant... but also which seemed heavily afflicted with skepticism to the extent that it would not say *why*."[14]

It was essential to Breton, in the end, to find a solution, which he was to announce in the first *Manifesto of Surrealism* in the autumn of 1924. It was just as inevitable that this would lead to a break with Picabia. One of Picabia's last contributions to *Littérature* was a poem (in the penultimate issue of that review, of October 1923, devoted entirely to poetry) which included the lines: "I feel the need to become/a contrary type/contrary to everything . . ./I am the contrary of an examination/the contrary of an analysis/the contrary of a belief."[15]

Fig. 7. Max Ernst. *Microgramme Arp*, 1921. Arp "poem" accompanied by diagram with key; India ink on paper. Photograph *Littérature* 19 (May 1921).

Fig. 8. Francis Picabia. Cover drawing for *Littérature*, 1923. India ink on paper. Photograph *Littérature* n.s. 10, 1 (May 1923).

Fig. 9. Francis Picabia. Cover drawing for *Littérature*, 1923. India ink on paper. Photograph *Littérature* n.s. 9, 1 (Feb.-Mar. 1923).

Fig. 10. Francis Picabia. Cover drawing for *Littérature*, 1923. India ink on paper. Photograph *Littérature* n.s. 8, 1 (Jan. 1923).

It is not surprising then that as Surrealism began to take shape as a movement in the spring of 1924, Picabia mobilized for attack. He seems to have taken the view that Surrealism was to be another fabricated experiment, and that its program was déjà vu. He revived *391*, his peripatetic and magnificently unpredictable review, which had started in 1917 and ran through the Dada years, but had lain dormant since 1921 while Picabia contributed to *Littérature*. Four issues appeared, from May to October 1924, with a series of comic and scurrilous drawings attacking Breton and his friends, and a final issue that attempted to undermine Surrealism with the announcement of a new "movement." Breton did not respond in kind. In the final, curious issue of *Littérature* (June 1924), a "demoralizing number" that still makes no mention of Surrealism, Breton even used for the cover one of Picabia's drawings, of roasting geese, which presumably intended a specific reference to Breton (and his friends) whose "goose was now cooked." With the *Manifesto*, and the review *La Révolution surréaliste*, whose first issue appeared in December, the new movement was established in strength.

So far, I have attempted broadly to delineate the state of mind of Breton and the *Littérature* group in the period leading up to the formation of Surrealism. But I have not yet discussed what was certainly the central experience of this time: the *sommeils* (hypnotic trances). It is in Breton's account of these, "L'Entrée des médiums" (*Littérature*, Nov. 1, 1922), that we find a clue to the meaning of "surrealism" at that time, and to the significance this experience was to have for the eventual creation of Surrealism.

In the autumn of 1922, René Crevel introduced the group to the technique of the self-induced hypnotic trance, which he had learned from a medium. The first séance took place on September 25, and for about three weeks they occurred daily. Only certain members of the group ever succeeded in falling into a trance, notably Robert Desnos and Benjamin Péret. Breton himself, like Ernst and Picabia — the only painters to attend — was among those obliged to remain a spectator. Those who fell "asleep" were, to the amazement of those still awake, capable of speaking, writing, even drawing, either independently or in response to an outside stimulus such as questions from the spectators. The experience of witnessing the sleepers, speaking or writing at will in a vein of pure imagination or prophetic frenzy, free from the constraints of logic and reason, profoundly shook all present. As Simone Breton wrote, "We are living at the same time in the present, past and future. After each séance we are so bewildered and shattered that we promise ourselves never to start again, and the next day, all we want is to find ourselves again in that catastrophic atmosphere where we all hold hands with the same anguish. Imagine our stupefaction when out of twelve people present *five* have been transformed into mysterious agents or ambassadors of a fascinating and strange domain"[16]

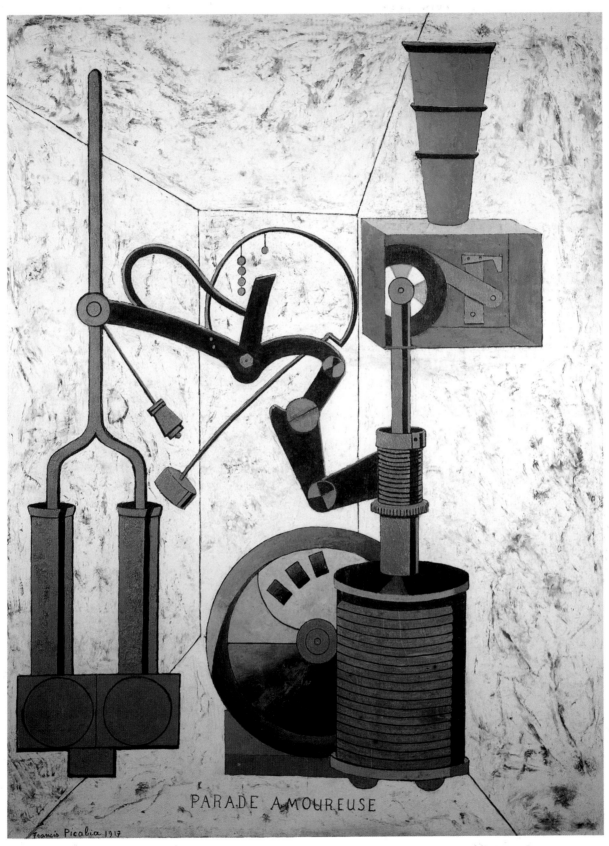

Pl. 19. Francis Picabia, *Amorous Parade*, 1917 (see p. 204)

What they felt they had stumbled upon was access to a "second state" of consciousness, which at first seemed to them to have advantages over the other routes that had previously been tried: automatic writing and the narration of a dream. Breton recorded some of the first sessions in "L'Entrée des médiums," and explained the importance of this new experience in relation to their enterprise as a whole: "We know up to a certain point, my friends and I, what we understand by *surrealism*. This word, which is not our invention and which could so easily have been abandoned to the vaguest critical vocabulary, is used by us in a precise sense. By it we have agreed to designate a certain psychic automatism which corresponds quite closely to the dream state, a state which it is today extremely difficult to delimit." Breton then described the initial experience of automatic writing, as he and Soupault practiced it in 1919, publishing the results under the heading "Les Champs magnétiques" in *Littérature*. The writing had been produced in a state as closely approximate as possible to that of half-sleep, in which images come unbidden to the mind. More recently, however, he wrote, the "incursion of conscious elements" had become more difficult to avoid, and had led to considerations of a predetermined, literary kind which had begun to make automatic writing less fruitful. More recently, the narration of dreams had been practices which Breton wanted to be "stenographic," like dictation. He had published three "*récits de rêve*" in the first issue of the new series of *Littérature* (Mar. 1922). But this in turn had disadvantages — such narratives were inevitably subject to memory, which was frail and liable to make mistakes. So he welcomed the third "solution to the problem," the hypnotic trance, through which a kind of verbal automatism was achieved, manifestly outside conscious control, like the dream.

Once awakened, those who had been in a trance had no memory of what they had said or done, which thereby seemed all the more like a spoken dream. Aragon, in "Une Vague de rêves," wrote that "Desnos learned to dream without sleeping. He came to speak his dreams at will. Dreams, dreams, dreams, the domain of dreams grows wider at every step"[17] But it was a "dream state" closely approximate to rather than identical with dreams and it was not Freud who presided over this epidemic of "dreams," important though Freud had been and was again to be for Breton. Indeed, Freud seems to have been relatively under a cloud at this point. In the first issue of *Littérature*, Breton had published what he later regretted as an "ungenerous" account of a visit to Freud in the summer of 1921. "Interview du Professeur Freud à Vienne" opens: "To the young people and romantic spirits who, because psycho-analysis is all the rage this winter, need to imagine for themselves one of the most prosperous agencies of modern charlatanism, Professor Freud's cabinet with its machines form transforming rabbits into hats...."[18] That he published the three "dream narratives" in the same

issue as his attack on Freud was a clear indication that his interest in dreams was not primarily in analyzing them; they were poetic texts in their own right, bearing witness to the operations of the mind in nonconscious states, and their interest was not to be confined to a tool for psychoanalysis.

Psychoanalysis enjoyed a vogue in Paris at the time and this is confirmed by such articles as that published by the editor Jean Paulhan in *La Nouvelle Revue Française* in 1922 which attempts to give an account of the major tenets of Freud's theory as a guide to those currently obsessed with interpreting their dreams.[19] It is not surprising that the *Littérature* group wanted to dissociate themselves firmly from this shallow and sensational fashion.

Although the hypnotic trance was introduced via the spiritualist medium, it should be pointed out that Breton rejected out-of-hand the mediums' claim of receiving messages from the dead. It was the activity of undirected thought and its poetic possibilities, parallel to that in dreams but no longer subject to the problem of recall, that they valued in the trance as "psychic automatism." This was to form the heart of the definition of Surrealism as Breton gave it in the first *Manifesto of Surrealism:* "Pure psychic automatism, by which it is intended to express, either verbally, or in writing, or in any other way, the true functioning of thought. Thought dictated in the absence of any control exerted by reason, and outside any moral or aesthetic considerations." But now, almost all reference to the hypnotic trance has gone, and automatic writing ("Surrealist composition") has been reestablished as the central Surrealist practice.

It should be emphasized here, as Marguérite Bonnet has confirmed, that there was a difference between the "psychic automatism" of "L'Entrée des médiums" and the automatism studied by psychiatrists and psychologists during the interest in hypnosis at the end of the 19th century, when the connections between an "automatic state" and the unconscious were observed. For Pierre Janet, for example, automatism as it was manifested by patients in states of withdrawn consciousness or under hypnosis, and as he described it in his "*L'Automatisme psychologique*" of 1889, was a mechanical form of response. As Bonnet said, Janet always deprecated it: "He insists on the creative powerlessness of automatism which he considers a degradation of past psychic activity, a kind of residual function capable only of conserving and repeating."[20] Carl Jung accounted for the mediums in similar terms. In *On the Psychology of So-Called Occult Phenomena* (1902), he wrote that the automatism of the medium revealed an "unconscious personality . . . [that] owes its existence simply to suggestive gestures which strike an answering chord in the medium's own disposition." Though the experiments with automatic writing and other forms of automatism helped to determine for psychologists in the 19th century the existence of an unconscious, automatism did not produce a model of the

unconscious as a potentially creative force, which was the aspect of their experiments that so enthralled Breton and the *Littérature* group. The speech and writing of the "sleepers" was remarkable for the degree of the poetic and the marvelous, quite unlike the mechanical responses recorded by Janet. The experience was overwhelming insofar as it served to "elucidate the nature of the poetic word and to localize the source of images." Breton's interest in abnormal states of mind and the possibilities they revealed of a new source of poetic language went back a long way. In 1916, while he was stationed as a medical auxiliary at the neuro-psychiatric center at St-Dizier, he wrote to Théodore Fraenkel: "Precocious demoness, paranoia, twilight states/O German poetry, Freud and Kraepelin!"[21]

Freud's linking of the dream process to the working of the unconscious mind was one of the factors that invested the unconscious with "creative power"; and in the *Manifesto of Surrealism*, Breton once again made Freud central, recalling both his importance in 1919 for the first experiments with automatic writing ("Occupied with Freud as I still was at that time and familiar with his methods of examination that I had had some occasion to practice on the sick during the war...") and the more recent and more general importance for him of Freud's work on the dream ("If the depths of our mind conceal strange forces capable of augmenting those on the surface, or of fighting victoriously against them, it is of the utmost interest to seize them, to seize them first, and submit them afterwards, if needs be, to the control of our reason..."). What Breton, perhaps ironically, saw in Freud was confirmation that the "materialist-realist attitudes" needed challenging; he believed that Freud had proved the existence of a psychic reality, psychic activity, beyond the "summary realities" of everyday, and that to escape from the constriction of the "reign of logic," we had to open up or explore all areas of mental life. But at the period of the trances, Freud seems to have been relatively absent from the group's thought.

The experiments with trances were not to last long; they continued sporadically in December but, having gotten dangerously out of hand, were altogether abandoned by the end of the winter. Once, for instance, Crevel was discovered leading a group suicide attempt. Desnos, too, became violent, and eventually harder and harder to awaken from his trance, preferring, it seems, the "dreams" to his waking life.

However, if the trance proved in the end impossible to use, the group's belief in "psychic automatism," as we have seen, was not shaken. But the failure of the trances left the group once again directionless and Breton veered between active plans and complete discouragement. One active proposal was for a new salon, which Breton seems to have put some hopes in during the spring of 1923, even — in vain — trying to interest Picasso in it.[22] Duchamp's importance had been underlined from an unexpected direction. A number of elaborate word plays were published in *Littérature* (Oct.

1922) under the authorship of "Rrose Sélavy," for example: "paraître/Abominables Fourrures abdominales/Rrose SELAVY." In the text "Marcel Duchamp" in the same issue, Breton explained the identity of Rrose Sélavy (Duchamp's female alter ego).

One of the most bizarre events of the *sommeils* was the sudden ability of Robert Desnos to produce word plays of a very similar kind, which he claimed were somehow "transmitted" to him by Rrose Sélavy; these were published in *Littérature* (Dec. 1922), at the same time as another text of Breton's, "Les Mots sans rides," in which Breton examined the transformations of words, the "freeing" of words from conventionally utilitarian usage, which he saw as a major part of the new poetic, and in relation to which he named the word games of Rrose Sélavy as important examples. During the same period Desnos produced a series of paintings — of dubious technical merit, though perhaps that was not really their point. The paintings were directly related to the "conversations" of the trances, and were a strange assemblage of words and images, acting almost like attributes in a portrait; among them were the *Death of André Breton* (fig. 11), the *Death of Max Morise*, and the *Death of Max Ernst*.

What I would now like to consider is the effect of Ernst's arrival in Paris, and what, if any, influence the trances and "psychic automatism" had upon his work. That Ernst, now living with Paul Eluard and Gala, straightaway made contact with the *Littérature* group and participated in the séances has already been mentioned. He commemorated the "saintsimonian" collective of the *mouvement flou* at the time of the *sommeils* in his huge canvas *The Meeting of Friends* (fig. 12), painted in December 1922, just over two months after his arrival in Paris. Ranged across the canvas, gazing out at the viewer like the "disciples" in Fantin-Latour's *Homage to Delacroix*, are the *Littérature* group plus some distant friends. Stretching back into the distance is a column of anonymous people, as though the figures in the foreground are the first of a multitude to follow. The friends are united not by allegiance to an honored predecessor, but by the shared and marvelous experiences of the kind described above. There is, though, an odd echo of the "homage" tradition, though of a highly unconventional kind: Ernst depicted himself seated on the knee of Dostoevsky, one hand in his beard. A certain lack of cordiality in Ernst's painting has been ascribed to the latent tensions within the group, but this is perhaps rather an effect of their absorption in the extraconscious experience of the *sommeils*. Not all of those depicted had in fact participated in them: apart from Dostoevsky, Ernst had also included de Chirico and his old collaborators from the Dada days in Cologne, Johannes Baargeld and Jean Arp (who had not yet moved to Paris), thus affirming the continuity and affinity of his earlier activities. Seated on Dostoevsky's other knee is Jean Paulhan, an old friend of Eluard's who for a while made "common cause" with the *Littérature* group; he

Fig. 11. Robert Desnos. *Death of André Breton*, 1922. Oil on canvas; 129.5 x 55 cm. Private Collection, Paris.

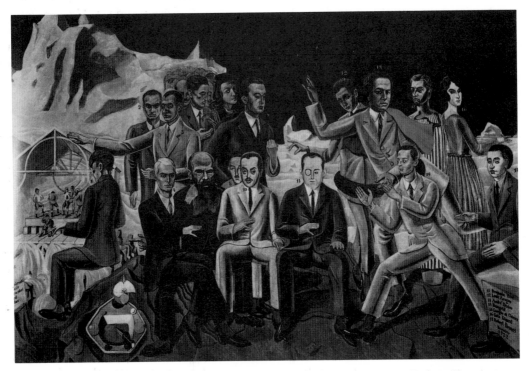

Fig. 12. Max Ernst. *The Meeting of Friends*, 1922. Oil on canvas; 129.5 x 193 cm. Wallraf-Richartz Museum, Cologne.

had managed to acquire false papers for Ernst (in the name of Jean Paris). To emphasize the "sur-real" nature of the gathering, Ernst has placed them not in a studio or a café, but in a strange domain, an otherworldly landscape with lunar hills against a nearly black sky, the circles of the heavens hinting at planetary revolutions. Breton, his hand raised in a vatic gesture, already dominates the group. René Crevel, initiator of the trances, is shown seated at the far left as though at a piano but in fact gazing at a miniature stage with game players on it.

or the reverie of a dream state, although the narrative is not "coherent." They are drawn in a relatively rudimentary manner and contain a similar kind of juxtaposition of heads and figures, architecture or fragments of architecture, with other signs and words, such as those in Robert Desnos's paintings. The suggestion of a mountainscape and of geological layers, out of which and against which the figures emerge, also relates to *The Meeting of Friends* and to Ernst's earlier collages. Written as a kind of "title" toward the center in one drawing, near Gala's head, are the words *"l'aimant*

Fig. 13. Max Ernst. *Automatic Writing Lesson* or *The Magnet Is Undoubtedly Close*, c. 1923. India ink on paper; 17.3 x 169 cm. Galerie André-François Petit, Paris.

The stiffness of the painting has been explained as a deliberate parody of Ernst's own father, an assiduous Sunday painter, but could also be part of a deliberate strategy of rejecting painterliness. That Ernst might also have been commenting upon the current state of painting and his relations to it is hinted at in the odd little still life down by Ernst's feet. Among the objects is an apple in the process of being cubed — a dig at Cubism, still the dominant avant-garde style.

The Meeting of Friends was sent to the 1923 Salon des Indépendents (together with two works painted in Cologne, *Oedipus Rex* and *Celebes* [sic] and the more recent *Interior of the View*). Ernst asked the high price of 10,000 francs for *The Meeting of Friends* and it remained unsold. The following year, with the exception of canvases that were already in the Surrealists' own collections, like *Revolution by Night*, which belonged to Eluard, he sold off his entire Paris production to his old supporter Johanna Ey ("Mutter Ey" of Düsseldorf), and set out to follow Eluard to the Far East.

If *The Meeting of Friends* celebrates the collective experience of the group during the *sommeils*, other works by Ernst in the following months reveal his responses to the concept of "psychic automatism" as Breton defined it in "L'Entrée des médiums." Two drawings (dated by Werner Spies c. 1923) bear the title *Automatic Writing Lesson* (see fig. 13). They do not relate to the gestural automatism of André Masson's drawings of around 1924, which have come to dominate our idea of visual Surrealist *Littérature*. They seem rather to bear a relationship to the "psychic automatism" of the trances, produced in a state quite closely corresponding to that of a dream. The drawings are very long (over 169 cm) and narrow (17 cm) — more like a written scroll than a picture. They are clearly meant to be read like a narrative

est proche sans doute" (the magnet is undoubtedly close). This might, perhaps, suggest that the dispersed and extended images are about to be gathered into a new order.

By contrast to these drawings, Ernst's *Pietà* or *Revolution by Night* would seem to represent not the image sequences of trance but a single image from a dream. It seems to parallel what Freud called the "dream-work" of the mind with the use, for example, of condensation and displacement. I would like to suggest that this painting is as consciously Freudian as are such earlier works as *Oedipus Rex,* but that its theme is also related to the experience of the trances.

Because of the enigmatic nature of the image, its components should first be identified. There are three figures, and each has a double identity. The title *Pietà* confirms the derivation of the two primary figures from Christian iconography, but with a difference. The son is held not by a mourning mother but by a gloating (impassive?) father. Also, the father is on his knees, holding his son as though offering him as a sacrifice, which brings to mind Abraham and Isaac. The son is clearly Ernst himself; it is visibly a likeness, and Ernst's identification with Christ goes back to his childhood, when his father painted the little boy as the child Jesus. The father, therefore, is also Ernst's father, and indeed he bears the turned-up mustaches of his father as Ernst remembered them in his later account of a "vision of half-sleep" experienced between the ages of five and seven.[23] The father also bears a resemblance to de Chirico's *The Child's Brain,* and indeed stands centrally in a Surrealist tradition of Oedipal-parental imagery stretching from de Chirico to Dali. The mustached man appears in several Ernst paintings of the period, for example, *Old Man, Woman, and Flower,* in the first version of which he is juxtaposed to a grotesque creature formed of a spinning top/brick wall, which in a painting of

1924 is identified as *Ubu Imperator*: the identification with Alfred Jarry's dictatorial "père Ubu" underlines his oppressive nature.

If these two figures are Father and Son, the "invisible" figure on the wall naturally becomes the third figure of the Trinity, the Holy Ghost. The vaguely sacrilegious character of this is entirely in line with other paintings of the period like *The Resurrection of the Flesh*. The second identity of this figure is more difficult to determine, and indeed there are various possibilities. First, it bears a resemblance to Freud himself; next, its head is bandaged, recalling de Chirico's prophetic portrait of Apollinaire with a head wound. Malcolm Gee has suggested it might represent Ivan from *The Brothers Karamazov,* who wrapped his head in a towel to shut out the Devil after he found himself indirectly responsible for the murder of his father. The identity of the figure, indeed, is inextricable from attempts to read the image, and also bears out Freud's statement that "a single element of the manifest dream often stands for a whole number of latent dream-thoughts as though it were a combined allusion to all of them; and in general the compass of the manifest dream is extraordinarily small in comparison with the wealth of material from which it has sprung."[24]

The central subject of the painting would still seem to be Oedipal, but instead of killing the father, the son himself is dead. Whether this is self-inflicted or whether the father is responsible is impossible to determine. Gee made the interesting suggestion that the painting represents an inverted Oedipal wish, and refers to a case study of Freud's known as "The Wolf Man," in which the patient's neurosis goes back to a childhood disturbance springing from conflicting emotions of desire and fear for the father. An identification with Christ allowed him "to satisfy, temporarily, his ambivalent feelings toward his father. As Christ, he could indulge his general masochistic tendencies; he could love his father without restraint; and under this 'cover' he could speculate on the possibility of sexual relations between them."[25] Gee also suggested that the strange shower head or light object could then be explained as a "detached phallus," symbolizing the necessity for castration in the Wolf Man's scenario. That Ernst seems to have known "The Wolf Man" is confirmed by another painting of 1923, *Souvenir of God,* and it is very possible that his knowledge fed into the *Pietà.*[26]

A further suggestion could be made, that the Son/Ernst is turned to stone (as figures so often are in de Chirico) not because he is dead but because he is in a catatonic state, a deathlike trance. Turning again to Dostoevsky, who was an author much read and discussed in Ernst's household — his *The Eternal Husband* was Eluard's favorite novel, while Gala, Eluard's Russian wife with whom Ernst was passionately involved, tended to turn things into "Dostoevsky dramas"[27] — we find another possible hint. Dostoevsky suffered from epileptic attacks, which seem to have been associated by him with guilt about his father's death. In *The Idiot* the Prince is saved from committing a murder by an epileptic fit, and falls downstairs. (This might suggest a further identity for the third figure.) It seems very likely that Ernst knew of Dostoevsky's epilepsy, though he cannot have known a text by Freud that runs very close to the *Pietà* or *Revolution by Night.* In 1928 Freud wrote "Dostoevsky and Parricide"; he defined parricide as the principal and primal crime of humanity, and suggested that it could manifest itself in neuroses in various ways. Freud defined Dostoevsky's attack of epilepsy as acute hysteria caused by the shock of his father's death. Such attacks "signify an identification with the dead person, either with someone who is really dead or with someone who is still alive and the subject wishes dead. The latter case is the more significant. The attack then has the value of a punishment. One has wished another person dead, and now one *is* this other person and is dead oneself. At this point psycho-analytical theory brings in the assertion that for a boy this other person is usually his father and that the attack . . . is thus a self-punishment for a death-wish against a hated father."[28]

Woven into the Freudian imagery are references to the conversations of the "sleepers" as recorded in Breton's "L'Entrée des médiums" — and perhaps others which we shall never know as they were not recorded. In Desnos's conversation particularly, and in the paintings already mentioned by him, death, suicide, and madness are common themes. In one séance, for example, Eluard asked Desnos when he would die, and received the reply, "one day in October." Ernst twice received replies from an entranced Desnos running on about madness:

q. To what is he destined?
a. Mad.
q. What madness?
a. Honey.

On a third occasion Desnos introduced a specific image which Ernst used in the *Pietà.* Asked, "What do you know of Max Ernst?" he replied, "The white shirt of Fraenkel at the Salpêtrière." The Salpêtrière was the hospital-asylum where Jean-Martin Charcot had made his studies of hysteria in the 1870s, and where Freud had come to study. Fraenkel, like Breton, had been a medical student. Ernst depicted himself wearing a white shirt, perhaps that of a patient rather than a doctor, which also suggests an "hysterical" trance.

Connections between a number of Ernst's paintings of this period and specific case studies by Freud have been established.[29] Not only, then, did Ernst have a knowledge of Freud's theories in a general sense, but he was familiar with his writings in more detail probably than were either Breton or any other member of the *Littérature* group at the time. It would perhaps, then, not be unreasonable to suggest that Ernst himself and such paintings as *Pietà* or *Revolution by Night* contributed to the renewed interest in Freud demonstrated in the first *Manifesto.* At the same time, the

communal experiences of the *sommeils* encouraged Ernst to present the associations and memories of his childhood in more autobiographical form, and the themes of death and suicide dressed themselves in Freudian imagery. With this painting, and with those by Ernst of the same period, such as

Of This Men Shall Know Nothing, by far the most substantial visual achievements of the *mouvement flou,* it must have seemed to Breton as if, at least in the sphere of painting, there was about to be a new direction.

Notes

1.
André Breton, *Entretiens 1913-1952* (Paris: Gallimard, 1952), p. 155.

2.
André Breton, Preface, "Max Ernst," *Exposition Dada Max Ernst* (Paris: Au Sans Pareil, 1921), in Max Ernst, *Beyond Painting and Other Writings by the Artist and His Friends,* ed. Robert Motherwell, The Documents of Modern Art (New York: Wittenborn, Schulz, 1948), p. 177.

3.
William Rubin, *Dada and Surrealist Art* (London: Thames & Hudson, 1969), p. 145.

4.
John Russell, *Max Ernst* (London: Thames & Hudson, 1967), p. 74.

5.
For example, see Michael Sanouillet, *Dada à Paris* (Paris: Jean-Jacques Pauvert Editeur, 1965) and Marguérite Bonnet, *André Breton et la naissance de l'aventure surréaliste* (Paris: José Corti, 1975). Both are indispensable for a study of this period, but take a very different attitude to Dada. Sanouillet argued that Surrealism was the form Dada took in Paris, while Bonnet lessened the significance of the Dada experience for Breton, stressing the continuity of his ideas from an earlier time.

6.
Breton, *Entretiens* (note 1), p. 71.

7.
Louis Aragon, *Le Libertinage* (Paris: Gallimard, 1924), p. 25.

8.
For example, Rubin (note 3).

9.
Breton, *Entretiens* (note 1), p. 76.

10.
André Breton, *Clair de terre* (Paris: Gallimard, 1966), p. 72.

11.
Or possibly an Atget-like photograph by Man Ray.

12.
See William A. Camfield, *Francis Picabia: His Art, Life and Times* (Princeton: Princeton University Press, 1979) for a more detailed discussion of Picabia during this period.

13.
Breton published the following "poem" in *Clair de terre:* "A RROSE SELAVY/André Breton n'écrira plus." *Journal du Peuple* (April 1923): "J'ai quitté mes effets/mes beaux effets de neige." The example of Duchamp, therefore, influenced Breton in his (temporary) decision to write no more.

14.
André Breton, "Second Manifeste du Surréalisme," *La Révolution surréaliste,* Dec. 1929.

15.
Francis Picabia, "Bonheur nouveau," *Littérature* 11-12 (Oct. 1923), p. 21.

16.
Simone Breton, letter to Marguérite Bonnet (note 5), p. 265.

17.
Louis Aragon, "Une Vague de rêves," *Commerce* (Paris: S.N.E., 1924), p. 110.

18.
Littérature n.s. 1 (Mar. 1922). The word I have translated as "charlatanism" was "*Rastaquouerisme,*" which implies unscrupulous adventurer, and was one of the favorite terms of Picabia, who had published a book entitled *Jésus-Christ Rastaquouère* (Paris: Au Sans Pareil, 1920).

19.
See Jules Romains, "Aperçu de l'art psychanalyse," *La Nouvelle Revue Française* 1 (1922).

20.
Bonnet (note 5), p. 107.

21.
Breton in Bonnet (note 5).

22.
Undated letter to Picabia, in Sanouillet (note 5), p. 528.

23.
Max Ernst, "Visions de demi-sommeil," *La Révolution surréaliste* 9-10 (Oct. 1927). Ernst specifically described the mustaches as "*retroussés*" in a later version of the same text, *Cahiers d'Art* 2, 6-7 (1936). See Malcolm Gee, "Max Ernst, God and the Revolution by Night," *Arts Magazine* 55, 7 (Mar. 1981), pp. 85-91 for a discussion of this motif and its significance.

24.
Sigmund Freud, *An Outline of Psycho-Analysis,* ed. and trans. James Strachey (London: The Hogarth Press and The Institute of Psycho Analysis, 1969), pp. 24-25.

25.
Gee (note 23), p. 89.

26.
Ernst was clearly making conscious use of Freud; the publication of childhood memories, etc. (e.g., "Visions de demi-sommeil" [note 23]), classic tool of psychoanalysis, would seem to encourage a psychoanalytical approach to his paintings.

27.
Matthew Josephson, *Life Among the Surrealists: A Memoir* (New York: Holt Rinehart and Winston, Inc., 1962), p. 179; also see Jean-Charles Gateau, *Paul Eluard et la peinture surréaliste* (Geneva: Droz, 1982).

28.
Sigmund Freud, "Dostoevsky and Parricide," *Collected Papers of Sigmund Freud,* vol. 5, ed. and trans. James Strachey (London: The Hogarth Press and The Institute of Psycho Analysis, 1952), p. 229.

29.
For instance, Geoffrey Hinton, "Max Ernst: les Hommes n'en sauront rien," *Burlington Magazine* 117 (May 1975), pp. 292-99; Carlo Sala, *Max Ernst et la demarche oneirique* (Paris: Klincksieck, 1970); Gee (note 23); and studies by Werner Spies.

Pl. 20. Georges Hugnet, *Untitled*, c. 1934 (see p. 154)

Photography's Exquisite Corpse

By Rosalind E. Krauss

Inconspicuous, decorous, laconic, the mastheads of periodicals stand in contrast to a journal's changing contents. Announcements of editorial steadfastness, they are ordinarily the declarations of the nothing-new.

But the opening issues of *La Révolution surréaliste*, the magazine that spearheaded Surrealism as a movement, carry mastheads that make for reading of a certain interest. For they enact a struggle that was being waged at the heart of Surrealism, a struggle, among other things, over the relation of art to a genuinely revolutionary avant-garde.

The first two numbers (Dec. 1924 and Jan. 1925) list Pierre Naville as the magazine's editor and its address as 15 rue de Grenelle, the same location as the Surrealist "Centrale," the movement's "office of research." In the third number the masthead suddenly announces André Breton as editor, echoed by a change of address northward toward Pigalle and his apartment on the rue Fontaine. Naville then retakes the journal for the fourth number only to lose it permanently to Breton by the fifth.

Naville's essay "Beaux-Arts," which ran in the third issue (April 1925), articulates the substance of the struggle over the role of aesthetics within Surrealism, for his hostility toward painting was boundless. "Masters, master-crooks," he proclaimed, "smear your canvases. Everyone knows there is no *surrealist painting*. Neither the marks of a pencil abandoned to the accident of gesture, nor the image retracing the form of the dream."[1]

Since in the very next issue of the magazine, Breton was, indeed, to launch the notion of "Surrealism and Painting" with the first installment of what was to be a four-part essay justifying the role of Surrealist art, it is obvious that Naville's attack had a specific target in mind. For the two technical possibilities that he equally disbarred as Surrealist resources — automatism and dream-images — would be just those two avenues along which Breton was to describe a Surrealist pictorialism as moving. In opposition to Naville's declaration "I have no tastes except distaste," Breton opened the Galerie Surréaliste in March 1926, the date of publication of the second part of his defense of painting.

It was not, of course, that Naville had refused all aesthetic experience. "Memory and the pleasure of the eyes," he wrote, "that is the whole aesthetic." The list of things he provided as legitimately conducive to this visual pleasure includes streets, kiosks, automobiles, cinema, and photographs. Indeed, in the journal *La Révolution surréaliste*, as Naville had conceived it, photography played the premier role of illustration.[2]

In the eyes of contemporary art history, Naville's stance is often dismissed as retrograde, the mere resurrection of a "futurist" position, a now-tired machine-aesthetic waiting to be replaced by a new phase in the forward march of modernist painting and sculpture.[3] This assessment is made, however, without understanding the degree to which modern technology had entered the imagination of the entire 1920s avant-garde, promising the possibility of realizing the utopian project of their modernism. Photography's ascension to a place of importance, even of centrality, in the teachings of the Bauhaus or the Inkhuk (Institute of Artistic Culture, Moscow) was a function of photography's role in this war on backwardness, narrowness, poverty. Like any other technological tool, the camera was understood as vastly extending the powers of man, liberating, magnifying, sharpening his sight (see pl. 20). In Germany photography had become a kind of triumphant deity of the arts, apotheosized in the 1929 Stuttgart exhibition "Film und Foto." Thus whatever its position within the history of *form*, Naville's acceptance of photography is nothing but progressive within another history of the avant-garde.

But Surrealist photography which developed in the path of Naville's activity, filling the magazines produced for the movement — not only *La Révolution surréaliste* but journals like *Documents, Le Surréalisme au service de la révolution*, and *Minotaure* — did not serve the same positive view of the camera's relation to the human condition as was to be found in Germany and Russia. The Surrealist photo-aesthetic must be seen, instead, as having been generated in relation to the specific content of the magazines in which it appeared. Given Surrealism's attempt to reconstruct the human subject through the grid of psychoanalytic theory, it is not surprising to find that the Surrealist photographers' attitudes about the camera's

relation to the human condition tend to register the same "yes, but" that one hears in Freud's reflection on this and other technologies in his *Civilization and Its Discontents:*

> By means of all his tools, man makes his own organs more perfect — both the motor and the sensory — or else removes the obstacles in the way of their activity. Machinery places gigantic power at his disposal which, like his muscles, he can employ in any direction; ships and aircraft have the effect that neither air nor water can prevent his traversing them. With spectacles he corrects the defect of the lens in his own eyes; with telescopes he looks at far distances; with the microscope he overcomes the limitations in visibility due to the structure of his retina. With the photographic camera he has created an instrument which registers transitory visual impressions, just as the gramophone does with equally transient auditory ones; both are at bottom materialization of his own power of memory.[4]

But at the same time that Freud named this technological perfection and extension of the body, he characterized it as grotesque, as a set of prosthetic devices that impose their own heavy psychological burdens. For he added, "Man has become a god by means of artificial limbs, so to speak, quite magnificent when equipped with all his accessory organs; but they do not grow on him and they still give him trouble at times."[5]

As we shall see, Surrealist photography was to become the photography of the camera-as-prosthetic-device, the technology that gives and takes away at the same time. It was to become the photography through which was visually registered a deep ambivalence about the technological future.

Nowhere is the difference between French and German vanguard photographic positions more obvious than in *Foto-Auge,* a book published by the critic Franz Roh at the time of "Film und Foto."[6] At once a compendium of modern images and a kind of manifesto of photographic technologism, the camera aesthetic manifests itself in these pages in a variety of plunging perspectives and radical close-ups, in negative prints and stop-motion shots that are familiar emblems of photographic modernism. One image in this collection, however, demurs from the tone of exuberant promise extended elsewhere by the "photo-eye." This is Maurice Tabard's *Hand and Woman* (fig. 1) in which the theme of an expanded vision is abruptly contradicted for this photomontage which certainly addresses the issue of sight, and does so negatively. In this image of a certain generalized dread, the woman in question holds a hand-mirror before her in such a way as to replace her face entirely by the faceless plane of the mirror, thereby rendering her self-absorption into an image of sightlessness. Reversing the German avant-garde's terms with regard to vision, this work introduces into the compendium of *Foto-Auge* two of the major themes of Surrealist photography, combining them into a single image. For it speaks of the obliteration of the human head in the production of the *a-céphale* or

Fig. 1. Maurice Tabard (French, 1897-1984). *Hand and Woman*, 1929. Photomontage of silver gelatin prints.

headless man, and it concentrates on the mirror, presenting it not as an instrument of self-possession (narcissism) but of dispossession. True to the letter of Surrealism's relation to the psychoanalytic text, this image stages, as we will see, Freud's "uncanny" — in all of its regressive, primitivizing condition.

Within Surrealist circles the code-name for the *a-céphale* was Minotaur, the mythical inhabitant of the labyrinth, the terrifying conception of the man whose head has been replaced by that of a beast. One of the great images of this condition was by Man Ray in his frontispiece photograph for *Minotaure* (fig. 2), where the head of a woman, obliterated by deep shadow, is visually displaced downward to transform her recorded torso into the face of the bull. But Man Ray did not depend on the Minotaur as a pretext for the depiction of the *a-céphale*. We find it, for example, in his photograph *Anatomy* (fig. 3) where a violently upended neck and chin produces the image of the human head as though suddenly replaced by the belly and jaw of a frog. We discover this theme again in the pages of *Minotaure* in an extraordinary image by Brassaï (fig. 4) where

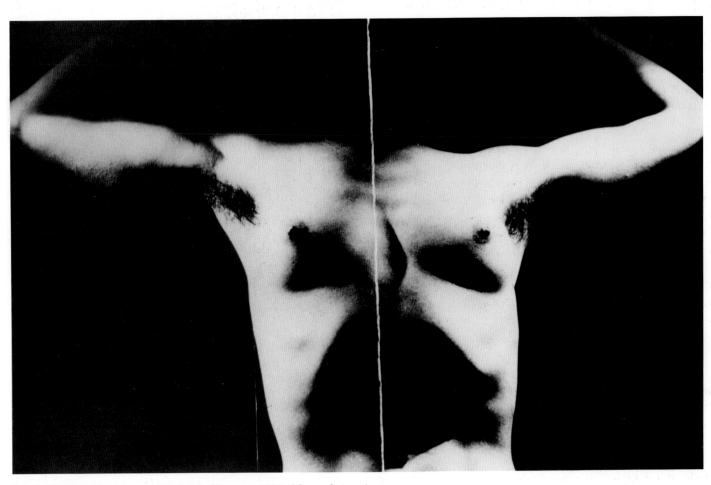

Fig. 2. Man Ray (American, 1890-1976). *Minotaur*, 1935. Silver gelatin print.

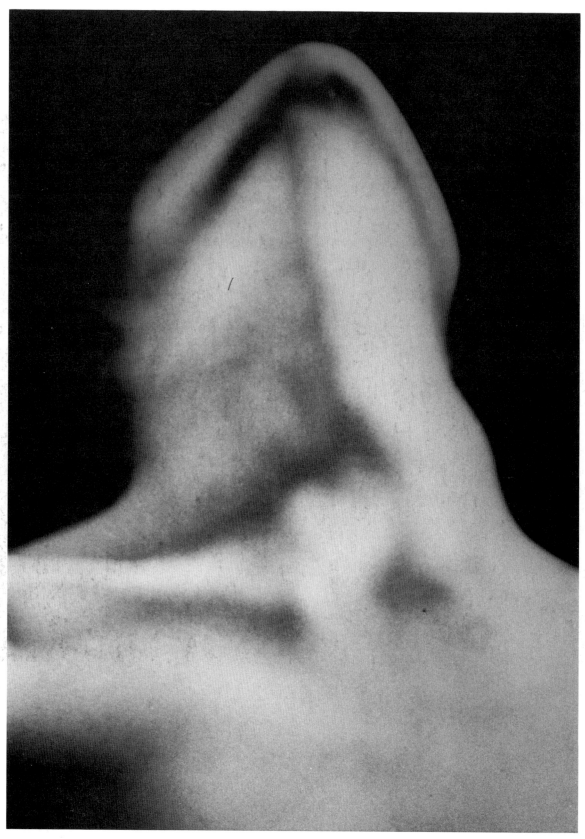

Fig. 3. Man Ray. *Anatomy*, 1930. Silver gelatin print.

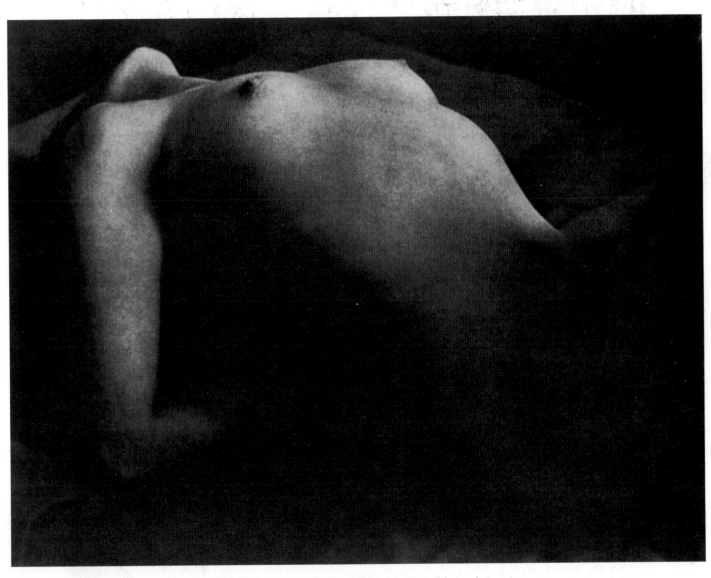

Fig. 4. Brassaï (Gyula Halász) (French, b. Hungary, 1899-1984). *Untitled (Nude)*, 1933. Silver gelatin print.

the steep camera angle from which a nude is regarded once more serves to "decapitate" her and transform her body into the image of animality, her breasts suggesting the horny tufts of the forehead of an unknown beast, her torso and upper arm doubling as face and ear.

These headless creatures, these humans-as-beast, are portrayed as having lost their seats of reason, and therefore as having fallen into the condition of the animal. On a scale of evolution, they are thus as far as possible from that ascendant view of the species advancing triumphantly into the future, armed with reason, with science, with logic. A creature of illogic, the *a-céphale* is also a creature of the loss of what logic produces: namely, those distinctions by which order is created from chaos, distinctions of a formal kind. For Georges Bataille, working from his position as editor of *Documents*, the concept of the *informe* or formlessness was necessary in order to strip the "mathematical frockcoats" from the creations of reason through which man constructs his great self-deluding alibis.[7] *Minotaure* was indeed named by Bataille, for whom the man/beast served as an implosion of one of those formal distinctions by which civilization is defined — separating a specifically human nature from nature-at-large.

Among the Surrealist avant-garde this distinction was being challenged by the theoretical works of Roger Caillois as well. In several essays that appeared in the early 1930s in *Minotaure*, Caillois insisted on the continuity of all organic instinct, on, for example, the relevance for man of the mating habits of the praying mantis.[8] And in this text the acephallic condition is once more equated with formlessness — with a terrifying loss of those distinctions through which we understand the real as structured. For even decapitated the mantis, like a ghastly insentient machine, can continue to function. "Which is to say," Caillois wrote, "that in the absence of all centers of representation and of voluntary action, it can walk, regain its balance, have coitus, lay eggs, build a cocoon, and what is most astonishing, in the face of danger can fall into a fake, cadaverous immobility. I am expressing in this indirect manner what language can scarcely picture, or reason assimilate, namely, that dead, the mantis can simulate death."[9]

What language can scarcely picture or reason assimilate is this removal of the boundaries between life and death, between the real and its imitation. Yet for Caillois the biological world was filled with these eradications of difference, this failure to maintain the neat distinctions on which one would have thought that life itself depends: distinctions like what is inside an organism and what is outside it, a question of boundaries that the phenomenon of animal mimicry continually violates.

Animal mimicry was in fact the subject of "Mimicry and Legendary Psychaesthenia," Caillois's most important text for *Minotaure*, and an essay that was to have extraordinary resonance within the psycholanalytic circles developing in Paris in the 1930s. Jacques Lacan, for example, continued to express his debt to this text, particularly in his working out of the concept of the "mirror-stage" and its effect on the formation of the human subject, a principle he first presented publicly in 1936, though he did not publish it until 1949.[10] But beyond its usefulness to a psychoanlytic conception of the human subject's formation in relation to his or her pictured duplicate, Caillois's work had great importance in a Surrealist context. Combining the theme of acephallism and formlessness with the concept of mirroring or imitation, Caillois's text becomes a key to the conceptual linkage of the two themes that appear in Tabard's *Hand and Woman*, the image with which this investigation began. It thus rewards a certain sustained examination.

Most of the scientific explanations for animal mimicry relate it to adaptive behavior. The insect takes on the color and patterning of its environment, we would think, in order to outwit either its predator or its prey. But, Caillois showed, this phenomenon is not only counter-adaptive, but since it functions exclusively in the register of the visual, it does not really count in the process of animal hunting, which is largely dependent on smell. Instead, tying mimicry to the animal's own perception of space, Caillois hypothesized that this phenomenon is a kind of insectoid psychosis — the psychasthenia of his title referring to Pierre Janet's psychiatric notion of a catastrophic drop in the level of psychic energy, a loss of ego substance, or what one writer has called a kind of "subjective detumescence."[11] The life of any organism depends on its being able to maintain its own distinctness, the boundary within which it is contained, the terms of what we could call its self-possession. Mimicry, Caillois argued, is the loss of this possession, because the animal that merges with its setting becomes dispossessed, derealized, as though yielding to a temptation exercised on it by the vast outsideness of space itself. In a kind of ecological swoon, the animal submits to a temptation to fusion.

Lest it seem too bizarre to apply psychological concepts to such an occurrence, Caillois reminded his readers of the terms of primitive sympathetic magic, in which an illness is conceived of as a possession of the patient by outside forces that dispossess him from his own person. The logic of animism then decrees that like must combat like; through the mimicry performed by the shaman, these forces are withdrawn from the victim in a rite of repossession. In another instance Caillois likened this yielding to the temptation of space — the one that produces the *informe* in a spasm of nature in which boundaries are broken and distinctions blurred — to the reported responses of schizophrenic patients. "Space seems for these dispossessed souls," Caillois told his readers, "to be a devouring force...it ends by replacing them. The body then desolidifies with his thoughts, the individual breaks the boundary of his skin and occupies the other side of his sense. He tries to look at himself from any point whatever of space. He feels himself becoming space....He is alike, not like something but simply *like*. And he invents spaces of which he is 'the convulsive possession.'"[12]

The image of the invasion of the body by space — the body becomes the convulsive possession of space — is everywhere

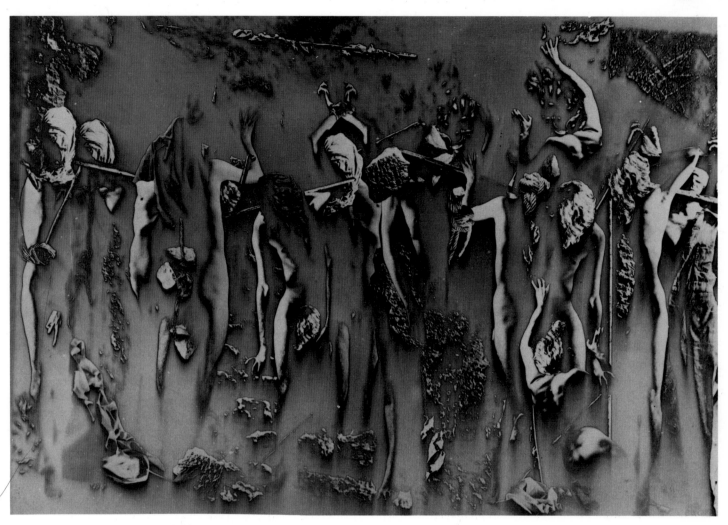

Fig. 5. Raoul Ubac (French, b. 1910). *The Battle of the Amazons (Group III)*, 1939. Photomontage of silver gelatin prints, solarized.

to be found within Surrealist photographic production. Ubac's long series of solarized photomontages, called *The Battle of the Amazons* (see fig. 5), projects the condition of Bataille's *informe* through a depiction of the body's contours deliquescing in response to a kind of optical force. In the images he made by melting the photographic emulsion, as in *Woman/Cloud* (fig. 6) — Ubac again created an effect of the spatial invasion of corporeal boundaries, one that he defined as "an automatism of destruction, a complete dissolution of the image towards an absolute formlessness."[13] But other Ubac images depict the more specific quality of invasion as a function of mimetic duplication, as in the photograph he made of the Surrealist mannequin constructed by André Masson, in which the caged head of the female, her prey in her mouth, evokes the praying mantis (fig. 7). For there the insect, which possesses, is simultaneously possessed by the mesh of space, an effect that is to be found as well in an image by Jacques-André Boiffard of the woman/spider (fig. 8). If the result of mimicry is the inscription of space onto the body of an organism, then this

is, of course, the theme of one of the very first photographs ever to be published by the movement: Man Ray's *Return to Reason* (fig. 9) in the first issue of *La Révolution surréaliste* where the nude torso of a woman is shown as if submitting to the possession by space.

The image of a body in camouflage may imply the intention of that body to hide or to secret itself. This, indeed, is the theory of "adaptation" with regard to animal mimicry. But if the camouflage is projected onto the body from outside, is — in effect — written onto the body by its surroundings, the psychic underpinnings of this transaction are rather different. For then the being in question becomes a kind of screen of projection and is transformed from a seeing subject to a subject seen. And this transformation is exactly what happens in that breakdown in the organism's relation to space that Caillois analyzed in his *Minotaure* essay. For the breakdown occurs precisely at that point where the organism must form for itself a representation of the space-at-large that constitutes its surroundings. Because space, Caillois argued, "is inextricably both

49

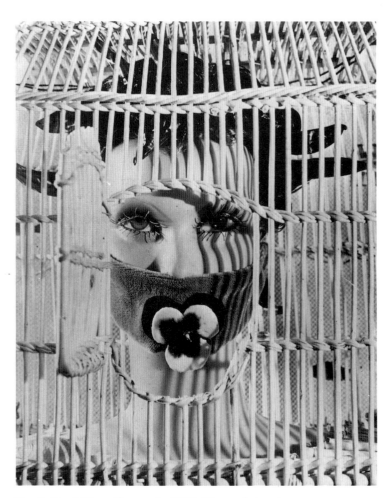

Fig. 6. Raoul Ubac. *Woman/Cloud*, 1938. Silver gelatin print, heat distorted.

Fig. 7. Raoul Ubac. *Mannequin*, 1937. Silver gelatin print.

perceived and represented." In order to describe this relationship of interdependence, Caillois used the figure of the dihedron, a geometrical object constructed (like a T-shape) of two planes at right angles. Space, he explained, is a *double-dihedron*:

> ...changing at each moment in size and situation: *a dihedron of action* the horizontal plane of which is formed by the ground and the vertical plane by the man himself who walks and who, because of this, carries the dihedral relation along with him; and *a dihedron of representation* determined by the same horizontal plane as before (but represented and not perceived), intersected vertically at the distance where an object appears. It is with repre- sented space that the drama becomes clear: for the living being, the organism, is no longer the origin of the coordi- nates, but is one point among others; it is dispossessed of its privilege and, in the strongest sense of the term, *no longer knows where to put itself*.[14]

The image of the organism dispossessed by sight took on psychoanalytic résonance when, in Jacques Lacan's

construction of the "scopic drive," he used Caillois's notion of the double-dihedron to create a diagram of the psychological subject alienated in vision, "dispossessed" or "derealized" by his very drive as a viewing being.[15] Unlike Caillois's configuration of this effect, Lacan's diagram uses triangles instead of T-shapes, for Lacan exploited here the conventional "pyramid of vision" of Western perspective. This pyramid he charted with a triangle facing in one direction — the viewer's eye stationed as usual at its apex, and the thing he sees found at its base. But in a second triangle facing in the opposite direction, the apex is "occupied" by a point of light radiating outward, and the base of this projection is indicated as "picture." Somewhere along this plane, this "picture," the perceiving organism will be located, although obviously stripped of the position of privilege he had held in the first construction. Now he is simply "one point among others" — to use Caillois's expression — rather than being the subject that experiences himself in his own act of constituting his world. Now he is merely a figure in a picture for which he is not the viewer, but the thing viewed. The difference between the two triangles, as Lacan analyzed them, is that the first is really the representation of the world experienced by touch, while it is

Fig. 8. Jacques-André Boiffard (French, 1902-1961). *Woman/Spider*, 1931. Silver gelatin print.

Fig. 9. Man Ray. *Return to Reason*, 1923. Silver gelatin print.

only the second that plots the world as it opens — uncertainly to be sure — to vision. This is why a psychoanalysis of the purely *visual* will inevitably be a matter of the "mirror" and the "picture."

The emphasis that both Lacan and Caillois placed on visuality moves, then, in the opposite direction from the triumphant experience of vision that we associate with modernist aesthetics and its assumption that optical power could serve as the appropriate metaphor for a utopian idea of the future. Sensuous mastery and the liberation of each sensory system into the purity of its own experience was a modernist conception explicitly contradicted by Caillois's mimicry and Lacan's mirror-stage. For the visuality Lacan and Caillois described is a mastery from without; it is imposed on the subject who is immobilized in a cat's cradle of representation, lost in a hall of mirrors, adrift in a labyrinth.

Photography is, of course, the ideal medium for projecting this experience of labyrinthine doubling, of a mirroring in which the subject-viewed is the subject-dispossessed. The camera image may be a "mirror" of the subject whose picture is taken, but if so, it is a mirror manipulated not by the subject but by the taker; the subject is always seen, as in Lacan's

second triangle, by another eye for which — somewhere along its plane of vision — he or she becomes "picture."

The closeness of the relationship between Surrealist photography, Caillois, Lacan, and *Minotaure*, can be summarized through a single example: the photograph Ubac produced to accompany an article called "Miroirs" (by Pierre Mabille), which was published in *Minotaure* in 1939 as a popularization of Lacan's theories of the mirror-stage.[16] For here one finds an extraordinary image of the disarticulation of the self by means of its mirrored double (fig. 10). In this photograph we see a face reflected in a mirror, which is to say, become an image for itself. And that image — due to the corrosion of the mirror — is strangely occluded, distorted. The lower half of the face, modeled by brilliant illumination, is youthful and lovely, but the upper part, submitting to the decay of the surface on which the image is captured, is blurred and contorted. In this act of being captured by the mirror, by the viewer from space-at-large, this being becomes the very image of the Lacanian subject or of Caillois's object of analysis. It yields to the pressures of the *informe*, its boundaries seem to crumble, it is as if invaded by space.

The image of invasion, or threat from without, linked with

the theme of the mirror, connects Tabard's *Hand and Woman* to this photograph by Ubac. For in Tabard's montage it is also a mirror that functions as a hinge between the experience of the self and a threatening pressure from space outside. In this image the mirror, which completely obliterates the face of the woman, seems instead to be reflecting the male presence looming in the shadows behind her, thus dramatizing the relationship between the figures as one of psychological dread.

It could also be said that the drama that is being played out — by means of the mirror — in both the Tabard and the Ubac image relates quite obviously to another text from the psychoanalytic corpus, a text that gives both another name and another reading to the photographs we are looking at. That text is Freud's essay "The Uncanny," in which he described the sense of dread that many primitive peoples have of mirrors, believing them to be the form in which the souls of the departed return to take possession of the living. In this primitive working of thought, the double of oneself that appears in the mirror's surface is transformed into a "Doppelgänger" — a double who is not the self, but an "other" being who will invade and destroy that self.[17]

Such a relation between the mirror and the fear of death is explained in "The Uncanny" as having evolved from an infantile or primitive belief that death could be evaded by vesting immortality in those images — whether the shadows one casts or the mirror-projections of oneself that one discovered — that double one's own body. Through the activity that Freud called the omnipotence of thought, primitive narcissism thus begins by giving great power to the double. But then, by a peculiar inverse logic, those very beings to whom such power has been given turn on their primitive or infantile subjects as purveyors of death, as threats of that very thing they were invented to forestall.

The figure of the uncanny is thus not only the figure of the *informe* but the figure of the ghost. As such it connects directly to one of the central characters within the Surrealist canon: to Breton's *Nadja* whose heroine leads Breton to an experience of strange psychic powers and to open his novel by insisting that one should rephrase the question by which one asks the meaning of one's life, changing "who am I?" to "whom do I haunt?"

Indeed, Breton's entire conception of "objective chance" — the phenomenon central to his conception of Surrealism — is closely related to what Freud meant by the uncanny. All those experiences which Nadja has in which she seems to be able to predict the future, having premonitions of what will happen, or she seems to discover in the most banal of objects hidden signs addressed directly to herself, all these relate to what Freud meant in "The Uncanny" by the recurrence of that childish "omnipotence of thoughts" which leads one to "the idea of something fateful and unescapable where otherwise we should have spoken of 'chance' only."[18]

The "convulsive beauty" that Breton set at the heart of Surrealism was indeed a function of objective chance for it

arose within an event that could shake the subject's self-possession, bringing exaltation through a kind of shock — what Breton called an *"explosante-fixe"* (see fig. 11).[19] And Breton's experience of the omnipotential of objective chance cannot but be illuminated by what Freud meant by the uncanny, where shock mixed with the sudden appearance of fate engulf the subject. For in Freud's argument this ascription of meaning to happenstance and this assumption of the powers of clairvoyance can be understood as the sudden reassertion within adult life of more psychologically primitive states — namely, those related to the "omnipotence of thoughts" and to belief in animism:

> Our analysis of instances of the uncanny has led us back to the old, animistic conception of the universe, which was characterized by the idea that the world was peopled with the spirits of human beings, and by the narcissistic overestimation of the subjective mental processes (such as the belief in the omnipotence of thoughts, the magical practices based upon this belief, the carefully proportioned distribution of magical powers or "manna" among various outside persons and things), as well as by all those other figments of the imagination with which man, in the unrestricted narcissism of that stage of development, strove to withstand the inexorable laws of reality. It would seem as though each one of us has been through a phase of individual development corresponding to that animistic stage in primitive men, that none of us has traversed it without preserving certain traces of it which can be re-activated, and that everything which now strikes us as "uncanny" fulfills the condition of stirring those vestiges of animistic mental activity within us and bringing them to expression.[20]

The collapse of the distinction between imagination and reality was an effect devoutly wished by Surrealism where it was considered revolutionary, a revolution in consciousness. Yet in this text it was analyzed by Freud as regressive, a throwback to the primitive belief in magic, which like animism, and the narcissistic belief in omnipotence, is a potential trigger of that metaphysical shudder that is the uncanny. For all these represent the breakthrough into consciousness of "earlier" states of being, and in this breakthrough, itself the evidence of a compulsion to repeat, the subject is stunned by the experience of fate, in which, Freud reminded his reader, is encountered the idea of death.

Two texts, thus, might be understood as providing a kind of outline for the thematics of Surrealist photography. Caillois's essay of mimicry provides a series of terms through which to think about the continual representation of a loss of distinction through the disruption of boundaries in order to fuse an object with its surrounding space, an effect that turns on imitation, on loss of distinctness through mirroring. Freud's discussion of the uncanny brings out another aspect of this notion of the mirror, for through its surface another collapse occurs, another loss of distinction, this time between the world

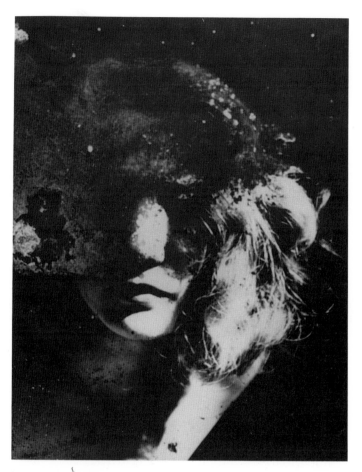

Fig. 10. Raoul Ubac. *Portrait in a Mirror*, 1938. Silver gelatin print.

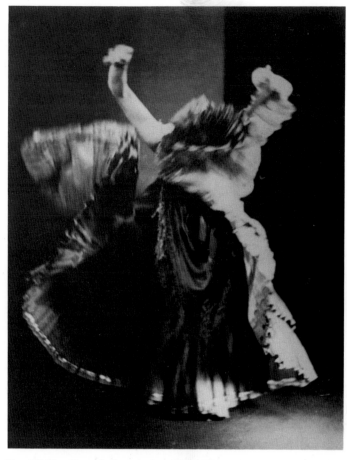

Fig. 11. Man Ray. *Explosante-fixe*, 1934. Silver gelatin print.

of reality and that of the imaginary — the world of the self and its projected, ghostly "double."

As we might imagine, a visual corollary for these powerful themes is to be found in the very structuring of the Surrealist photograph. For the agency of formal "doubling" is one of the major resources of the movement's practice of the medium. In certain cases the double is the result of actual mirroring, as in André Kertész's Distortions series. At other times doubling is set up within the object pictured, as in the example of Hans Bellmer's Dolls where the mechanically duplicated parts of the doll's anatomy allow for a doubling of what already exists in duplicate and the doll herself can be composed of identical pairs of legs mirroring one another (fig. 12a). Doubling was exploited by Bellmer not only within the very construction of the doll, but also from the doll's momentary arrangement for a given photo session, or through paired prints of near-twin images (figs. 12b, 12c). Sometimes these doubled objects are then redoubled by the internal manipulation of the photographic process, as when Bellmer used double-exposures to multiply his multiples. Double-exposure functions in Man Ray's work as well, to produce, for example, the famous doubling of the eyes of the Marchioness Casati (fig. 13).

That photographs, multiple by nature, can themselves be doubled makes further doubling available, as in the case where images are stacked, with one photograph placed atop its twin. Man Ray's collage of doubled breasts in the opening number of *La Révolution surréaliste* is a famous example; Frederick Sommer's doubled Arizona deserts in *VVV* (1944) is another. Or Man Ray sometimes produced doubles in rayographic form, as the mass-produced, multiple object of the phonograph record (made of translucent plastic in the days in which this work was realized) is paired and thereby twinned (fig. 14). Another essentially photographic access to the condition of the double stems from the transparency of the photographic negative, which means that it can be printed from either side. Tabard exploited this possibility by flipping negatives and, through combination-printing, arriving at his conception of the "double" (fig. 15).

The kinds of manipulations motivated by the theme of doubling produce the familiar look of that photography identified with Surrealism, a photography that is often segregated off from the "purer" use of the medium. For manipulation is shunned by this pure, or "straight" photography, which views it as a departure from camera-work's essential objectivity, its

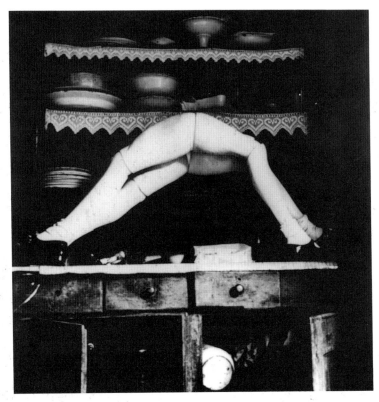

Fig. 12a. Hans Bellmer. (Polish/French, 1902-1975). *Doll*, 1934. Silver gelatin print.

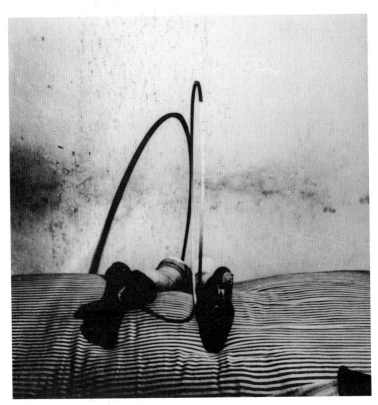

Fig. 12b. Hans Bellmer. *Doll*, 1934. Silver gelatin print.

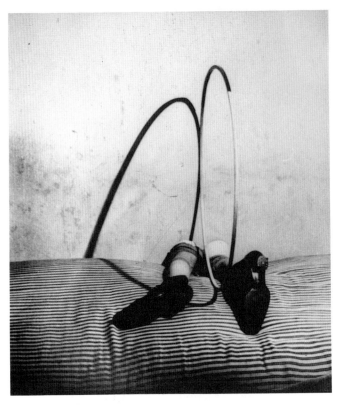

Fig. 12c. Hans Bellmer. *Doll*, 1934. Silver gelatin print.

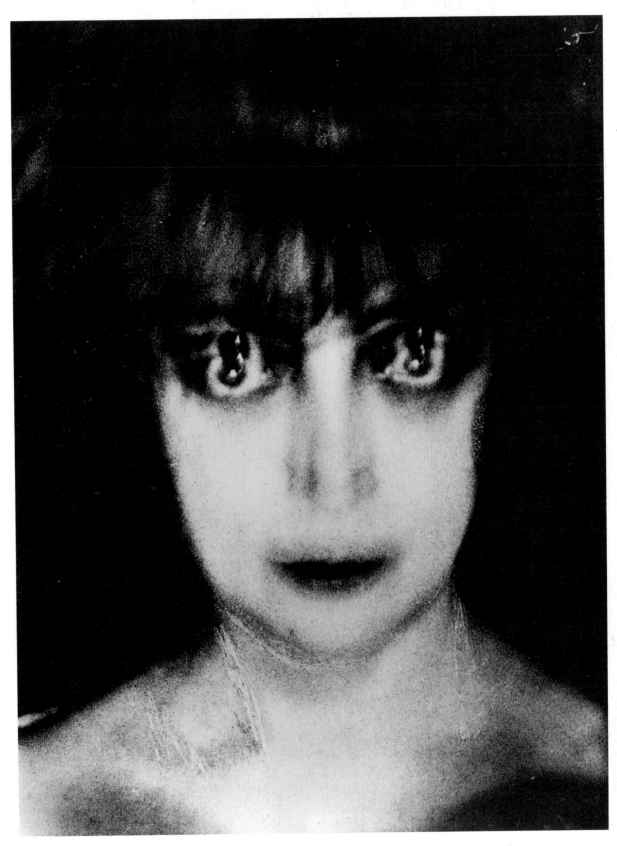

Fig. 13. Man Ray. *Marchioness Casati*, 1922. Silver gelatin print.

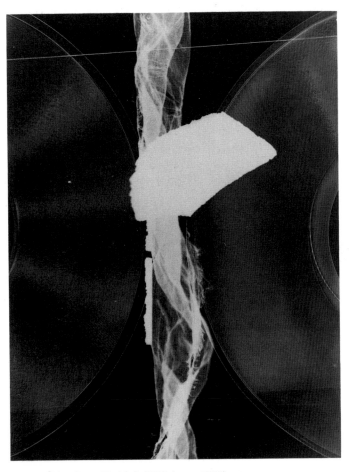

Fig. 14. Man Ray. *Untitled*, 1923 (see p. 176).

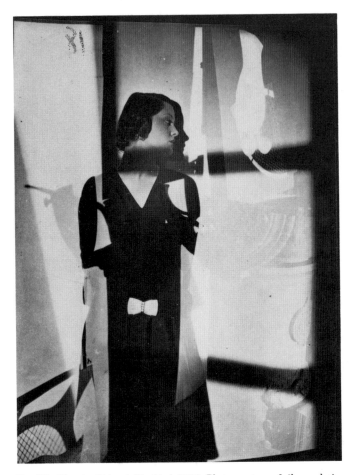

Fig. 15. Maurice Tabard. *Untitled*, 1929. Photomontage of silver gelatin prints.

access to a truthful recording of the real. Thus, although the double and doubling might be available naturally to this most reproducible of all media — and this availability was what the Surrealist photographers exploited — it is seen as unnatural at the same time: a betrayal of photography's vocation to constitute a faithful document.

But if we agree that the distinction between Surrealist and straight photography hinges on the issue of manipulation, we must realize the two questions that follow from this. The first has to do with the nature of Surrealist photographic manipulation and whether the distinction manipulated/straight is merely a technical matter, turning on the photographer's refusal to intervene after the image has been taken. For many of the great Surrealist photographs are themselves innocent of darkroom reorganization, recording the event in front of the camera as faithfully as any other documentary photograph. Man Ray's *Anatomy*, Brassaï's *Nude*, Ubac's *Portrait in a Mirror* are all instances of this. Yet we would say, they all feel manipulated nonetheless, for they all perform a feat of seeing that loosens a given object from its singular identity and, as though doubling it from within, produces the condition of alterity that we associate with metaphor: x is also y. In

Anatomy the human is also animal; in *Nude* the female body is also phallic; in *Portrait in a Mirror* youth is also decrepitude. We are therefore forced to conclude that in the case of Surrealist photography, the image is *always* manipulated quite independently of whether montage, double-exposure, or solarization have intervened. One is dealing here with a vision that is defined, from the start, as constituted *in* the doubled, the split, the composite.

The second, related issue turns on the faith of straight photography in the unmanipulated image. For while it is true that photography records the event in front of the camera, making of it a photo-chemical trace or imprint, it is not true that nothing in this document is manipulated. The lens, the aperture, the panchromatic range of the film, all have been constructed to produce a certain field of vision. This field, organized through the conditions of centering and unity, is built around the notion of tonal gradation and continuous focus into depth, to produce the illusion of visual mastery of an accessible reality. Indeed, it has become a commonplace of photographic criticism that this space which the camera's lens constructs is a replica of the perspective-space of Renaissance vision, similarly unified and organized around a single point

56

and bound through the ordered containment of a frame.[21] And what follows from all of this is also a commonplace of the story Western humanism tells itself about what was constituted by the invention of perspective. The point, for example, of Jacob Burckhardt's account of the Renaissance is the invention of the individual, the formation of the singular ego whose selfhood somehow coincided with — was in fact constituted by — the organized mastery of what he surveyed. By producing the illusion that all the camera is doing is documenting what exists before it, photography intensifies this effect of mastery.

But photography's straight image constructs a viewer to go with it as surely as did any 16th-century demonstration of central-point perspective; and that viewer is defined as unambivalent, unified, organizing and, therefore, organized. For if the viewer of the straight photograph is constructed as this master of a unitary vision, produced as it were by the focused field of the image, the work of that construction or that productive activity is elided in our experience. It is "naturalized." Photography generates the powerful illusion that reality itself is laid bare for the viewer and nothing — neither the image nor its perceiver — has been produced. Convinced by the power of its own illusion, any other system of seeing seems, for straight photography, to be a scandal.

If Surrealism as a movement was collectively aware of anything, it was that reality and consciousness "produce" one another, that the operations of construction are everywhere. And Surrealist photography, locating this experience of construction in a moment of arrested vision, an "explosante-fixe" that produces the conviction that x is also y, serves this awareness. Surrealist photography does not admit of the natural as opposed to the cultural or made. And so all of what it looks at is seen as if already, and always, constructed, through a strange transposition of this thing into a different register. We see the object by means of an act of displacement, defined through a gesture of substitution. The object, "straight" or manipulated, is always manipulated, and thus always appears as a fetish. It is this fetishization of reality that is the scandal.

A direct demonstration of this principle occurs in both Tristan Tzara's essay in *Minotaure* "On a Certain Automatism of Taste," and Man Ray's photographs created to illustrate it.[22] Analyzing fashion as the unconscious construction of a changing set of signs for the erogenous zones of the body, Tzara's text goes on to define fashion as a system for rewriting the sexual organs in the register of a peculiar displacement of sexual identity — the fashions of 1933 having decreed that women wear hats that create representations of female genitalia in the form of masculine apparel, namely, the split-crown fedora. In the images Man Ray shot for Tzara's essay, we see this construction. One of his photographs, for example, produces the image of collapsed sexual identity as the hat's rounded expression of the head beneath it articulates both male and female organs at once (fig. 16). In this image the effect of Surrealist photographic metaphor is given a specific cast. For the x is y functions to blur distinctions of a most

essential kind. Male collapses into female and female stands for male in the peculiar blurring that we encountered before, as in Brassaï's 1933 *Nude*, where the female body and the male organ have become each the sign for the other (fig. 17).

Thus the concept of fetishism is another way of locating the work of manipulation wrought by the Surrealist photograph. For the logic of the fetish, invented as a substitute of the unnatural for the natural, turns on a refusal to accept difference, specifically sexual difference. According to Freud, "To put it plainly: the fetish is a substitute for the woman's (the mother's) penis which the little boy once believed in and for reasons familiar to us does not wish to give up."[23] The fetish-as-substitute is not only a denial of sexual difference but it often bears the imprint of its genesis within a moment of arrested vision. "When the fetish comes to life," Freud wrote, "some process has been suddenly interrupted…what is possibly the last impression received before the uncanny traumatic one is preserved as a fetish…the last moment in which the woman could still be regarded as phallic."

Insofar as the work of fetishism is this denial of difference, this enactment of a desire to believe in the masculinity of the female, this famous "yes, I know, but…," it can be seen to relate to Bataille's concept of the *informe*, which is to say the blurring of distinctions, the refusal of categories. And insofar as it is a function of a visual perception turned into a "misrecognition," the fetish is instated within that very domain of the visual that Lacan had erected on the site of the "mirror" and the "picture." Indeed the visuality of mechanism through which fetishism constructs its peculiar substitute for the object of desire is underscored by the first example Freud gave in his article on the "Fetish," namely, one of his patient's mysteriously eroticized objects: "a glance at the nose." This is a glance at the nose by means of which "reality" — the sexual object — is wholly fabricated, is constructed by means of the psychic drives.

Within the practice of Surrealism, there was an important relationship to the subject of sexuality as a function of fantasy and representation, rather than a function of the purely biologically or naturally given. Sexuality for Surrealism was, like the fetish, a construct. Aragon vigorously insisted on this idea, for example, during a famous discussion of sexual practices. Rebuking Breton at one point, for seeming to reject certain types of sexual behavior as "unnatural," Aragon insisted that this is (or should be) unacceptable to a Surrealist for which no biologically determined idea of the "normal" should operate.[24] For Surrealism, then, sexuality, the object of desire, the female, were all functions of the fabrication of the real that one encounters in the mechanism of fetishism.

Having dissolved the natural in which "normalcy" can be grounded, Surrealism was at least potentially open to the dissolving of distinctions that Bataille had called for when he invoked the *informe* or Caillois had described when he explored mimicry. Gender, male/female, was one of these categories. If within Surrealist poetry "woman" was constantly

Fig. 16. Man Ray. *Untitled*, 1933. Silver gelatin print.

Fig. 17. Brassaï. *Untitled (Nude)*, 1933. Silver gelatin print.

Fig. 18. Dora Maar (French, b. 1909). *Untitled,* c. 1933. Photo collage.

Pl. 21. Maurice Tabard, *Untitled*, 1930 (see p. 219)

in construction, then at certain moments that project could at least prefigure a next step, in which a reading is opened onto deconstruction. It is for this reason that the frequently heard accusations of Surrealism as antifeminist seem to me to be mistaken.

Within Surrealist photographic practice, too, "woman" was in construction, for there she is as well the obsessional subject (see fig. 18). Further, because the vehicle through which she is figured is itself manifestly constructed, "woman" and "photograph" become figures for each other's condition: ambivalent, blurred, indistinct, and lacking in the authority dear to straight photography (see pl. 21).

The late 20th century has absorbed the avant-garde. There is little in its practice that can continue to shock our sensibilities, little that will strike us — the avid consumers of culture — as scandalous. But Surrealist photography continues to produce this scandal. Its manipulations, in the revulsion that they still provoke, call forth yet another of the figures that psychoanalysis recuperated from past cultures to describe a moment of arrest in time and space that constitutes the subject. This time it is the image of the Medusa, whose decapitated head signifies castration. "The terror of Medusa is thus," Freud wrote, "linked to the sight of something," specifically the female genitals experienced as castrated. Further, this is a visual moment which both constitutes the "real" and constructs, through a kind of mirroring agency, its viewer: "The sight of Medusa's head makes the spectator stiff with terror, turns him to stone. Observe that we have here once again the same origin from the castration complex and the same transformation of effect! For becoming stiff means an erection. Thus in the original situation it offers consolation to the spectator: he is still in possession of a penis, and the stiffening reassures him of the fact."[25]

To identify Surrealist photography as an "exquisite corpse" is to signal both a set of themes and forms, calling attention to this work's preoccupation with the human body and its formal folding and manipulations of its fields. But one could use another name, less the exclusive property of the Surrealist movement. Within the politics of visual representation, this work could be termed Medusa's Head, thereby invoking its continuing condition as scandal.

Notes

1.
Pierre Naville, "Beaux-Arts," *La Révolution surréaliste* 3 (Apr. 1925), p. 27.

2.
The making of the magazine is described in Pierre Naville, *Le Temps du surréal* (Paris: Galilée, 1977), pp. 99-110.

3.
See, for example, Dawn Ades, *Dada and Surrealism Reviewed* (London: Arts Council of Great Britain, 1978), p. 199.

4.
Sigmund Freud, *Civilization and Its Discontents* (Garden City, NY: Anchor Books, 1958), p. 34.

5.
Ibid., p. 35.

6.
Franz Roh, *Foto-Auge* (Stuttgart: Akademischer Verlag, 1929).

7.
Georges Bataille, "Informe," *Documents* 7 (1929), p. 382.

8.
Roger Caillois, "La Mante religieuse," *Minotaure* 5 (1934), pp. 23-26.

9.
Ibid., p. 26.

10.
Jacques Lacan, "The Mirror Stage as Formative of the Function of the I," *Ecrits*, trans. Alan Sheridan (New York: Norton, 1977), pp. 1-7.

11.
Dennis Hollier, "Mimesis and Castration: 1937," *October* 31 (Winter 1984), p. 11.

12.
Roger Caillois, "Mimétisme et psychasthénie légendaire," *Minotaure* 7 (June 1935), pp. 8-9.

13.
Unpublished letter to Yves Gevaert from Raoul Ubac, dated Dieudonné, Mar. 21, 1981.

14.
Caillois, "Mimétisme" (note 12), p. 8.

15.
Jacques Lacan, *The Four Fundamental Concepts of Psycho-Analysis*, trans. Alan Sheridan (New York: Norton, 1981), p. 91.

16.
Pierre Mabille, "Miroirs," *Minotaure* 11 (1938), pp. 14-18.

17.
Sigmund Freud, "The Uncanny," *Studies in Parapsychology* (New York: Collier Books, 1963), p. 40.

18.
Ibid., p. 43.

19.
André Breton, *L'Amour fou* (Paris: Gallimard, 1937), p. 21 and fig. opp. p. 16.

20.
Freud, "The Uncanny" (note 17), p. 46.

21.
For example, see Joel Snyder, "Picturing Vision," *Critical Inquiry* 6 (Spring 1980), pp. 499-526.

22.
Tristan Tzara, "D'Un Certain Automatisme du goût," *Minotaure* 1, 3-4 (1933), pp. 81-85.

23.
Sigmund Freud, "Fetishism," *Sexuality and the Psychology of Love* (New York: Collier Books, 1963), p. 215.

24.
"Recherches sur la sexualité," *La Révolution surréaliste* 11 (Mar. 1928), p. 37.

25.
Sigmund Freud, "Medusa's Head," *Sexuality and the Psychology of Love* (note 23), p. 212.

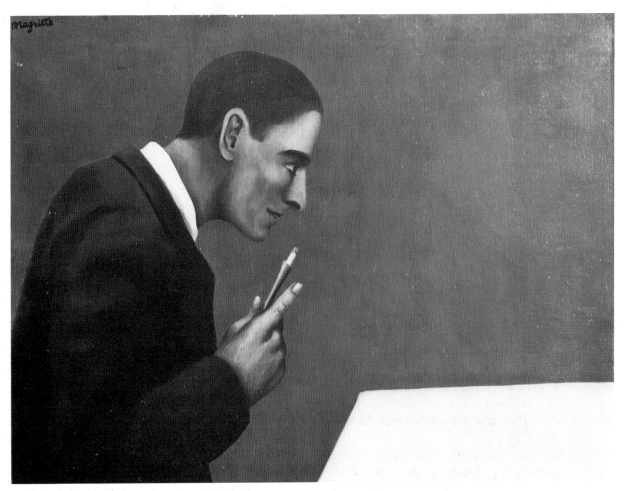

Fig. 1. René Magritte (Belgian, 1898-1967). *Person Meditating on Madness*, 1928. Oil on canvas. Private Collection. Photograph Giraudon/Art Resource, New York.

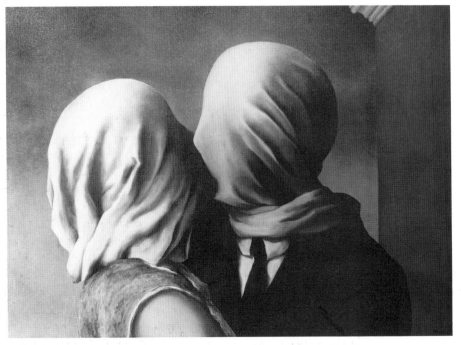

Fig. 2. René Magritte. *The Lovers*, 1928. Oil on canvas. Collection of Richard S. Zeisler, New York. Photograph Courtesy Richard S. Zeisler.

Meditations on Madness: The Art of René Magritte

By Mary Mathews Gedo

One of René Magritte's most provocative paintings from the late 1920s, the period when he first hit his stride as an artist, portrays a young man staring fixedly at what appears to be a blank table top. The picture's title, *Person Meditating on Madness* (fig. 1) does little to illuminate its enigmatic imagery. Is the youthful protagonist merely meditating on the nature of madness, or is he experiencing a psychotic state himself? His inappropriate expression and strange half-smile certainly suggest that he may be projecting a bizarre inner vision onto the blank surface before him, a hallucination from which the spectator is forever excluded.

I believe that this picture occupies a unique position in Magritte's oeuvre, constituting a painted statement of the genesis of his Surrealist style, as well as a forecast of the program that he would follow during the remainder of his career.[1] For the art of René Magritte seems to me best defined as an unending meditation on the nature of madness, conducted by an investigator who may well have demanded the maintenance of that exploration to bind his psychic tension.

Certainly, Magritte possessed impeccable credentials for undertaking such a program: throughout his childhood, he lived in the closest intimacy with a woman he perceived as mad, his mother, who finally terminated her tortured existence by drowning herself in 1912, when the future artist was 13 years of age.

As Magritte later remembered it, when they retrieved his mother's body from the River Sambre in the Belgian town of Châtelet where the family then made its home, "they found her nightgown wrapped around her face. It was never known whether she had covered her eyes with it so as not to see the death she had chosen, or whether she had been veiled in that way by the swirling currents."[2] The relationship between this vivid description (as David Sylvester recently demonstrated, it is a reconstruction more mythic than accurate)[3] and the repeated images of veiled female figures that recur in Magritte paintings like *The Lovers* (fig. 2) has not escaped critical attention. Psychologically oriented critics have pointed out numerous additional connections between Magritte's female imagery and his mother's suicide. For instance, Elena Calas

cited *The Unattainable Woman* (1927), with its repeated depictions of "hands searching blindly but avidly along a wall in a fruitless attempt to reach a nude woman 'attached' to the wall, in full view of the beholder," as but one example of Magritte's continued search for the mother from whom he had been so prematurely and traumatically separated.[4] The late psychoanalyst of children, Martha Wolfenstein, pointed out many other images that refer to the artist's mother, including paintings in which the woman simultaneously seems "both alive and dead, there and not there. *The Inundation*, for example, shows a nude woman standing beside a river; the upper part of her body fades out and her head is invisible."[5]

No one, however, not even Wolfenstein, has emphasized the equally obvious relationship between the unique character of Magritte's imagery, his portrayal of a bizarre world, and the severe psychological disturbance from which his mother undoubtedly suffered for many years prior to her suicide.[6] This essay attempts to define and explore this connection, to demonstrate how the artist's unique relationship to his mad mother formed and fueled his creativity, setting his brand of Surrealism apart from that of such contemporaries as Max Ernst, whose art certainly had a profound effect on Magritte, but who created a more playful, benign fantasy world than did his Belgian counterpart (see pl. 22). This study focuses exclusively on the pictures that Magritte painted during his first Surrealist phase (around 1925-30), especially those canvases completed between 1926 and 1928. This period represented a time of great productivity for the artist, who later recalled that he painted more canvases during 1926 than ever again in his career (see pl. 23).[7] This heightened creativity seems to have been accompanied by heightened anxiety, a quality reflected in the expressionistic character of many of these paintings, with their unpleasant, dark, metallic colors and invented or bizarre anthropoid creatures. As Louis Scutenaire noted, many of these pictures cannot be viewed, even today, without uneasiness. Both the palette and the imagery employed in *The Palace of Curtains II*, 1928 (fig. 3) typify this type of painting. Despite its title, the bizarre beings depicted in this canvas can hardly be identified either as

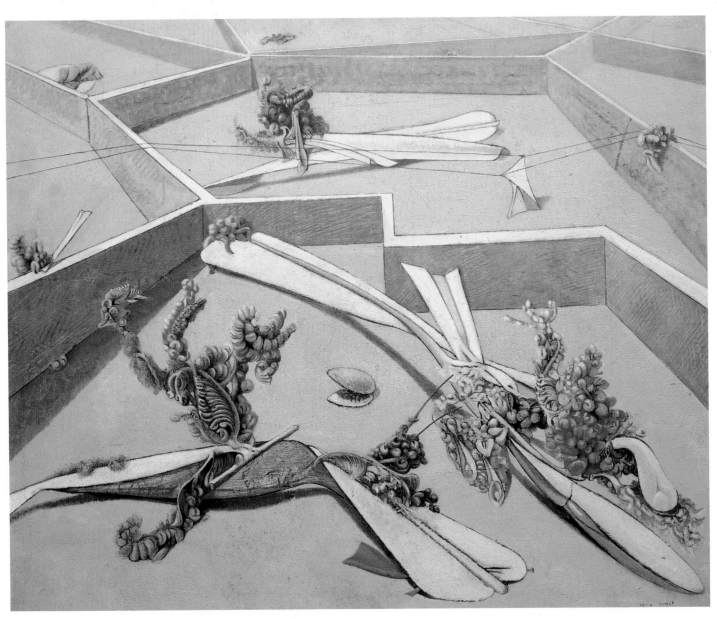

Pl. 22. Max Ernst, *Garden Airplane Trap*, 1935 (see p. 146)

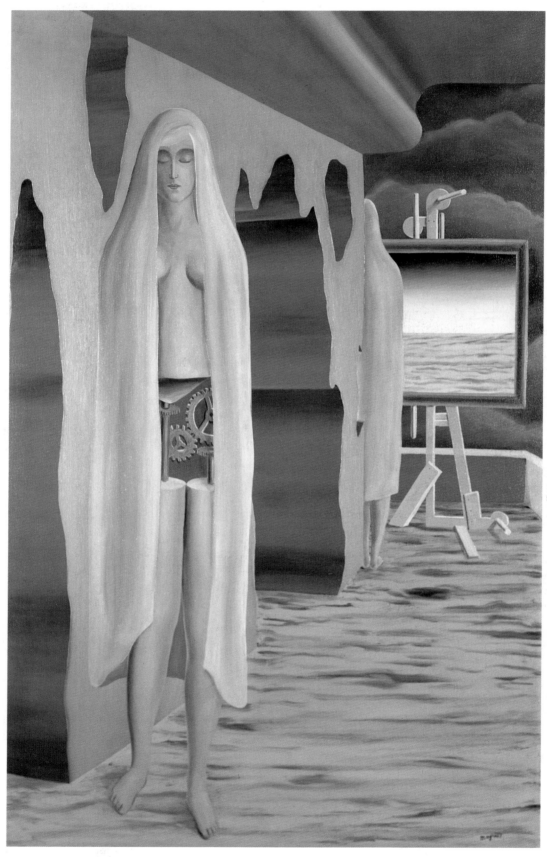

Pl. 23. René Magritte, *The Age of Marvels*, 1926 (see p. 165)

Fig. 3. René Magritte. *The Palace of Curtains II*, 1928/29. Oil on canvas. Museum of Contemporary Art, Chicago, Gift of Mr. and Mrs. Kenneth Newberger (80.69). Photograph Courtesy Museum of Contemporary Art.

"curtains" or as a palace. Rather, these phantoms seem to be formed from some type of metal or rubber piping, animated, like Frankenstein's monster, by the hand of their creator.[8]

In such canvases, Magritte forced the viewer to share his personal anxiety without making the audience privy to the sources of this tension. Their expressionistic *angst* also sets these works apart from certain others from this same period that seem more typical of the artist's later oeuvre. The latter paintings feature brighter, clearer colors and recognizable objects and figures that are surreal only because of their improbable juxtapositions or contexts.[9] Although many of the motifs and protagonists that Magritte initially introduced in his more disturbing early pictures recur throughout his career, they appear in their later incarnations in toned-down, transformed states.

To date, these strange paintings from Magritte's first Surrealist phase have not received the kind of detailed psychological examination that they deserve, despite the fact that many critics have recognized that they seem almost to demand psychoanalytic interpretation as the painted equivalents of a patient's dreams. Far from providing a

definitive psychological reading of this type, this study offers only a beginning; it identifies a number of the major personalized themes that Magritte developed between 1925 and 1930, illustrating each of them by only a fraction of the relevant pictures he produced during this prolific phase. A more comprehensive and reliable analysis must await publication of the catalogues raisonnés, which will help us to make more accurate assessments of the relative significance of these private themes, as well as to trace their evolutionary pattern. It is hoped additional biographical data will also eventually come to light, enabling us to read some of the more hermetic pictures from these years with greater confidence.

We can only speculate about Magritte's motivations for abandoning his expressionistic early style. It seems possible that he made this decision solely on aesthetic and practical grounds, because he realized that the raw power of these works made them too unpalatable and hence unsalable. But his change of style also coincided with several important changes in the artist's life. In 1929 Magritte's contract with his Belgian dealer ended when the latter suffered bankruptcy, and the following year the artist left Paris, where he had resided for three years, and returned to Brussels.

Whatever role such external circumstances may have played, I believe that one should not dismiss the possibility that this change in style also mirrored a change in Magritte's inner world. His earliest paintings, especially those he produced prior to his move to Paris in 1927, convey an atmosphere of extreme anxiety, and the imagery is flooded with suicidal preoccupations. Between 1930 and 1940 one does not often encounter such overt indications of inner tensions. The history of the artist's adolescence, briefly reviewed below, certainly suggests that Magritte must have veered dangerously close to psychosis in the years immediately following his mother's death. As I also hope to demonstrate, his marriage in 1922 produced a very salutary effect on the artist. The change in his style, increasingly evident by 1929 and 1930, then, may really reflect the fact that the effects of his terrible childhood were gradually healing over and he no longer needed to probe the open wounds so deeply. If this theory is valid, whatever else may have determined this stylistic departure, it reflects a change for the better in Magritte's psychological status. The fact that an enforced separation from his wife in 1940 triggered renewed suicidal obsessions and led to another wrenching change in the artist's style suggests that one should not underestimate the therapeutic effects that Mme. Magritte exerted on her husband (see pl. 24).[10]

To date we possess only the most limited biographical data about Magritte, who absolutely resisted providing information about his personal history. "I detest my past and that of others," he declared, and he lived by this precept. Apparently he did not share personal information of this type even with his wife; at least, during an interview conducted after the artist's death, she expressly denied that he had ever mentioned his mother's suicide to her during their 45 years of marriage."[11]

The scant biographical data that we do possess comes to us mainly from the writings of the Magrittes' lifelong intimate friend Louis Scutenaire, with whom the artist did share a few revelations of this type, supplemented by information supplied by his younger brother, Paul.[12]

As loathe to discuss the iconography of his art as the story of his personal past, Magritte always insisted that his images were not symbols, but rather poetic mysteries — mysteries that he evidently intended his public to contemplate but not to penetrate. He inveighed against psychoanalysis and psychoanalytic interpretations with such frequency and vehemence that one can only conclude that he feared that psychologically informed investigations of his imagery might reveal aspects of his character and experiences that he wished to keep forever submerged — perhaps even from his own awareness.

The bare-bones facts reveal that René, the eldest of the three Magritte sons, was born on November 21, 1898. His brother Raymond followed in 1900, Paul in 1902. Mme. Magritte evidently came from a lower-class background — at least she had worked as a milliner before her marriage, while the father's family belonged to the prosperous bourgeoisie. Apparently the Magrittes subsisted primarily on his inheritance and family reputation. At least, the father's occupational record seems vague and spotty, and the family moved rather frequently — relocations evidently tied to their variable economic fortunes.[13] These changes must have aggravated the mother's adjustment difficulties, and Abraham Hammacher noted that her life in Châtelet, to which the family moved two years before her suicide, was filled with problems.[14]

It seems revealing of the emotional climate that prevailed in the Magritte household that as soon as the children could communicate with one another, René and his younger brother, Paul, formed a coalition against the middle boy, Raymond — a conspiracy of hatred that evidently endured until the artist's death.[15] A surviving family photograph taken when René was about six or seven shows Raymond standing alone, ignored, while his father embraces Paul, and René and his mother pose with arms intertwined.[16] The visual evidence derived from Magritte's paintings of 1925-29 corroborates the impression obtained from this picture, suggesting that he may have been his mother's favorite, the child to whom she most often confided her bizarre perceptions of the world of reality.

Even prior to his mother's death, René thought and behaved in an eccentric manner. A childhood mystic, obsessed with guilt, preoccupied with thoughts of "Jesus, His mother, His dove, and the saints of the stained glass windows," the boy frequently played at saying Mass before a little altar he had fashioned. He apparently suffered from numerous ticlike facial grimaces, distorted expressions that Scutenaire loyally attributed to the boy's religious hyperscrupulosity. These tics apparently persisted throughout Magritte's life, long after he had abandoned all his religious convictions — a fact that may not be unrelated to the inappropriate facial expression of the protagonist depicted in *Person Meditating on Madness*. De-

spite his renunciation of all religious beliefs, a goodly number of his paintings suggest an underlying identification of himself with Christ, or other deities.[17] In the light of such iconography, it is probably no coincidence that he chose the dove or pigeon as his favorite totem animal, an identification perhaps related to his early interest in the dove of the Holy Ghost.[18]

In retrospect, the artist claimed that his only reaction to his mother's suicide had been a thrill of pride in his new identity as "the son of a dead woman." His behavior following this event, however, scarcely accorded with this optimistic description. He now stopped "saying Mass" but substituted bizarre public rituals for his former private devotionals. "Hands folded, mumbling what sounded like prayers and genuflecting rapidly, he would make ten or twenty lightning-fast signs of the cross, to the stupefaction of those present. This behavior greatly upset the maids, who complained to the head of the household."[19] To put the most favorable light on it, such behavior suggests that Magritte must have reacted to his mother's death with extreme panic and disorganization. It seems likely that the repetitious rituals were designed to fend off internal experiences that the boy concretized as "demons," demonic presences that may have involved actual hallucinations as well as disturbing, frightening thoughts, although we do not have the confirmatory data to evaluate definitively the significance of this interlude.

In the light of such behavioral descriptions, it is scarcely surprising to learn that, a few years later, Magritte withdrew from his academic studies without securing his baccalaureate degree. At age 16 he left home (with his father's approval) to enroll in the Académie des Beaux-Arts in Brussels, where he apparently also attended class irregularly and also failed to graduate.[20]

Magritte described the origins of his inspiration to become an artist in terms that match the eccentric character of his other childhood reminiscences. As a boy he spent his summers with his grandmother in a small town in the Belgian countryside. His favorite occupation there involved exploring a disused cemetery in the company of a special little girl. One day, as they emerged from an underground vault, the children came upon an artist from the capital who was serenely working at his easel among the broken stone columns and piles of dead leaves. From that moment painting seemed a magical occupation to Magritte, and the course of his future was determined.[21] At least as he remembered it, then, his artistic vocation was from the beginning associated with an atmosphere of mystery and death. As Wolfenstein suggested, his predilection for depicting scenes in which darkness and light coexist in a single time and place probably derive from this memory. Like the story of his mother's death, this account seems quasi-mystical and probably constitutes another instance of what psychoanalysts would call "a screen memory."[22]

The paintings that Magritte executed prior to his Surrealist breakthrough of 1925 reflect his youthful indebtedness to the Futurists, as well as to certain "second generation" Cubist

Pl. 24. René Magritte, *Song of Love*, c. 1950/51 (see p. 170)

Fig. 4. René Magritte. *The Invention of Life*, 1926. Oil on canvas. Private Collection. Photograph Harry Torczyner, *Magritte: Ideas and Images*, New York, 1977, fig. 394.

painters, like Delaunay and Léger. During this same period Magritte gradually became intimate with various youthful avant-garde literati then resident in Brussels. The members of this circle all shared a similar affection for detective and mystery stories, as well as an interest in the expiring Dada and burgeoning Surrealist movements then active in Paris. It was one of these literary associates who first called Magritte's attention to the art of de Chirico, whose paintings struck the young Belgian with thunderclap force.

Characteristically, Magritte never discussed the genesis of his Surrealist style in much detail. It seems quite certain, however, that he quickly became aware of the interest that the French Surrealist poets and painters evinced in evoking preconscious (often erroneously called unconscious) fantasies by inducing hypnogogic states. Magritte surely made use of similar techniques to tap the wellspring of memories that he introduced into his early Surrealist paintings. As a mature artist, he stressed the importance of the ideas that came to him during the half-awakened state that precedes rising for the day.[23]

In 1922 (the same year that he saw his first reproduction of a de Chirico canvas) Magritte married Georgette Berger. He had met this beautiful young woman many years earlier, when they had both ridden the carrousel together during a town fair at Charleroi, where Magritte's father had moved the family following his wife's death. The horse imagery that would play such a significant role in Magritte's art probably should be attributed to this encounter. (His frequent use of sleigh bells, however, may have had a different origin. He certainly seemed to associate the latter objects with his mother rather than Georgette.[24])

If de Chirico provided Magritte with the grand example, and his Belgian literary friends with stimulus and support, his marriage to Georgette provided him with the stability he required to undertake these daring new artistic ventures. She became, in a very real sense, his lifeline, and the artist's intimates all testified to his unusual devotion to her. With Georgette, Magritte re-created the best aspects of his relationship with his mother, the tender intimacy they sometimes shared — an intimacy that bound him to her memory forever. Unlike the artist's mother, however, his wife possessed a solid sense of self; she created an orderly (perhaps even compulsively rigid) domestic atmosphere that permitted his creativity to flower. One of Magritte's early paintings in his new manner documents this theory that Georgette represented the "good" replacement for the original "bad" mother. *The Invention of Life* (fig. 4) (both its title and the fact that it belongs to Scutenaire seem significant) depicts Georgette in a verdant

Fig. 5. René Magritte. *The Lost Jockey*, 1926. Collage and gouache on paper. Collection of Harry Torczyner, New York. Photograph Harry Torczyner, *Magritte: Ideas and Images*, New York, 1977, fig. 62.

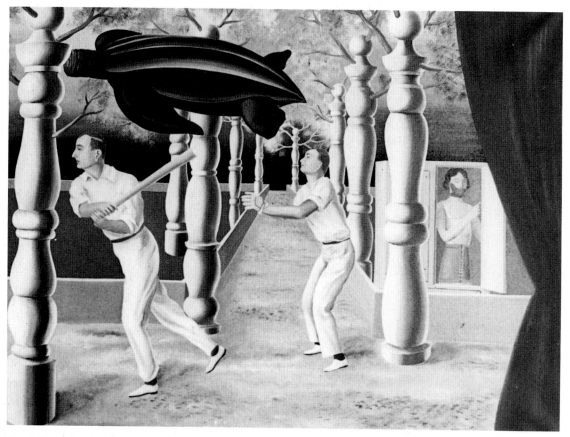

Fig. 6. René Magritte. *The Secret Player*, 1926. Oil on canvas. Collection of R. Nellens, Knokke-Le-Zoute, Belgium. Photograph Patrick Waldberg, *René Magritte*, Brussels, 1965, ill. p. 199.

seashore setting.[25] Young and vibrant, she stands beside a shrouded figure, veiled as Magritte believed that his mother had been swathed by the river that had swallowed her. Here the water has disgorged her, and she stands beside her replacement as a silent but omnipresent specter destined to haunt Magritte's art forever.

The first important picture that Magritte created with his new Surrealist style, *The Lost Jockey*, deals still more dramatically with this central issue of his art and life: his unending preoccupation with the internalized image of his mother. The artist repeated the Jockey theme three times within a twelve-month period in 1925-26. The most successful of these versions, the collage and gouache now part of the Harry Torczyner collection (fig. 5), depicts a realistically rendered horse and rider in a decidedly surreal setting. The parted draperies of the foreground plane allude to a theatrical presentation, a metaphor that would recur regularly in Magritte's art.

Although the jockey whips his horse as steed and rider strain frantically ahead, both seem forever frozen in their space, caught in the delicate network of lines stretched across the picture's central space. Giant balusters or bilboquets, magnified versions of the turned wooden forms commonly used as decorative table legs or, in smaller editions, as wooden chess pieces, surround horse and rider. Here the bilboquets appear transformed into wintry trees, their trunks composed of collaged bits of sheet music and with painted bare branches that stretch heavenward like the arms of female choristers in a Greek tragedy.

The bilboquet soon became a central motif in Magritte's art; his subsequent use of it leaves little doubt that it constituted one of his principal symbols for his mother. Hammacher, who knew the artist personally, has written most perceptively about the complex symbolic implications of this form:

> Instead of accepting conventional things as they were, Magritte began a challenging game with them to resuscitate not only their stranger aspects but those which cannot be named; to this end, he devised new functions for them. For instance, he transformed ordinary boring table legs made of turned wood into "chessmen" in a copse. As his source of inspiration for these figures Magritte himself mentioned only the table legs. But the term "bilboquet" which was later applied to these forms, I can see only as a reference (not meant to be taken literally) to something that falls over and rights itself again. It also indicates an old-fashioned toy, used in the cup-and-ball game — a small wooden ball attached to a cup by a string — metaphorically (see Littré, *Dictionnaire de la langue française*) a thing which always lands on its feet. In addition the term is used for a person lacking stability.[26]

The varied meanings that Hammacher proposed for the bilboquet all seem pertinent to Magritte's motivations in se-

lecting this object as a symbol for his mother: like the bilboquet, she lacked stability and may have collapsed and righted herself again psychologically many times before her final breakdown; the analogy with the game of ball-and-cup is equally appropriate. As a small child, necessarily involved in her bizarre thoughts and actions, Magritte may have felt like a battered ball in a particularly useless and sadistic game of ball-and-cup.

If the lost jockey symbolizes Magritte himself and the bilboquet his mother, the horse probably represents his wife, Georgette, the long-ago partner of the carrousel ride. In *The Lost Jockey*, then, Magritte portrayed himself aided by Georgette as he struggles to escape from the wintry wood of his past, with its ice-mother bilboquets.

The jockey motif had so much valence for Magritte that he went on repeating variations on it until shortly before his death. In a version from 1960, just seven years before his end, the artist again portrayed a horse and rider, but this time they attempt to flee from an interior, a room with paintings recalling favorite Magritte motifs resting against the wall. Only one bilboquet appears in this version, standing like a tall sentry at the open doorway, as if threatening to block the rider's exit. Beyond the door one glimpses a wooded grove. As discussed below, the tree was another of Magritte's principal symbols for his mother. This duplication of her symbolism, occurring both inside and out-of-doors, indicates that no haven could offer the artist protection against the internalized image of the mother that accompanied him everywhere throughout his life. Magritte gave this particular canvas a new title, *The Childhood of Icarus*, a name that suggests analogies with the fate of the youth who suffered death by drowning because his hubris led him to soar too near the sun.

Magritte employed the bilboquet motif again in 1926 in another, much larger, more ambitious picture painted in pallid colors. *The Secret Player* (fig. 6) is staged in a kind of formal garden with neat cinder paths and lush flowering bilboquets replacing conventional trees. Two impeccably garbed young men play a ball game, while above them a large, terrapinlike creature floats unnoticed. The players seem equally oblivious to the presence of another silent participant: an open cupboard resting on the low garden wall reveals the half-length image of a masked and tightly corseted female figure. Her enigmatic presence particularly puzzled Calvocoressi, who described her as "half-nurse, half-sex object," noting that she represented the perverted, sadistic strain so often characteristic of Magritte's art.[27] I would interpret this figure, rather, as an image of the "skeleton in the closet," the mad woman in the attic — a bizarre hidden force locked away yet haunting the activities of the youthful protagonists as forcefully as the surrounding bilboquets. But the image simultaneously presents the mother as a kind of icon or idol, enshrined in a case whose form recalls those of Renaissance portable altarpieces that often feature images of the Virgin and were

carried by devout travelers on their journeys. The flying tortoise seems still more enigmatic. In French as in English, however, the words turtle and turtle dove both begin with the same syllable; in light of Magritte's fondness for punning, it seems possible that the tortoise may be a covert reference to his totem animal, the dove.

The anthropomorphic bilboquet appears as the chief protagonist in two additional 1926 canvases, both painted in strong, dark colors and filled with an expressionist tension absent from *The Lost Jockey*. Both these paintings seem to refer to the period immediately preceding the mother's suicide. *The Birth of the Idol* (fig. 7) takes place at night during a wild storm at sea. Whitecaps simultaneously breaking from all sides suggest that the wind blows from the four cardinal points at once. The waves dash against the idol's base, a large, terracotta platform that floats on the sea like a raft. Above, phosphorescent clouds skitter across the sky, reinforcing the impression conveyed by the agitated water. At the rear of the platform, a blind staircase terminates in a precarious parapet overlooking the sea. Just anterior to the stairs, a wood-framed mirror and a large form that resembles a sheet of richly veneered plywood rest against the parapet. The veneered object has several rectangular holes punched in its surface. Described by various critics as a series of open doors or windows, this mysterious object resembles some large leftover carpentry, perhaps yet another reference to the mother's wooden quality — an analogy the artist would make more explicit in successive pictures.

Looming up in the right foreground of the picture plane, the idol itself teeters on the neck of the cut-out silhouette of a wooden mannequin, itself precariously stretched across a table with only three visible legs. As if to underscore the idol's helplessness, Magritte has endowed it with a plaster arm that dangles uselessly at its side, attached to its body by a single thread.

Although many details of *The Birth of the Idol* reflect the influence of de Chirico, the high level of anxiety that Magritte conveyed through its composition constitutes its fundamental originality.[28] One of his earliest painted references to his mother's suicide — there would be many others — this composition re-creates the atmosphere of desperation and helplessness that must have surrounded her preceding her death. The blind stairs, the holes in the veneer, the dangling arm — all these features symbolize her inability to improve her precarious situation, the latter suggested by the idol's position on that makeshift diving board from which she seems about to be catapulted into the foaming sea.

Since the idol seems in imminent danger of destruction, rather than about to be born, Magritte's title initially appears quite puzzling. This paradox resolves itself when we realize that the artist's process of idealizing his mother — a process expressed much more emphatically in many of the paintings he produced after 1930 — may have been initiated by her death. Her demise as a bizarre mortal, then, may have coincided with

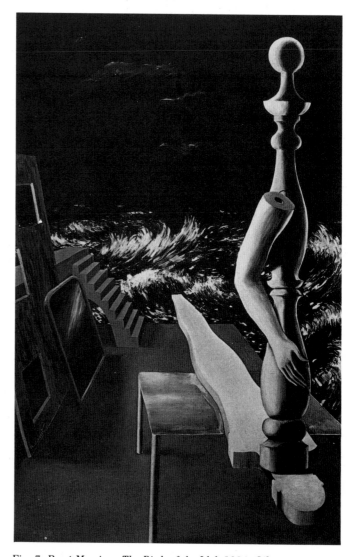

Fig. 7. René Magritte. *The Birth of the Idol*, 1926. Oil on canvas. Private Collection. Photograph A.M. Hammacher, *René Magritte*, New York, 1973, ill. p. 71.

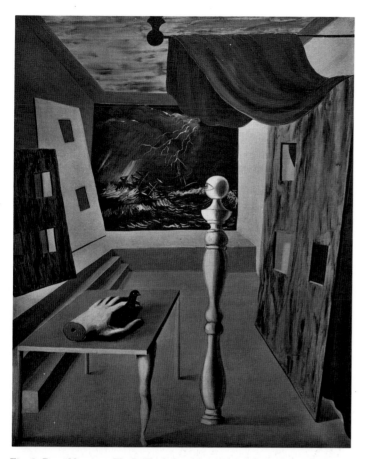

Fig. 8. René Magritte. *The Difficult Crossing*, 1926. Oil on canvas. Private Collection. Photograph Courtesy the Institut Royal du Patrimoine Artistique, Brussels.

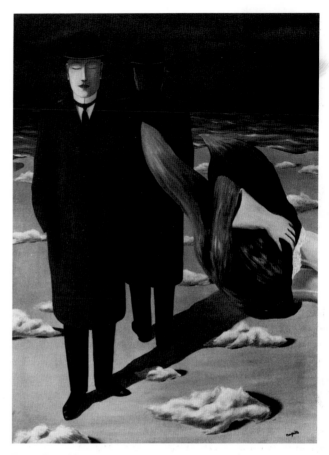

Fig. 9. René Magritte. *In the Land of the Night*, 1927. Oil on canvas. The Menil Foundation Inc., Houston, Texas. Photograph Courtesy the Menil Foundation Inc.

her birth as an idol. The title also suggests references to the myth of the foam-born Venus and the underlying fantasy that the mother might reemerge from the waters of the Sambre as Venus had from the sea, a theme also implicit in *The Robe of Adventure* (1926), which shows a shapely nude floating down a stream on a pod-shaped vessel. Like some modern-day female Moses, she seems to await discovery by Pharaoh's daughter. Above her, again a giant tortoise hovers, a ponderous, airborne guardian.

Shortly before Magritte painted *The Birth of the Idol*, he dealt with the same theme of the mother's suicide in another canvas, *The Difficult Crossing* (fig. 8).[29] This version introduces the humanized bilboquet, blind staircase, and large veneered object with cutouts that recur in *The Birth of the Idol*, but this time locked in the enclosing safety of a room. The bilboquet, equipped with a wild human eye, now stands on the floor, while the nearby table top holds only a detached classical hand (another de Chirico reference) imprisoning a struggling, live bird.

In this first treatment, Magritte represented the turbulent sea as a marine painting that fills the back wall of the room. This painting-within-a-painting depicts two storm-tossed

sailing ships foundering in the wild ocean, the scene illuminated by dramatic flashes of lightning. The large vessel, apparently on the verge of going down, has rolled over on its side, while the smaller ship, though clearly endangered, remains upright.

Because we confront the agony of the endangered bilboquet so directly in *The Birth of the Idol*, this picture seems, in many ways, more expressionist than *The Difficult Crossing*. However, the latter canvas contains pessimistic references to Magritte's own psychological status not present in *The Idol*. For it seems likely that the trapped bird of this painting represents the artist himself, locked in the stony prison of his memories; the smaller ship, another apparent self-reference, suggests the recurring suicidal preoccupations that haunted him at intervals throughout his life.

Such thoughts apparently came thick and fast during the first years of Magritte's Surrealist career, when he dealt so openly with extremely disturbing material. For example, *In the Land of the Night* (fig. 9), another eerie, dark canvas from 1927, also seems to refer to such self-destructive ideas. Magritte's bowler-hatted Doppelgänger appears twice in this picture, again set on the seashore. In one aspect he faces us,

Fig. 10. René Magritte. *Check and Mate*, 1926. Gouache on paper. Private Collection. Photograph Harry Torczyner, *Magritte: Ideas and Images*, New York, 1977, fig. 65.

Fig. 11. René Magritte. *Discovery*, 1927. Oil on canvas. Private Collection. Photograph Harry Torczyner, *Magritte: Ideas and Images*, New York, 1977, fig. 471.

his eyes cast down, his features expressionless. But he — or his twin — is represented again with his back turned to us, as though about to walk into the water that waits to receive him. Eerie, unidentifiable forms dotting the beach symbolize foam, flotsam and jetsam thrown up by the sea, or some still more mysterious object. Whatever their origin, they have assumed a life of their own: the largest of them looms behind the solitary wanderer, reaching out to touch his back — a gesture meant to comfort, or perhaps to urge the protagonist toward his death.

Perhaps because Magritte believed that the picture's cartoonlike style would belie its grim underlying message, he portrayed his recurring suicidal obsession quite openly in *Check and Mate* (fig. 10), a gouache from 1926. The action takes place in a small chamber with a checkerboard floor. In a back corner of the room, a bilboquet careens crazily, as though about to fall; meanwhile, in the right foreground, a young man raises a pistol to his temple. The implied connection between the endangered status of the bilboquet and the young man's desperate action recalls the parallel situation of the two ships in *The Difficult Crossing*.

A lost canvas from these same years, *The Weariness of Life*, portrays a disembodied yet seemingly alive man's suit as it floats off into space like an inflated balloon. In this instance, the artist seems to have imagined himself experiencing a kind of apotheosis in lieu of death, and it should be noted that motifs strongly suggestive of resurrection and assumption fantasies recur throughout Magritte's oeuvre. Such themes probably reflect the underlying fantasy that the mother might rise once more from the dead or be assumed into heaven, despite the fact that she took her own life, an act condemned by Catholic dogma.[30]

Magritte's repeated depiction of the unstable bilboquet was far from the only analogy he employed to emphasize both his mother's wooden quality and her emotional difficulties. In several other canvases from the late 1920s, he implicitly compared her to small, rootless trees perched unsteadily on table tops, as well as to trees that seemingly grow upside-down, crowns pointed earthward. A frequent variant on the latter motif shows trees that possess two crowns, one in the normal position, one obscuring the lower trunk. *The Oasis* (1925/27?)

and *The Cultivation of Ideas* (1927) both present such rootless, table-top trees. The two trees in the latter picture form a single crown, a device that, coupled with the short shadow their trunks throw, transforms them into a metaphor for a striding person about to walk off the table.[31] The latter painting should be compared with a lost canvas from the same period portraying a bathing-suit-clad woman moving across a sandy beach; like the rootless trees, she seemingly possesses no feet, and her limbs closely resemble the humanized tree trunks in *The Cultivation of Ideas*.

Magritte continued this painted analogy between his mother's abnormalities and trees in another group of pictures depicting what appear to be sections cut from painted stage scenery simulating forests. These seemingly useless fragments stand, cast shadows, and generally function as though they were three-dimensional living beings rather than pieces of flat, painted canvas.

In *The Empty Mask* (1928), one of the Magrittian pictures featuring words instead of images, the artist explicitly equated the tree with the human body, inscribing *"corps humain (ou fôret)"* (human body [or forest]) in the upper right corner. As Sylvester pointed out, when Magritte painted the two versions of *The Empty Mask* with pictures in place of words, "four of the six images corresponded to the words in the first version: since the words in one quarter presented an alternative,…he made one version with a forest, the other with a female torso."[32]

Discovery (fig. 11) depicts a beautiful nude as a contemporary Daphne whose flesh changes to wood before our very eyes. In discussing this picture, Hammacher emphasized that despite Magritte's hostility to psychoanalytic interpretations, it seems impossible to ignore the fact that "Freud saw a connection between wood and the idea of the woman, the mother. He referred to the name 'Madeira,' the wooded island, since it means 'wood' and is derived from the words *mater* (mother) and *materia* (material)."[33] Through this picture Magritte seems to have been sharing with his public a possible experience of watching his melancholic mother turn wooden, unresponsive, and uncommunicative as she withdrew from outer reality into her inner world.

Magritte's insistent repetition of the woman-wood equation, which endured long past his initial Surrealist phase, reminds one that his earliest childhood memory involved a recollection, as in a vision, of a large wooden chest that had stood enigmatically near his cradle. This recollection appears to have been another screen memory, a mixture of fact and fiction, recall and revery, that encoded his earliest experience of the repeated metamorphoses that his mother suffered when she became wooden and emotionally unavailable, yet simultaneously confining like a closed chest.[34]

The implicit connection between wood and fire suggested by the flamelike patterning of the wood graining as it consumes the flesh of the nude in *Discovery* becomes more explicit in several of the compartmentalized pictures (characterized by seemingly unrelated images separated by painted frames) that

Magritte produced beginning in 1928. Thus, *The Six Elements* (1928) features a nude female torso centered between scenes of flames and trees (the latter with Magrittian double crowns). *On the Threshold of Liberty* (fig. 12) includes these same images in a larger repertory of eight scenes along with a panel simulating wood planks.

Magritte's fascination with fire continued throughout his career; he frequently depicted objects being consumed by spontaneous combustion, like the piece of paper, egg, and key in *The Ladder of Fire* (1939), burning atop a wooden table that remains paradoxically intact. During the 1940s he created a flaming bilboquet, evidently the hybrid offspring of a union between his earlier baluster and a plumber's torch.

Fire, with its intense heat and bright colors, connotes not only warmth and comfort, but excitement, danger, and destruction. In associating fire with memories of his mother, could Magritte have been recalling a very different aspect of her behavior than her woodenness — possibly wild outbursts, periods when without provocation, like objects undergoing spontaneous combustion, she "ignited" into frenzied excitement or rage?[35]

A written statement that Magritte made about trees suggests that he may also have made some deep-level association between the all-consuming character of fire and his mother's disappearance into "thin air."

> Pushed from the earth toward the sun, a tree is an image of certain happiness. To perceive this image we must be immobile like a tree. When we are moving, it is the tree that becomes the spectator. It is witness, equally, in the shape of chairs, tables, and doors to the more or less agitated spectacle of our life. The tree, having become a coffin, disappears into the earth. And when it is transformed into fire, it vanishes into the air.[36]

The perversely entitled *Pleasure* (fig. 13), perhaps the most horrifying canvas Magritte ever created, suggests just how uncontrolled the mother's wild outbursts might have been. The canvas depicts a daintily dressed young girl who wears a proper Belgian lace collar and cuffs. Her behavior, however, is anything but fastidious: she has just taken a huge bite from the breast of the living bird she grasps in her hands; its blood runs down her fingers as she crunches its feathers, bones, and flesh in her teeth.[37] Meanwhile, several other birds remain perched in the tree just behind her, unaware that they may serve as the next course in this grisly meal. *The Murderous Sky* (1927) reads almost like a sequel to *Pleasure*: four dead birds float belly-up in the ether, exposing mutilated breasts from which huge chunks have been bitten. Both these canvases portray helpless birds as the victims of a savage predator who, like a wild animal, devours its prey alive. On a symbolic level, this imagery graphically suggests the type of permanent injury that Mme. Magritte must have inflicted on her sons, wounds that surely left them permanently scarred.[38]

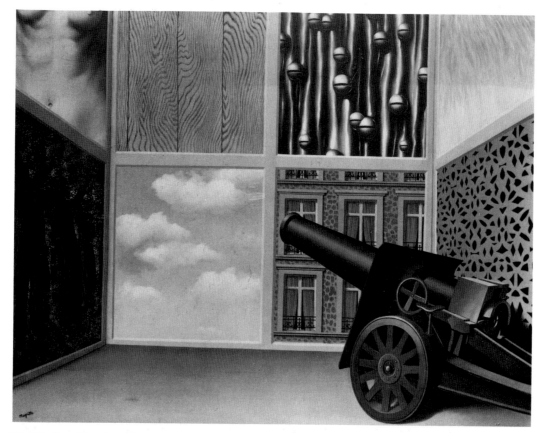

Fig. 12. René Magritte. *On the Threshold of Liberty*, 1929. Oil on canvas. Museum Boymans-van Beuningen, Rotterdam. Photograph Courtesy the Museum Boymans-van Beuningen.

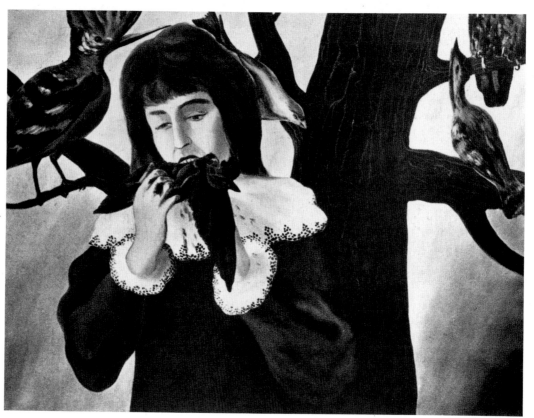

Fig. 13. René Magritte. *Pleasure*, 1927. Oil on canvas. Kunstsammlung Nordrhein-Westfalen, Düsseldorf. Photograph A.M. Hammacher, *René Magritte*, New York, 1973, ill. p. 14.

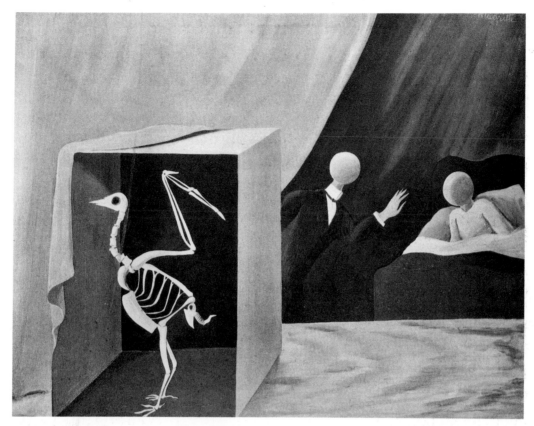

Fig. 14. René Magritte. *The Great News*, 1926. Oil on canvas. Present location unknown. Photograph Patrick Waldberg, *René Magritte*, Brussels, 1965, ill. p. 49.

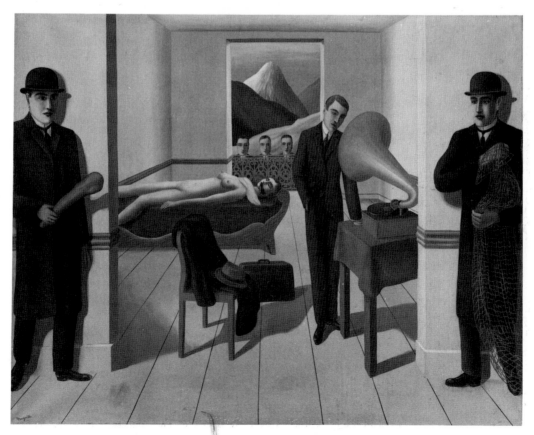

Fig. 15. René Magritte. *The Menaced Assassin*, 1927. Oil on canvas. The Museum of Modern Art, New York. Photograph Courtesy The Museum of Modern Art.

Sadism begets sadism, and a number of other canvases from this period reflect the reciprocal rage and murderous impulses that apparently assailed Magritte throughout his childhood. *The Great News* (fig. 14) recapitulates events from the night the artist's mother suicided. An adult male humanoid awakens a similar child figure (both characters have knob tops instead of human heads). The child strains forward attentively in bed to listen to the midnight message. In the foreground an open theatrical curtain exposes a shadow box containing the skeleton of an improbable bird. The "great news" to which the title refers may be the child Magritte's initial sense of relief — it would soon be followed by panic, guilt, and confusion — on learning about the death of his mother, represented here by a bizarre skeletal bird in a coffinlike box.

The Comic Spirit (1927) reveals a "child" murderer about to crush the skull of a sleeping "adult" with an enormous, potato-shaped rock. Perhaps in an effort to blunt the impact of this homicidal message, Magritte painted both figures as paper lace figures (a pseudo-collage technique he used in several contemporary canvases showing hobgoblins; in addition to their other meanings, such images evidently parody the fame of Brussels lace). Although it is not clear whether the adult personage in *The Comic Spirit* represents a woman or a man, Magritte later made a statement alluding to his patricidal wishes.[39] *The Comic Spirit*, then, may comment on another aspect of Magritte's tragic childhood: his father's failure either to help his wife or to protect his children adequately against her psychological defects, a failure that may have resulted in the kind of impulses on Magritte's part portrayed in this picture.

The Menaced Asssassin (fig. 15), an unusually large and complex painting from early 1927, recasts the mother's death as a murder rather than a suicide. As Sylvester (who called it the artist's "one narrative picture of consequence") emphasized, this key work contains prototypes or early examples of many important Magrittian motifs.[40] It is unique in another way as well: it presents past, present, and future pictorial events in a condensed fashion unduplicated in any of Magritte's other paintings. I believe that the central section of the picture, the room that houses the assassin and his victim, symbolizes the pictorial present. The cool, collected assassin, his hat, coat, and valise at the ready, pauses before a gramophone (was the murdered woman listening to music in a voluptuous state of nudity when her murderer surprised her?).[41]

The body of the shapely victim rests on a couch behind the murderer; a veil covers her throat, disguising the fact that her head and torso seem out of alignment; this detail conveys the grisly impression that her head has actually been severed from her body. Outside a wrought-iron balcony at the rear of the room, three young men impassively survey the room. Beyond them is a mountain range that features a peak similar to the type from which Magritte would later "carve" the stone bird of the multiple versions of *The Domain of Arnheim*. The appearance of the triplets recalls the fact that the bird in the Arnheim

paintings hovers above a nest containing three eggs. The many instances of triplet imagery in Magritte's oeuvre must refer to the artist and his two brothers as children. Even though the triplets of the *Assassin* appear in the nominal guise of adults, they witness incidents from their childhoods — in this case, as Magritte seems to have wished to believe, the way in which the father "killed" the mother through cool indifference.

In addition, one wonders whether the father was unfaithful. Waldberg noted that following his wife's suicide, he had a series of liaisons — a practice that may have predated her death. (In this connection, it should be noted that Magritte prefaced his mythical recounting of the mother's suicide by noting that she shared the youngest son's bedroom and was discovered to be missing when he awoke and found her gone.[42])

In the foreground of the painting, bowler-hatted "twins," who represent future time, wait in hiding, apparently planning to trap the murderer as he departs. The left twin holds a club shaped like a human limb, while his counterpart carries a heavy net, similar to those used by gladiators.[43] The twins, Magritte's double Doppelgängers, represent his punitive wishes toward the father, his desire to expose and eliminate his transgressing parent. Indeed, through his art Magritte succeeded in living out this fantasy, for in *The Menaced Assassin*, he condemned his father as the mother's callous killer, holding him up to the world's censure. Through this device Magritte simultaneously projected his own hostile impulses and underlying guilt toward the dead mother, making explicit that his father (not himself) should be held accountable for her death.[44] The father's culpability, moreover, justified the artist's patricidal fury. *The Menaced Assassin*, then, is not only complex and ambitious; it is also extremely tidy, a painting that permitted Magritte to deny and project his own rage toward the mother while simultaneously viewing her as an innocent victim rather than a self-murderer.

In a number of other paintings he produced in his first Surrealist style, Magritte explored another troubling aspect of his childhood: his sense of oneness with his mother. The vivid imagery in several pictures suggests that the artist may have been involved in a psychological fusion with the mother so profound that he must frequently have experienced difficulty in separating his emotions and reactions from hers. In order to investigate this novel theme, Magritte made clever original adaptations of the Surrealist penchant for producing twin or double images, creating a series of pictures featuring androgynous beings whose ambiguous sexual identity may reflect the fact that Magritte's mother-child merger required him to cross sexual lines.

He Doesn't Speak (fig. 16), one of the earliest of these works, introduces a new character, a shaven-headed protagonist whose baldness suggests masculinity but whose delicate facial features seem more feminine. This special alter ego appears in a number of key paintings through 1931, then disappeared from Magritte's art for good, in contrast to his

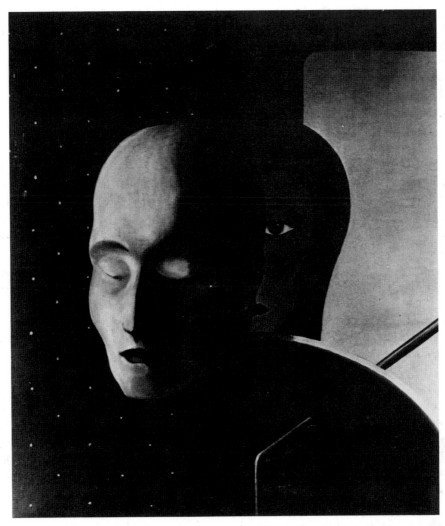

Fig. 16. René Magritte. *He Doesn't Speak*, 1926. Oil on canvas. Private Collection. Photograph Harry Torczyner, *Magritte: Ideas and Images*, New York, 1977, fig. 35.

other Doppelgänger figure, the bowler-hatted man, who remained a fixture in his compositions. These bald personages recall figures depicted in the paintings and sculpture of ancient Egypt, a culture whose art especially interested Magritte at the time.

In *He Doesn't Speak* the bald protagonist, his eyes cast down, his lips tightly closed, appears as a bodiless head floating against the wood-grained, nail-studded ground. The back of his head merges with the forehead of his female counterpart, whose single visible eye is wide open, though her mouth, too, is tightly shut. Like her masculine companion, she resembles a plaster head more closely than a living person, though she also recalls contemporary photographs of the artist's wife. (Several years later, the Magrittes posed for a photograph apparently intended as a send up of *He Doesn't Speak* that reversed the male-female positions in this canvas.)

This enigmatic composition suggests that Magritte may have consciously recognized that only his stabilizing relation-ship with Georgette permitted him the freedom to "speak" to the world about the intimate details of his childhood history. His wife became the ventriloquist, as it were, through whom the artist, here cast in the role of puppet, spoke without acknowledging that act.

The Double Secret (fig. 17) presents another "plaster" pair; in fact, it would be more accurate to describe this picture as a representation of a single fragmented bust, pictured side-by-side together with its missing piece. In this instance Magritte has forced us to perform the work of closure, to reunite the bust with its fragment and form a complete figure once again. Although this androgynous personage has thick brown hair closely resembling Magritte's and cut in a masculine style, the figure's finely shaped lips and arched brows make the bust read more like an effigy of a young woman with a boyish bob. The missing fragment reveals that the bust's interior is composed of sleigh bells clinging to an irregular metallic interior. Here Magritte portrayed the underlying uncertainty of

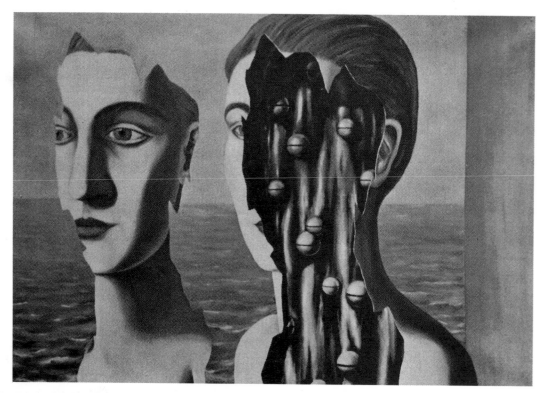

Fig. 17. René Magritte. *The Double Secret*, 1927. Oil on canvas. Musée des Beaux-Arts, Liège, Belgium. Photograph Courtesy the Institut Royal du Patrimoine Artistique, Brussels.

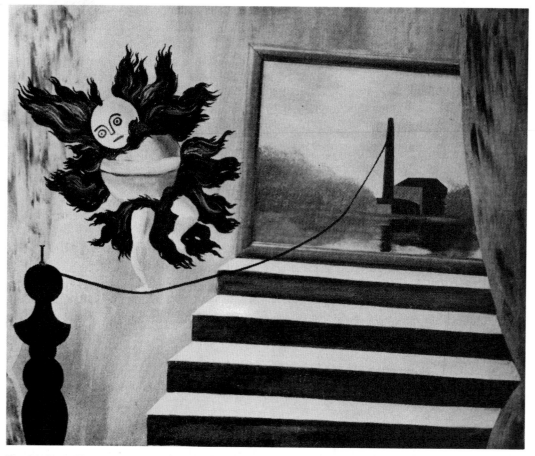

Fig. 18. René Magritte. *The Master of Pleasure*, 1928. Oil on canvas. Present location unknown. Photograph Patrick Waldberg, *René Magritte*, Brussels, 1965, ill. p. 81.

his sexual identification, as well as his fundamental feelings of emptiness. The fragmented state of the bust alludes not only to his mother's mental disintegration but to his own sensations of falling apart when her suicide forcibly separated the future artist from his secret double.

Magritte produced a variant on this theme called *The End of Contemplation* (1927). In this version the twins appear as profile bald busts, as alike as duplicate reserve heads from an Egyptian tomb. Both figures have suffered identical mutilation; their appearance suggests that a contiguous jagged piece has been hacked or cut away from their lower faces and chests (but the sharp treatment of the saw-toothed broken edges also makes the bust read like cut-paper silhouettes, done violence with a scissors). In this instance, unlike in *The Double Secret*, superimposing the two images would not restore the integrity of the figure, any more than Magritte himself could ever completely close over the gaping psychic wounds inflicted by his childhood experiences.

Numerous other canvases from these same years treat the theme of fusion (and confusion) with the mother. For example, both versions of *The Lovers* (fig. 2) show virtually identical loving couples with their heads completely veiled. We read the one character as male, the other as female, only because the artist suggested this identification by providing glimpses of their sexually differentiated clothing. *La Raison d'être*, a lesser-known gouache from 1928 whose title might be translated as *The Reason for Existence* or *The Justification for Being*, depicts the silhouette of a mannequin in the act of fusing with — or emerging from — a bilboquet. *The Titanic Days*, painted the same year, offers a much more violent interpretation of a male-female merger as a grotesque female nude with heavy limbs and feet struggles against a male figure whose clothed silhouette is entirely contained within her body. Usually interpreted as a depiction of a rape, the scene surely portrays instead the terrible internal struggle against an enforced fusion that will destroy the separate identities of both protagonists. The funereal light and the black garb of the male aggressor also support the notion that the picture may simultaneously portray the mother's titanic struggle against death, who, in the end, will forcibly carry us all off. The latter aspect of this ambiguous work raises an additional question: did Magritte feel that his mother suicided *because* he was about to succeed in the struggle against fusion and, with the approach of adolescence, liberate himself from the suffocating

grasp? In this connection, one recalls that in *On the Threshold of Liberty*, painted in 1929, Magritte included a detailed replica of an actual cannon with its muzzle aimed right at the compartment containing the effigy of a nude female torso.

The Master of Pleasure (fig. 18) might serve as a painted summation of the motivating forces underlying Magritte's art — his permanently unresolved state of psychic separation from the mother. This canvas reintroduces the familiar device of the raised theatrical curtain to reveal a corner of a small room. A blind staircase terminating halfway up the back wall of the room serves as a ledge supporting a painting. The latter shows a factory or powerhouse situated alongside a stream. A "real" rope connects the tall smokestack of this building to an "actual" bilboquet standing in the room. A tightrope walker makes his perilous way between this bilboquet and the painting-within-a-painting. This bizarre little person's head and torso seem to be composed of two flaming sleigh bells (their rounded forms also suggest an underlying reference to the game of ball-and-cup). Surely this poignant little creature represents Magritte himself, forever tenuously balanced between his art and his memory, his painting and his past.

The picture's title initially seems ironic; certainly painting such compositions cannot have given the artist pleasure, although it probably provided him with a sense of relief. On another level, however, Magritte's ability to make high art from such horrifying dross did demonstrate his mastery over his tragic past. By replicating these events in encoded form in his paintings, he assumed control, forcing us, his viewers, into the role he himself had played during childhood. The canvases of his first Surrealist period present this message with an insistent intensity unmatched in his later oeuvre. Whether this change of style should be attributed primarily to personal, artistic, or practical motivations remains problematical. However, the fact that Magritte was so unusually productive during his first few years as a practicing Surrealist suggests that a gradual discharge of tension may have been an important determinant in effecting this change. Certainly during the 1930s he painted a long series of successful pictures that ultimately gained great popular approval and secured his artistic reputation. These paintings possess much more charm and appeal than many of his canvases of 1925 to 1930, but they seldom, if ever, equal the disturbing power he achieved during the fervor of his initial meditations on madness.

Notes

1.
This painting belongs to the Belgian poet Louis Scutenaire. Probably Magritte's most intimate friend, Scutenaire has written authoritatively on the painter as a person as well as an artist. He also owns many pictures from Magritte's so-called Renoir and Vache periods, paintings that have never won the universal admiration accorded his more characteristic works.

2.
This famous quotation, reprinted everywhere, appeared in Louis Scutenaire, *René Magritte* (Brussels: Librairie Selection, 1947), pp. 71-72. It is the sole reconstruction of the events surrounding his mother's suicide that Magritte ever produced. It is quoted in its entirety in the more readily accessible Suzi Gablik, *Magritte* (Boston: New York Graphic Society, 1976 [orig. pub. Greenwich, CT, 1970]), p. 22.

3.

Sylvester quoted several contemporary Belgian newspaper accounts of Mme. Magritte's disappearance and the subsequent recovery of her body several weeks later. Although Magritte's story implies that he had been present at the latter event, this clearly was not the case. The advanced state of decomposition in which the body must have been found scarcely tallies with his romantic account of the dead mother's appearance. See Sylvester's essay "Portraits de Magritte," trans. Anne Perez, in the exhibition catalogue *Rétrospective Magritte* (Charleroi, Belgium, 1978), pp. 52-53.

4.

See Elena Calas, "Magritte's Inaccessible Woman," *Artforum* 17,7 (Mar. 1979), p. 24. For a discussion of the problems faced by the children of suicides, see A. C. Cain, ed., *Survivors of Suicide* (Springfield, IL: C. C. Thomas Press, 1972).

5.

See Martha Wolfenstein, "The Image of the Lost Parent," in *The Psychoanalytic Study of the Child*, vol. 28, ed. Ruth S. Eissler, Anna Freud, Marianne Kris, and Albert J. Solnit (New Haven and London: Yale University Press, 1973), p. 446.

6.

The newspaper accounts provided by Sylvester (note 3) describe Mme. Magritte as a neurasthenic individual who had often threatened suicide. Another account indicates that she suffered from "a very cruel malady," whose pains caused her to flee her home the night of her suicide. A.M. Hammacher, in his *René Magritte*, trans. James Brockway (New York: Harry N. Abrams, Inc., 1973), noted that after the move to Châtelet, life was apparently "full of problems for Magritte's mother." At my request, he graciously agreed to ask the artist's widow whether she knew any further details about the artist's mother in particular and the family history in general, but this attempt proved quite unproductive (personal communication, Oct. 11, 1984).

7.

Scutenaire claimed that "between about 1925 and 1927 Magritte painted about a picture a day" (Louis Scutenaire, *Magritte*, trans. Eleanor Hodes [Chicago: The William and Noma Copley Foundation, 1948], p. 3), and this claim has been repeated by others. In several interviews Magritte himself mentioned painting 60 pictures a year in both 1926 and 1927. In his late "Interviews de Houston, décembre 1965," in René Magritte, *Ecrits complets*, ed. André Blavier (Paris: Flammarion, 1979), the artist noted, "I painted 60 paintings in 1926, but that was a youthful explosion...I paint far fewer now" (p. 617). It seems likely that Scutenaire's estimate is inflated, but this question cannot be answered definitively until the catalogues raisonnés are published. Scutenaire would divide the artist's career into a 1925-27 phase, followed by a longer second phase lasting from 1927 to 1940. Most other critics define Magritte's first Surrealist phase as enduring from 1925 to around 1929 or 1930.

8.

Scutenaire, *Magritte* (note 7), pp. 13-14. *The Palace of Curtains II* features one of the earliest, if not the first, instance in which Magritte contrasted light and darkness in a single canvas. The left-hand "curtain" with its dark, corrugated interior rather resembles the interior of some primitive sarcophagus. The right-hand figure, by contrast, presents a seemingly transparent interior. Note, however, that its sky-and-cloud interior interrupts the background of double-crowned trees, a fact that suggests it is not, in fact, transparent. If my reading of the left-most curtain as sarcophaguslike is accurate, the picture also prefigures the numerous later paintings featuring animated coffins.

9.

Hammacher (note 6) pointed out this distinction (p. 76). Some of the paintings with invented forms feature images that were apparently inspired by Magritte's fascination with the appearance of melted lead. *School Is Out* (1925?), with its invasive hobgoblin that menaces the interior it has penetrated, seems to derive from this source. It is illustrated in J. T. Soby, *René Magritte* (New York: The Museum of Modern Art, 1965), p. 22.

10.

I hope to explore this phase and its significance in a future essay. However, it should be noted that Magritte invented his Renoir and Vache styles during the decade following this unsettling separation. His enforced separation from Mme. Magritte, coupled with the German occupation of Belgium and other terrible events of World War II, evidently took their toll on the artist.

11.

In his *René Magritte*, trans. Elisabeth Abbott (Paris: Editions Filipacchi and ADAGP, 1970), René Passeron asked Mme. Magritte: "Things that happen in childhood often have a lasting influence. Did Magritte ever speak to you of his?" She responded: "René never spoke of his mother; he never confided anything about his relations to me. Neither the past nor the future interested him, only the present. He did not have a family feeling and he loved only his wife, his Pomeranian dog, his 'home' to the exclusion of everything else" (p. 12). At my request, Dr. Hammacher specifically asked Mme. Magritte about all these issues once again. She replied that the mother's suicide had occurred before she met the artist, and he never mentioned it to her. She noted that his brother (one assumes she meant Paul) behaved in the same way. "It was a kind of family taboo." Mme. Magritte did know the artist's father but never heard from him or anyone else about "things that happened between him and his wife." When Dr. Hammacher suggested that the artist's mother might have been "neurasthenic" (i.e., depressed), Mme. Magritte agreed, but — one senses — with some reluctance (personal communication, Oct. 11, 1984).

12.

The summary of this material most readily available in English can be found in Patrick Waldberg, *René Magritte*, trans. Austryn Wainhouse (Brussels: André de Rache, 1965), pp. 35-58, who quoted from his interviews with Paul Magritte as well as from Scutenaire's writings on the subject. For the latter's accounts, see his *René Magritte* (note 2); *Magritte* (note 7); and *Avec Magritte* (Brussels: Le Fil Rouge, Editions Lebeer Hossmann [1977]).

13.

According to Hammacher (note 6), p. 61, who provided the most precise dates, Magritte was born in Lessines; the following year the family moved to Gilly. In 1910 they moved again, to Châtelet, where his mother suicided. Following her death the family moved to Charleroi. In 1916 Magritte moved to Brussels without his father and brothers, but they followed him in 1918. According to Richard Calvocoressi, *Magritte* (Oxford: Phaidon Press, and New York: E.P. Dutton, 1979), p. 5, the family moved from Charleroi back to Châtelet again before the Brussels move. The existence of such an interim move might explain Mme. Magritte's statement that she met her future husband every day on the way to school (after their initial carrousel encounter) until the war of 1914 and his departure for art school in Brussels. Perhaps they actually lost sight of one another because he moved with his family back to Châtelet. At any rate he did not begin to attend art school until 1916, whereas his wife's account implies that he began around 1914.

14.

Hammacher (note 6), p. 61.

15.

Extremely disturbed mothers often select one child to be the family scapegoat, encouraging the siblings to join in abusing the chosen victim — a fact that may well be relevant in this case. Waldberg (note 12) described a scene between René and Paul Magritte that he witnessed: "We detected the winks and smiles the two men exchanged when we heard them, one at sixty-six and the other at sixty-two, evoke that association of long ago, i.e., their childhood alliance against Raymond; and understood that the old complicity is still alive" (p. 51). Waldberg went on to suggest that this animosity was exacerbated once the boys reached adulthood because Raymond quickly became prosperous while his two brothers remained impoverished for many years. He also described a conversation with Raymond Magritte in which the latter characterized his world-famous artist-brother as "an ass."

16.

This photograph is reproduced in Harry Torczyner, *Magritte: Ideas and Images*, trans. Richard Miller (New York: Harry N. Abrams, Inc., 1977), p. 23. The fact that this picture was obviously the work of a professional photographer need not vitiate its reliability as an index of family attitudes. It may be that the Magrittes naturally formed an arrangement that inspired the grouping memorialized in this photo, but it is equally likely that the photographer simply instinctively responded to subliminal cues informing him of family dynamics. Family therapists are increasingly utilizing informal and posed photographs for insights into intrafamilial relationships. For a popular account of this development, see Jane E. Brody, "Photos Speak Volumes about Relationships," *New York Times*, July 17, 1984, pp. 21, 25.

17.

David Sylvester, *Magritte* (New York and Washington, DC: Frederick A. Praeger, 1969), made a similar observation (p. 14). To his list of pictures with such "divine" self-references, I would add *The Annunciation* (1929/30), a painting that seems to me to be replete with symbolic references to the artist's mother, perhaps here represented as the future mother of a god to be named René Magritte.

18.

Magritte's most overt identification of himself with the pigeon or dove occurred in *The Man in the Bowler Hat* (1964), an apparent self-portrait in which the artist characteristically obliterated his own face, substituting the body of a white dove for his features. His earliest version of *The Healer* or *The Therapist* depicts an individual whose upper torso and face have been replaced by an open birdcage with doves. In 1937 Magritte himself, cast as the healer, posed for a photo mock-up of one version of this picture. Doves appear with great frequency in Magritte's oeuvre, along with birds of several other species, as well as numerous unidentifiable small birds depicted in his bird/leaf metamorphoses and usually shown in these instances as themselves leaf-green. He seemed equally preoccupied with bird/egg metamorphoses (see p. 78 above), and he also frequently associated symbols of his mother with birds. For example, *The Principle of Uncertainty* (1944) depicts a nude woman who casts her shadow on the wall in the form of a bird with spread wings. According to Scutenaire, *Avec Magritte* (note 12), p. 14, Magritte kept a dovecote and raised pigeons, but killed them for food during World War II despite the efforts of his wife to dissuade him.

19.

Cited in numerous sources, this quotation comes from Waldberg (note 12), p. 48. In the interview with Passeron (note 11), Mme. Magritte made light of the artist's bizarre religious behavior during childhood: "As a small boy he used to tease the maidservant, Anaïs, by making the sign of the cross at table or by setting up altars in his bedroom. . . . Child's play!" (p. 12). It seems quite likely that Mme. Magritte — and perhaps the artist himself during his later years — gradually realized that the public might regard this behavior as pathological, and so attempted to dismiss it as mere caprice.

20.

In *Avec Magritte* (note 12), p. 21, Scutenaire explained Magritte's irregular academic record as follows: "He was very young when he lost his mother. Bounced from town to town by a busy father, his studies — if they were long — were fragmentary and his education left to servants."

21.

The artist himself provided this reminiscence in a public lecture entitled "The Lifeline," delivered in Antwerp on November 20, 1938. It appears in the original French version in *Magritte* (note 7), pp. 103-30 and in a shortened form on pages 142-48. Torczyner (note 16) published the first version in English (pp. 213-16). None of the accounts makes clear exactly how old Magritte was when he undertook these cemetery explorations. In his "Esquisse Autobiographique," in *Magritte* (note 7), p. 366, Magritte mentioned spending his vacations at Soignies, and exploring the cemetery in a context which suggests either that he may have been much older when he undertook these explorations or, conversely, that he continued to engage in the activity during early adolescence. In any case, as Wolfenstein (note 5) suggested, the artist seemed to fuse memories of these excursions with his underlying wish magically to restore his mother to life (p. 452).

22.

A screen memory may be defined as "a recollection from childhood (which may or may not prove to be historically true); it characteristically has a high valence for the individual. When successfully decoded, it turns out to have a latent meaning like a dream; usually this meaning has applicability to a broad area of the child's inner life. Sigmund Freud first defined this concept in his 1899 paper, 'Screen Memories'" (John E. Gedo, personal communication, Nov. 26, 1984).

23.

Hammacher (note 6) noted that the artist rejected dreams as a source for his paintings, but then went on to quote from a statement that reveals that "the situation is not so simple as Magritte's outright rejection of the dream would make it seem" (p. 18). In his lecture "The Lifeline" (note 21), Magritte provided a vivid description of awakening one morning after a night spent in a room with a caged bird, to misperceive the bird as an egg. This experience revealed to him "a new and astonishing poetic secret" concerning the hidden affinity of bird and egg. This account suggests that Magritte did make use of hypnogogic techniques for inspiration.

24.

The artist frequently juxtaposed images of sleigh bells with figures or objects clearly associated with the mother. For example, several of his many versions of *Memory* depict a wounded and bleeding classical plaster or marble head of a woman accompanied by a sleigh bell. This picture has been widely interpreted as a reference to the suicide of Magritte's mother.

25.

Magritte attached great importance to the titles of his paintings, which were always chosen after the canvas had been completed. Hammacher (note 6) provided a good discussion of the importance of titles to the artist and the varied methods he used to select them (pp. 25-30). Hammacher noted that "According to what Magritte's surviving relatives and friends have said, the titles sometimes came about through Magritte's own invention, but also very often through discussions with others, at soirees, on the telephone, or in letters, when a painting would be made the subject of discussion" (p. 25). Just exactly when Magritte began to employ these unofficial "committees" of literati and other intellectuals to help him devise the names of his paintings is unclear. Whether he titled his earliest Surrealist paintings all by himself is not known. In any case, I believe that one must treat all Magrittian picture titles with the utmost seriousness if one wishes to decipher the psychological meaning of the work to the artist. The fact that he sought assistance from others and sometimes even accepted titles wholly invented by his friends need not render these titles personally less meaningful for him. His intimates, after all, must have been able to select titles that mirrored the underlying significance of the work for him.

26.

Hammacher (note 6), p. 68. Magritte's fascination with verbal as well as visual puns is well known. For several excellent examples, see Calas (note 4), pp. 25-27.

27.

Calvocoressi (note 13), p. 9.

28.

Hammacher (note 6) suggested that the mannequin introduced in this picture reflects de Chirico's influence (p. 70). Certainly, many aspects of Magritte's first Surrealist style reflect the potency of de Chirico's example. However — at least for this viewer — Magritte's early pictures always possess a level of extreme tension and an anxiety-provoking quality that de Chirico's paintings do not arouse. As Calvocoressi (note 3) noted, Magritte's bilboquet may also have originated in a borrowing — in this case, from Fernand Léger's baluster forms (p. 7). Once again, however, Magritte deployed this object in a way far different from Léger's neutral use of the image.

29.

In a personal communication (Jan. 29, 1985), Sylvester revealed that *The Difficult Crossing* was painted three weeks before *The Birth of the Idol*. Because the latter picture seems to me more tension-filled, I had assumed that it was the earlier of the two versions.

30.

Wolfenstein (note 5) suggested that the late Magritte gouache *The Beautiful Heretic*, showing an anthropomorphic wooden coffin seated on a low wall, may well refer to the mother's suicide "and a question to which it may have given rise as to whether she could be buried in holy ground" (p. 448). The Catholic Church assumes that a person who suicides dies in a state of mortal sin and should not be permitted a Church burial. In practice this rule is not always followed dogmatically; for example, if the person was psychotic at the time of the suicide, he or she presumably could not exercise free will.

31.

Hammacher (note 6), p. 94.

32.

Sylvester, *Magritte* (note 17), p. 5.

33.

Hammacher (note 6), p. 88. One wonders whether Magritte had actually read the French translation of Freud's *Interpretation of Dreams*, published in 1926. Despite his later hostility to psychoanalysis, Magritte may have been stimulated to dip into Freud through his contacts with André Breton and others. At least the symbolism in *Discovery* seems almost deliberate in its emphasis.

34.

Wooden chests, coffins, and the like often appear in Magritte's paintings. For example, in *The Reckless Sleeper* (1927), the androgynous protagonist rests in a "bed" that closely resembles a lidless wooden coffin turned on its side. In *Homage to Mack Sennett* (1934), an open wooden armoire reveals a hanging woman's nightgown with live, luminous breasts. This strange picture makes one wonder whether the future artist treasured items of his mother's clothing following her death. Shoes and other items that may well have been associated with Magritte's mother recur in his iconography. Mirrors, in particular, often containing painted wood graining instead of an image, probably also allude to his mother's narcissism.

35.

It is possible that Magritte's mother's excitable behavior even led to inappropriate sexual activity. The artist's images seemingly related to his mother are so steeped in eroticism that one wonders whether she sometimes behaved seductively with him. However, Waldberg (note 12) reported that the two older Magritte boys later boasted that they had enjoyed the favors of one or more of the mistresses their father took following their mother's death (p. 53). If this report is true, it may explain such strange, sexualized imagery.

36.

René Magritte in Torczyner (note 16), p. 109.

37.

Scutenaire, *Magritte* (note 7), reported that the painter was inspired to create *Pleasure* by seeing his wife, Georgette, eating a chocolate bird (p. 14). The collar and cuffs worn by the protagonist in this picture closely resemble those adorning Georgette in a photograph taken about the time she first met the artist.

38.

The scanty information available concerning the artist's brother Paul suggests that he must be quite an unusual personality. See, for example, Waldberg (note 12) for an account of the former's behavior during the course of a social evening spent in the artist's home (p. 51). See also Gablik (note 2) for a brief description of Paul, along with a quotation from one of his writings that she labels his "strange pseudo-dissertations" (p. 23).

39.

See the quotation in Torczyner (note 16), p. 90, in which the artist discussed the "patricidal rose," then noted that in an illustration he made for the cover of the first volume of *Fantômas* (a pulp thriller series featuring a criminal antihero much admired by Magritte and his peers), he replaced the murderer's knife with a rose. Several times he depicted a rose bush on which a rose and a dagger grow side-by-side. In 1936 he painted *Checkmate*, portraying two animated chess pieces, with the bishop stabbing the king to death.

40.

Sylvester, *Magritte* (note 17), p. 4.

41.

As Sylvester, *Magritte* (note 17), suggested, the gramophone horn is surely the prototype for the tuba that so often appears paired with the female nude in Magrittian paintings (p. 4). Does the association reflect the fact that the artist's mother spent a good deal of time unavailable to her children while listening to the gramophone?

42.

Waldberg (note 12), p. 53.

43.

The Magician's Accomplice (1926) shows a shapely nude, her head and neck "hidden" in a canister, encased in such a net; another canister reveals her head and upper shoulders, as though these had really been removed by the magician in a variation on sawing a woman in half. If this painting in fact predates *The Menaced Assassin*, it anticipates certain aspects of it, including the apparent decapitation of the nude.

44.

However, one should not overlook the fact that the assassin is portrayed as a young man, the apparent peer of the twins and triplets who silently survey him. It may be that in his image of the murderer, Magritte condensed references both to his father and to his hated brother Raymond. In either case, the statement about Magritte's use of this device to project his own guilt seems equally valid (i.e., "It was not I but my wicked brother Raymond who destroyed my mother").

Addendum: It Certainly Was Not a Pipe!

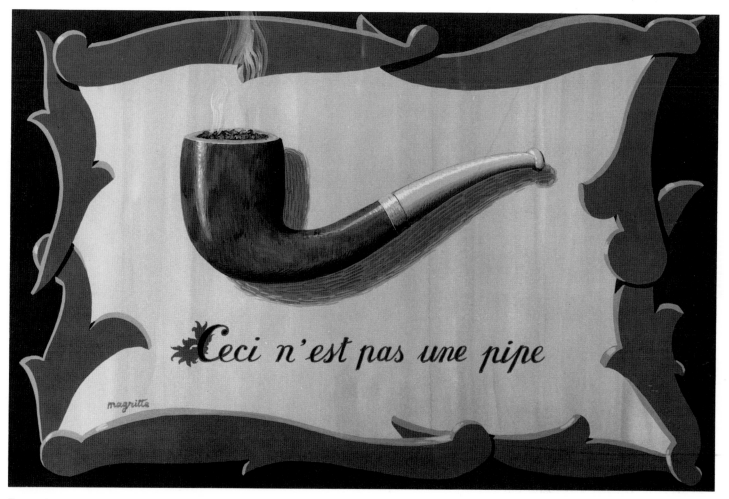

Fig. 1. René Magritte. *The Air and the Song*, 1964 (see p. 172).

Long celebrated as an implicit philosophical commentary on the distinction between word and image, representation and object, *Ceci n'est pas une pipe (This Is Not a Pipe)* probably ranks as René Magritte's most famous composition. It was certainly a personal favorite of the artist himself, who produced numerous near-duplicates of the original picture during the almost 50-year-span that followed its invention in the late 1920s (see fig. 1).[1] The image, simplicity itself, invariably presents an ordinary smoking pipe poised above a written or printed proclamation: *"Ceci n'est pas une pipe."* Since many of these canvases differ from one another only in minor details, such as decorative embellishments or changes of title, the determination of their exact chronology and titles presents special problems.

Unlike many of his other early creations, initially conceived in a raw, expressionist style that the artist modified and softened in later interpretations, the prototype *This Is Not a Pipe* made its initial appearance in its definitive form. Perhaps for this reason, as well as because of its lighthearted, witty character, this motif has never been identified, not even by the most psychologically minded Magritte critics, as one of his more personalized, loaded themes. His virtually ceaseless preoccupation with the composition, however, suggests that this subject may actually be replete with private symbolism successfully encoded in seemingly bland imagery.

The hidden ramifications of Magritte's pipe motif become apparent only when one examines it in conjunction with a number of other works. The earliest canvas related to this

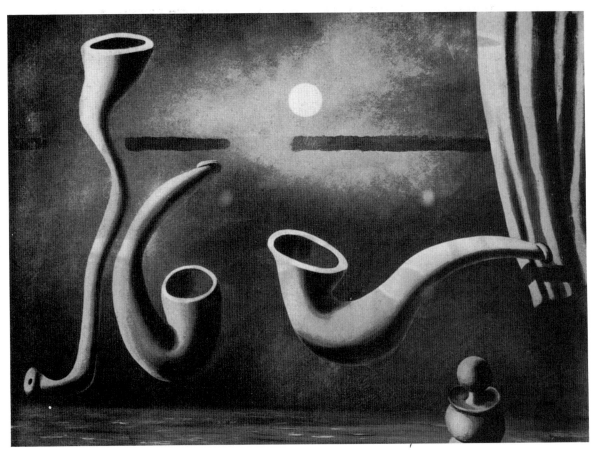

Fig. 2. René Magritte. *Pipes Enamored of the Moon*, 1928. Oil on canvas. Private Collection. Photograph Patrick Waldberg, *René Magritte*, Brussels, 1965, ill. p. 199.

theme, *Les Pipes amoureuses de la lune* of 1928 (fig. 2), apparently predates the seminal version of the classic pipe picture, usually assigned to 1928/29. Its punning title lends itself to various possible translations but is probably best rendered as *Pipes Enamored of the Moon*. Beneath a full moon that casts its pale light on the sea, three anthropoid clay pipes gyrate wildly above the water. In the foreground one glimpses the top portion of a bilboquet, an object that Magritte also introduced during this period in contexts that identify it as a symbol for his mother, who suicided during his adolescence (see page 63). I believe that the triplet pipes (each varies somewhat from the others in size and shape) represent Magritte and his two younger brothers at the time of the mother's death, which occurred when they were thirteen, eleven, and nine. Rather than lovesick, these frenzied pipes might better be described as moon-maddened: mad with grief, mad with rage, mad with confusion, they hover over the watery tomb of their mother, now become a being as cold, lifeless, and remote as the distant moon, to be worshipped from afar.

Nearly a decade later Magritte painted the beautiful canvas *Meditation* (fig. 3). Like the picture just described, *Meditation* features triplet figures, this time three zoomorphic worm-candles that slither across the beach holding their lighted heads erect. The subtle phosphorescent gleams that

emanate from the sand, setting its delicate pastel shades aglow, endow the painting with an almost religious mood. This supernatural atmosphere is reinforced by the halos surrounding the candles that also cast a reflective glow around the bodies of the worms themselves.

These fantastic wormlike beings seem to function as living vigil lights; their alert positions and erect flaming heads suggest that they maintain watch over the watery depths that have claimed so many victims, including the artist's own mother. Once again, these triplet figures suggest analogies to the Magritte children, perhaps during the period following their mother's death, before the stricken boys lost all hope that she might be restored to them. Here, in the guise of miniature, phallic lighthouses, they cast their beams over the sea to guide mother back to shore, should she magically reappear.[2]

Another zoomorphic worm-candle, again equipped with lighted wick and glowing halo, plays a prominent role in *The Philosopher's Lamp* (fig. 4). Perched on a pedestal around which it entwines its waxy tail, the creature illuminates a fantastic scene, highlighting the face of a pipe smoker who puffs on his own turgid nose, stuffed in lieu of tobacco into the bowl of his pipe. Apparently somewhat anxious and embarrassed about having his peculiar habit spotlighted in this fashion, the smoker regards us furtively from the corner of his eye. Al-

Fig. 3. René Magritte. *Meditation*, 1937. Oil on canvas. The James Foundation, Chichester, Sussex, England. Photograph Courtesy The James Foundation.

Fig. 4. René Magritte. *The Philosopher's Lamp*, 1936. Oil on canvas. Private Collection, Brussels. Photograph Courtesy the Menil Foundation Inc., Houston, Texas.

Fig. 5. René Magritte. *Untitled Drawing*, 1948. Ink on paper. Private Collection, Brussels. Photograph Harry Torczyner, *Magritte: Ideas and Images*, New York, 1977, fig. 199.

though Magritte was an inveterate cigarette smoker who never used a pipe, the "philosopher" appears here in the semblance of the artist himself, with his distinctive thick, straight hair and widow's peak carefully delineated. In this painting Magritte has supplied the first clue to the underlying significance of his pipe series: it seemingly encodes a shorthand reference to fantasies or activities of an auto-oral-erotic type. That same year he also drew a sketch of an anthropoid, pipe-smoking china coffeepot with its spout similarly stuffed into its pipe bowl. Unlike the philosopher the coffeepot personage stares out at us unabashedly, perhaps even slightly amused at our amazement over him and his activity.

As if to dispel any questions we might have concerning the implications of these two works, the artist added an explicit postscript to the series in 1948 (fig. 5). The untitled drawing again depicts the head of a male smoker, but this time his nose has been replaced by a turgid penis and testicles. With cross-

eyed intensity he gazes at his unique proboscis, as if attempting to guide it visually as it lowers itself into his pipe bowl.

I believe that the preceding compositions all share a familial relationship, collectively alluding to a chapter from Magritte's adolescent history that continued to haunt him in later life. The cumulative visual evidence suggests that during the period immediately following his mother's death, the distraught future artist may have turned to auto-fellatio as a self-comforting ritual that simultaneously provided him with the illusion that he could be self-sustaining.

Magritte further underlined the self-nutritive aspects of this activity in an undated drawing that transforms the common pipe into an architectural plan of a dining room and related areas. Written notations designate the pipe bowl proper as the "dining room," while the stem becomes the "billiard room," and the mouthpiece doubles as "faucet" and "safety valve." These labels suggest, respectively, the self-sustaining,

pleasurably playful, and tension-reducing functions of the particular form of masturbation that may have engaged the adolescent Magritte.[3]

An account supplied by the artist's most intimate friend, Louis Scutenaire, concerning the nature of Magritte's childhood religious preoccupations, might almost have been written instead as a description of the intense conflicts and ambivalence aroused by such peculiar masturbatory activities.

> He was a mystic, standing at attention before Jesus, his mother, his dove and the saints of the stained-glass windows. Evil confessions tortured him, and the liturgical chants, the candles, the incense made him giddy with happiness and discomfort. . . . Getting up some mornings, he would grimace into the mirror hanging in his little attic chamber, making faces that distorted his features, and that still do, for he hasn't abandoned this habit in his mature years. On other mornings, he would present a pale and solemn face to the mirror, gazing at himself with the firm resolve in his eyes and heart to be good, to live better; to this day with emphatic gestures of his hand and resolute nods of his head, he likes to make good resolutions.[4]

Long after Magritte had reached adulthood and had abandoned his religiosity, vestiges of those terrible childhood conflicts remained, not only in the form of grimaces but also in the artist's continued preoccupation with his secret adolescent sexual life, now encoded in the playful imagery of the *This Is Not a Pipe* pictures. The boy who had evidently once literally "smoked his own pipe" had now become the philosopher-painter who posed provocative questions to the world.

Notes

1.
The best-known publication of this type is probably Michel Foucault, *Ceci n'est pas une pipe* (Montpelier: Scholies [Fata Morgana], 1973).

2.
The candle-worms not only recall the practice of lighting votive candles but also the fact that in the Catholic Church, the sanctuary lamp burns continually, symbolizing that Christ, in the form of the consecrated host, is always a living presence at the altar. Such an idea may have been especially comforting to the bereft future artist during the years immediately following his mother's death.

3.
This drawing is illustrated in Foucault (note 1), p. 80. In French, as in English, the word "pipette" is used for small glass tubes used to draw liquids. Scutenaire made a special, sexualized use of this term in his "The Life and Acts of René Magritte of Yore," reprinted in Suzi Gablik, *Magritte* (Boston: New York Graphic Society, 1976 [orig. pub. Greenwich, CT, 1970]), pp. 189-92. In the original French, Scutenaire wrote, *"Magritte épouse Jean-Marie, vedette fameuse, dont il n'a pas de progeniture (because la pipette)."* Gablik translated this as: "Magritte weds Jean-Marie, a famous star; there are no offspring (*parce que* the wrong organ is played)." In a footnote, Gablik identified Jean-Marie as a male Parisian painter who liked to dress as a woman.

4.
Louis Scutenaire, *Avec Magritte* (Brussels: Le Fil Rouge, Editions Lebeer Hossman [1977]), p. 31 (my translation).

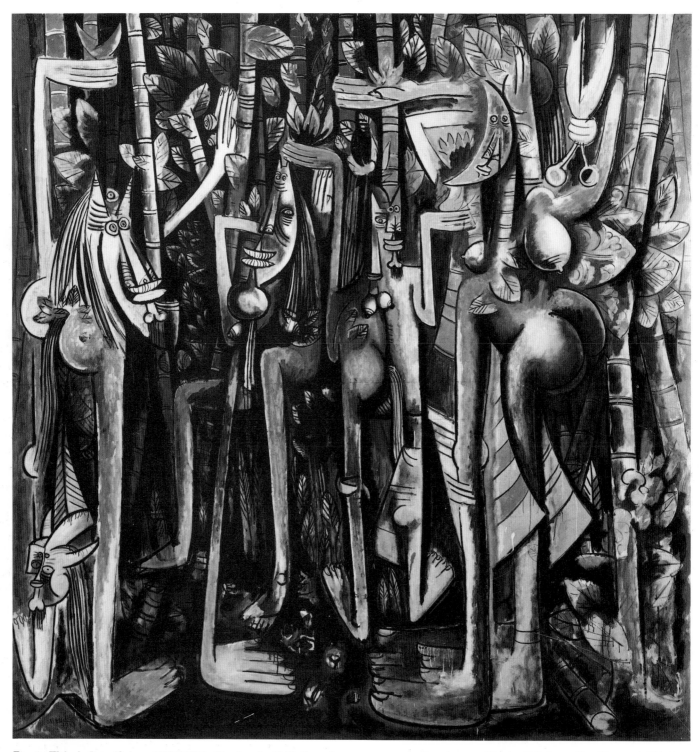

Fig. 1. Wifredo Lam (Cuban, 1902-1982). *The Jungle*, 1943. Gouache on paper mounted on canvas; 239.4 x 229.9 cm. The Museum of Modern Art, New York, Inter-American Fund. Photograph Courtesy The Museum of Modern Art.

Wifredo Lam and Roberto Matta: Surrealism in the New World

By Lowery Stokes Sims

...I was witnessing here, at the other end of the earth, a spontaneous outpouring of our own questioning spirit: what irrational laws do we obey, what subjective signals allow us to establish the right direction... which symbols and myths predominate in a particular conjunction of objects or web of happenings, what meaning can be ascribed to the eye's capacity to pass from visual power to visionary power?[1]

The Surrealist artists and poets especially appreciated and exalted the peculiar quality of the unexpected that they dubbed "the marvelous" — "an impassioned fusion of wish and reality, in a surreality where poetry and freedom are one"[2] — magic, if one will. By the 1940s they had completed their investigation of where the marvelous could be found: in the hallucinations of the insane, the literalness of folk or naive art, the art of children and that of so-called "primitive" cultures. It is their involvement with the last group that specifically concerns us here.

The Surrealists modified the map of the world to emphasize those areas they considered important: Africa, Alaska, Mexico, Latin America, and Oceania took predominance over the geopolitical powers of the time (the United States does not appear at all).[3] During their years in exile during World War II, the Surrealists were able to have firsthand contact with these cultures. Despite their dismissal of its importance, they traveled in the United States; Wolfgang Paalen and Benjamin Peret went to Mexico; Kurt Seligmann to the Northwest Coast of Canada; André Breton to Martinique and Haiti as well as the Dominican Republic. Their experiences had been preceded by that of William Seabrook, whose adventures in Haiti were reported by Michel Leiris in *Documents*.[4]

The appreciation of the art of these cultures and subcultures dates from the beginning of the century. Artists and scholars on both sides of the Atlantic had done much not only to expose this art, but also to critique it. They also drew on its formal qualities to rejuvenate the hackneyed conventions of their own cultures. But the Surrealists were the first not only to appreciate the psychological framework within which these alternate realities were conceived, but also to respect the cultural contexts of these works of art. They eloquently supported the right of these cultures to exist unmolested, and protested xenophobic attitudes that denied their validity.[5] They placed themselves in direct opposition to European colonialist policies — specifically those of France. Colonization was recognized as an economic and political issue; this condition often caused the colonial to disparage those qualities in himself that did not conform to the ideals of the conquering culture.[6] The Surrealists sought to change these attitudes, supporting the idea that these societies should not only be appreciated in their integral states, but also emulated by those seeking to free themselves from the neurotic strictures of European bourgeois capitalism.

More important, the Surrealists' appreciation encouraged the colonized to deal seriously with their own cultures once again. Two artists who joined the Surrealist movement in the late 1930s, Wifredo Lam of Cuba and Roberto Matta of Chile, were important signifiers of this process. Both artists were affirmations of the Surrealist agenda, being indeed conversant with both the concerns of the European avant-garde and the mythical mysteries of the "creolized" cultures of their homelands. Indeed, we can observe incidentally certain politico-cultural nuances in the pictorial strategies of these two artists — whose work is at once distinct and complementary — that indicate the way in which art in the Americas became "de-colonized" during the era between the two World Wars. Artists in New York, Mexico, Montevideo, Havana, and so forth began to forge their own individual styles from a synthesis of modernist styles and indigenous Amerindian art or transplanted Africanisms.

This process may be most dramatically observed in the career of Wifredo Lam. In the cosmological microcosm he first presented in 1943 in *The Jungle* (fig. 1), he domesticated Cubism to present a visual equivalent to the Cuban Santeria religious system which he had experienced as a youth in Sangra le Grande under the tutelage of his godmother, Montanica Wilson, a priestess in the religion. *The Jungle* is filled with myriad hybrids: plants and human beings possessing sibylline accouterments that indicate symbolic

import of the Santeria religion.[7] These disjointed anatomies are similar to the simultaneous views of forms that Picasso depicted in a work such as *Les Demoiselles d'Avignon*, done some 35 years earlier. In Lam's composition the rigid angles and geometry of classical Cubism's urbanized formal structures have been exchanged for a vocabulary steeped in the organic world of nature. Cubist interiors and still lifes have been supplanted by a lush tropical environment in which human and plant forms merge and emerge from the inherently surreal world that was the hallmark of the animistic cosmology that inspired the image.

It is clear that although Lam utilized a Cubist or Picasso-esque formal structure, the syntax has been greatly transformed in his adaptation. This factor has great import considering the aesthetic and theoretical differences of Cubism and Surrealism, which Lam succeeded in reconciling in this work. The Surrealists had taken the international avant-garde to task for its sanitizing of the art process through focusing on purely formal qualities. In his article "L'Esprit moderne et le jeu des transpositions," Georges Bataille condemned the estrangement of symbols from specific context which negated their primordial symbolism. In *The Jungle* Lam may be said to have achieved a resynthesis of form and symbol.

It appears that Lam utilized the formal system of Cubism — with its fracturing of the empirical world into several simultaneous modes of existence — to present the same multiplicities of reality that combine the empirical and surreal worlds in an African cosmological system. That it was African art that inspired Cubism in the first place completes the circle. Lam's work is the ultimate conclusion of Picasso's work from between 1907 and 1917.[8]

Lam's process is analogous to the syncretistic mimicry that was established in the New World between European religion and the Yoruba/Dahomean system. This melding of European, African, and Amerindian cultures has been given many labels in an anthropological context: "maroon," "creole," "hybrid," to name a few.[9] That these concepts have embodied an implied hierarchy of European "high" culture over a "low," disenfranchised, mestizo one is pertinent in considering the far-ranging implications of Lam's work.

One should note that other movements and intellectual currents specifically grounded in American culture had earlier complemented and perhaps influenced Surrealist thought in this matter. Since the late teens Frida Kahlo, Diego Rivera, and the artists of the Mexican Muralist movement had sought inspiration from indigenous Aztec culture. This stance was no mere flaunting of accepted Eurocentric bourgeois conventions. After the 1917 revolution this reclaiming of Mexican heritage was an expression of solidarity with the masses as well as a reaction against the positivism of 20th-century industrial technological culture.[10] Like the Surrealists the leaders of the Mexican revolution were convinced of the genius of the intuitive and they celebrated the art of the child, the peasant, and

Pre-Columbian ancestors. Michael Newman has noted that "This 'indigeneity' must be distinguished from the more generalized 'primitivism' of European and U.S. avant-garde art movements where it is supposed that tribal cultures have access to deeper currents of feeling or a collective unconscious. In 'indigeneity' there is a distinctly nationalistic component, a product of 19th-century romantic nationalism."[11] This nationalistic aspect was expressed in the reclamation and incorporation of Incan culture in Uruguay by the artist Joaquín Torres-García, who combined the ideographic system of this culture with the formal composition he learned in Europe and the United States to forge a personal pictorial statement that speaks of modernity as well as indigeneity.[12]

But this struggle to reach into national roots was not unique to the Latin countries of the Americas. In the United States artists had been seeking a modernist statement that was grounded in American culture. There was a decidedly anti-European nuance in this exercise, engendered by popular hostility to the Armory Show of 1913. Thomas Hart Benton's regionalist definition of suitable subject matter and style is the best-known manifestation. There is also the essay written in 1921 by Marsden Hartley in which he urged his readers to find inspiration for a truly American culture in that of the native American in the United States.[13] This particular idea came to fruition in the 1940s when American artists of the burgeoning Abstract Expressionist school were seeking totemic surrogates for old Greco-Roman models in their search for an innovative art. Adolph Gottlieb's dream-inspired pictographs based on Jungian archetypal interpretations mirror those of Torres-García.

Lam began to develop the formal vocabulary evident in *The Jungle* during the late 1930s, after he had been in Europe for over 14 years. Like any aspiring colonial "artist," Lam sought training in the imperial center, which for him was Madrid. His experience in the 1920s and 1930s was marked by a familiar progression: academic training, rebellion with a dissident group, and an encounter with Cubism which caused the first transformation. In the late 1930s he finally went to Paris, where he first contacted Picasso, who in turn introduced him to the Surrealists.

Although the critical evaluation of Lam's work has always been complicated by the close relationship perceived between his art and that of Picasso,[14] it was the association with the Surrealists that brought about the awakening of primordial memories of his childhood and youth in Cuba, which then fed directly into his art, resulting in the work of the early 1940s. The drawings that Lam did for André Breton's wartime publication *Fata Morgana* first indicate the results of his association.[15] Elements that may be ascribed to the "exquisite corpse" exercises of the Surrealists can be found in these richly appointed drawings whose images unfold organically like the disjointed collaborative drawings of the Surrealists. The vegetation, stars, and other heads from the main body of the drawing appear full-blown in the paintings that Lam

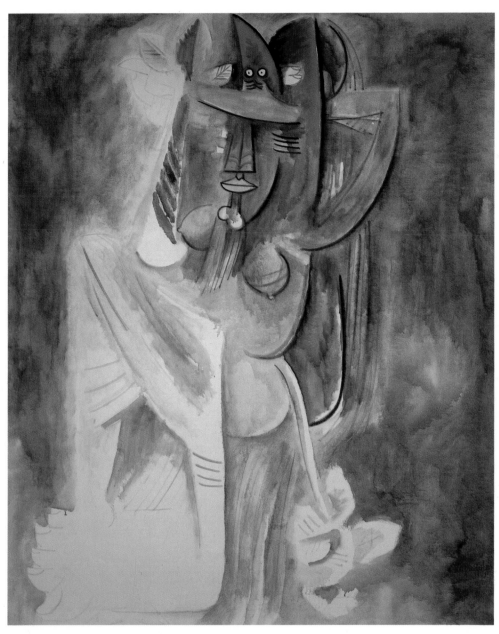

Pl. 25. Wifredo Lam, *Anamu*, 1942 (see p. 161)

completed in Cuba after he, in the company of Breton, found passage back to his homeland via Martinique. Lam's contact with the Martiniquan poet Aimé Césaire, whom Breton and Lam met while interned on Martinique in the course of their respective journeys to New York and Havana in 1941, is also crucial in illuminating the cultural politics operating here. It was the Marxist-Surrealist nexus that inspired Césaire and other Black colonials such as Leopold Senghor (later architect of the concept of "negritude"), who were students in Paris during the 1920s and 1930s, with a renewed sense of worth, and convinced them of the validity of their indigenous cultures and of the necessity of rejecting the values that had been imposed on them and their countrymen by the colonial powers. When Césaire returned to Martinique in the early 1940s, he established with his wife, Suzanne, and fellow student René Menil, the Surrealist journal *Tropiques*, which was modeled on Surrealist publications such as *Documents*, *La Révolution surréaliste*, and *Le Surréalisme au service de la révolution*. Césaire represented an anticolonialist stance by presenting ethnographic, artistic, and poetic definitions of Antillean culture. Among his collaborators were Breton and Pierre Mabille, who published one of the first extensive analyses of Lam's work.[16] This contact therefore was crucial for awakening in Lam a new sense of pride in his own heritage as an Afro-Cuban, and he did the illustrations for Césaire's epic poem *Return to a Native Country* in 1942.

Because Lam never lived in New York for any extended time, and because he was essentially a lone individual working

from his own cultural context, the nature of his interaction with the aesthetic and intellectual "soup" in New York during the early 1940s has been overlooked and never satisfactorily articulated.[17] Further study and analysis of contacts with artists at that time must be explored to elucidate this situation. But Lam's intentions paralleled those of New York artists of his generation, each of whom was working within his own special amalgam of Cubism and Surrealism toward a new and powerful pictorial statement.[18] While Lam's interpretation of the Cubist scaffold is certainly different from that of de Kooning, the appearance of strong linear elements in a coequal yet distinct relationship with color is comparable to developments in the work of Arshile Gorky (whose most pertinent relationship is with Roberto Matta). Lam's work also demonstrates a facture with similarities to those of the New York school. Even *The Jungle* of 1943 shows splashes and drips of paint in various areas that reveal the action of their application. And in a work such as *Anamu* (pl. 25), done about the same time, the delicately brushed, thinly painted background parallels Barnett Newman's subdued canvases of the late 1940s, such as *Concord* (fig. 2).

Lam's first visit to New York occurred in 1946 when he was on his way back to Europe. His work had been shown in that city in 1939 when he had his first New York exhibition at Perls Gallery, and his 1943 exhibition at the Pierre Matisse Gallery was distinguished not only by the controversy at his nonparticipation in an officially organized Cuban art exhibition held simultaneously in New York, but also by the purchase of *The Jungle* by James Johnson Sweeney for the collection of The Museum of Modern Art. Reviews of Lam's work evoking primordial references similar to those being sought by Rothko, Newman, Still, and Pollock, who were involved in "creating new counterparts to replace the old mythological hybrids who have lost their pertinence,"[19] indicate that his work was not insignificant for artists who were utilizing European models to paint their way to a uniquely American expression. Lam was one of many individuals who participated in this process. Most of the members of the Surrealist group who sought refuge in the United States during World War II had contact with various American artists, resulting in diverse painterly statements being concretized into the Abstract Expressionist school.[20] Lam and Matta occupied unique positions, as they too were American but had been to Europe and, like others (such as British-American painter Gordon Onslow Ford), were in the position of demonstrating the European avant-garde for their fellow artists back in the Americas.

Although political and economic concerns clearly were not absent from the sense of mission with which artists in New York were imbued in the 1940s, the socio-political framework for Abstract Expressionism has to date been largely avoided because of critical exigencies. Lam, however, seems to have been clear about the relationship between his aesthetic and

Fig. 2. Barnett Newman (American, 1905-1970). *Concord*, 1949. Oil and masking tape on canvas; 228.2 x 136.2 cm. The Metropolitan Museum of Art, New York, George A. Hearn Fund, 1968. Photograph Courtesy The Metropolitan Museum of Art.

thematic choices. Years later, he noted to his biographer and chronicler Max-Pol Fouchet:

> ...I decided that my painting would never be the equivalent of that pseudo-Cuban music for nightclubs. I refused to paint cha-cha-cha. I wanted with all my heart to paint the drama of my country, but by thoroughly expressing the negro spirit, the beauty of the plastic art of the Blacks. In this way I could act as a Trojan horse that would spew forth hallucinating figures with the power to surprise, to disturb the dreams of the exploiters. I knew I was running the risk of not being understood either by the man in the street or by the others. But a true picture has the power to set the imagination to work, even if it takes time.[21]

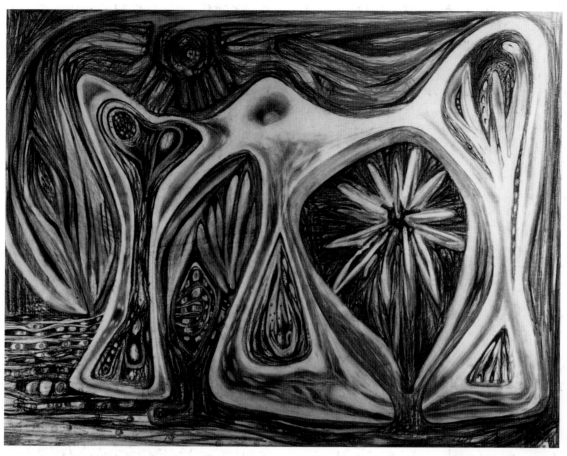

Fig. 3. Matta (Roberto Matta Echaurren) (Chilean, b. 1912). *Untitled*, 1938/39 (see p. 188).

In contrast to a Wifredo Lam, Roberto Matta must be located as within the frame of mind of a "primitivist." Eurocentric in culture, he had appreciation for the primitive rather than the natural affinity of Lam. But as we shall see, Matta's work was not immune to influences traceable to his own nationalistic sources. Whereas Wifredo Lam constructed his imagery primarily out of Cubism, Matta's primordial imagery has its roots in Salvador Dali's work of the late 1920s and Joan Miró's "field" paintings of the mid-1920s (see pl. 26). There is also a correlation with the horizonless biomorphism of Tanguy (see pl. 27), particularly in Matta's paintings of the early 1940s. Matta was initially influenced by the elegiac drawing style of André Masson, and his taut single line with its ever-changing chromatic quality has clearly been informed by automatic writing (see fig. 3). Matta's use of a type of polychrome pencil that changed color as he drew characterized his distinctive images, which are "brilliant and often fluid chromatic combinations complementing areas of atmospheric hues in which semi-formed bright minerals emerge from chaos...."[22] These compositions, which have been described as "volcanic," evoke netherworlds of chaos and creation — appropriate themes in view of the contemporary events of the Second World War.[23]

Matta also had a variety of pictorial strategies that coexisted with these references, giving his work its distinctive character. His compositions always make a very strong statement about space. This space is more than the illusionary third dimension where no earthly horizon exists, and, even more so than Tanguy's petroglyphic fantasies, the space evokes a state of mind as well as a dimensional location. This aspect is readily indicated in the recurring title that Matta gave his work in the early 1940s, the so-called "Inscape," with the additional qualification: "psychological morphology." According to William Rubin, these titles imply:

> a landscape "discovered" within the self, a morphological projection of a psychological state. The image was induced improvisationally, the landscape defining itself as the work progressed....*The Earth Is a Man* [pl. 11] is the brilliant synthesis of these amorphous landscapes.[24]

In *The Onyx of Electra* (fig. 4), Matta introduced marked perspectival elements in the space, providing what may be seen as a cogent allusion to interstellar space.

95

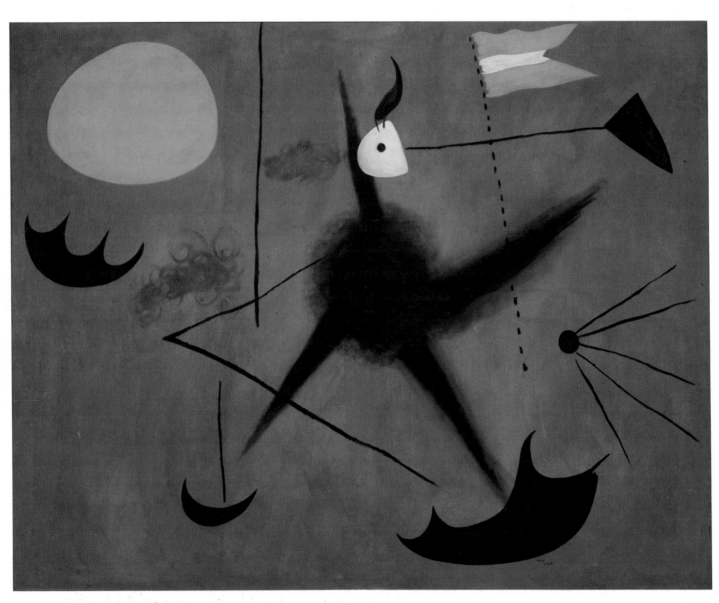

Pl. 26. Joan Miró, *Spanish Flag*, 1925 (see p. 196)

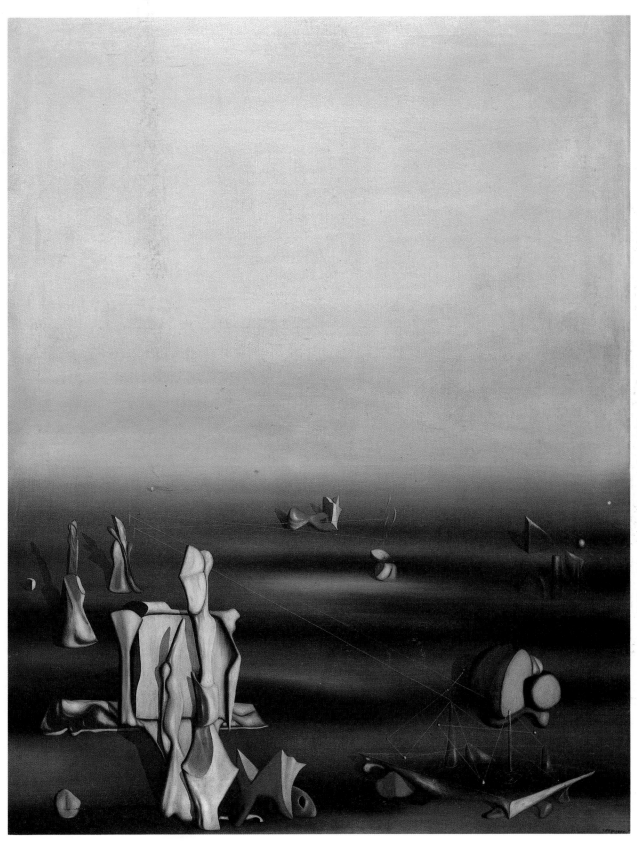

Pl. 27. Yves Tanguy, *Untitled*, 1940 (see p. 221)

Fig. 4. Matta. *The Onyx of Electra*, 1944. Oil on canvas; 127.3 x 182.9 cm. The Museum of Modern Art, New York, Gift of Mr. and Mrs. E.A. Bergman, Chicago. Photograph Courtesy The Museum of Modern Art.

Fig. 5. Matta. *A Grave Situation*, 1946. Oil on canvas; 139.7 x 195.6 cm. Museum of Contemporary Art, Chicago, Promised Gift of the Mary and Earle Ludgin Collection (PG81.15). Photograph Courtesy Museum of Contemporary Art.

As the eye tries to find its way through the penumbra, it slips into unexpected byways, is sucked into whirlpools of space, or is frustrated by opaque planes that block its passage — a symbolic drama of the mind's journey into its own unconscious.[25]

The nervous linearity that begins to appear in this work introduces one of Matta's fascinations which influenced the work of the mid-1940s: his interest in Duchamp's so-called "machinist" pictures of around 1912, particularly *The Large Glass.*

In his *The Bachelors Twenty Years After* (1943), Matta exploited the interaction between the glass space of the Duchamp work and the immediate environment in which it is seen at any given moment. This became a metaphor for Matta's interest in closing the gap between mind and space, the self and image, and as such, had many precedents in Surrealist theory. The spatial disequilibrium and the congruencies of matter, transparency, line, and space correlate with the extensive meditations on mirrored images, the eye as beholder, and mimicry and optical deception, that were painstakingly elucidated by individuals such as Roger Caillois, Pierre Mabille, and Jacques Lacan.[26] The psychosexual aspect of Duchamp's work was not lost on Matta and we will presently see the manner in which, in some of his works of the early 1940s, this was subsumed by a totemic aspect.

By 1943 Matta's wandering linear elements had coalesced to define awesome characters involved in horrific rituals. These compositions were often dominated by large masked figures. Evan Maurer pointed out that Matta did own several works of Oceanic art that resemble the face ornaments of these personages.[27] These sacrificial scenes came out of several obvious impulses. News of atrocities of the war was obviously one of the most potent. But the sacrificial aspect also refers to Pre-Columbian religious practices which were introduced to the Surrealist sphere in an article published in *Documents* by Roger Hervé.[28] This article was accompanied by illustrations from several Pre-Columbian codices showing dispositions of priests and victims that are similar to those in such compositions as *Men Made of Glass* (1944).

In other compositions, such as *A Grave Situation* (fig. 5), the central figure stands, arms outstretched, in a space where the planar dimensions have gone mad, and the whipping lines seen in *The Onyx of Electra* are accompanied by planes that seem to have been lifted out from the environment and activated so that they move within the ambience, disrupting the integrity of the spatial architectural setting.

This aspect of these works becomes interesting in view of Matta's early training as an architect in the atelier of Le Corbusier. One of the first public Surrealist statements that Matta made was a project for an apartment which appeared in the 1938 issue of *Minotaure.*[29] The Surrealist obsession with architecture was elucidated in a few instances during the 1930s: Dali published a polemic against modern architecture in *Minotaure,* as did Tristan Tzara at the end of a long article on

the unconscious psycho-sexual signaling that may be discerned in fashion.[30]

The Surrealists regarded the so-called international style of architecture as inimical to and incompatible with their concept of man's reintegrating himself with his subconscious and essential being. Therefore Matta's "inscapes" — as evocations of psychological as well as spatial realms — reflect his concept of space. The womblike sections in paintings such as *The Earth Is a Man* or *The Onyx of Electra* correlate to elements of primitive architecture in which there is a more anthropomorphic sense of space, which was particularly appreciated by the Surrealists.

The coincidences of Matta's concepts with those of Frederick Kiesler are especially pertinent to this discussion. Although not formally associated with the Surrealist movement, Kiesler was a sympathetic and kindred spirit who had been working in New York since the 1920s revolutionizing the field of store-window design as well as architecture. The focus of Kiesler's design philosophy was his concept of the "Endless House," which embodied his idea that "it was crucial to once again attain the 'primitive unity, the unity between man's creative consciousness and his daily environment.'"[31]

An early implementation of Kiesler's concept, a theater design, featured elements that would allow for continuous movement of the setting in such a way that it was coordinated with and complemented the actor's movements. Ramps were intertwined and their tilted planes activated the spatial arena. The ceiling and wall elements were movable flaps designed so that they could rotate constantly. Kiesler also laid out the space so that he could integrate the stage and seating areas to promote audience participation.[32]

As far as Kiesler was concerned, man should have remained in caves where he was able to experience a direct and personal relationship with not only space but also with his own psycho-magical creative impulse (as in cave drawings).[33] In the "Endless House" this metaphor was continued through the device of living areas that flowed from one into the next, and in the egglike form of the house where the walls and floors and ceiling were a continuous surface.

These elements of Kiesler's architecture are complementary to Matta's own design for an apartment but also provide analogous elements to the activated space of Matta's compositions of the early 1940s. Kiesler's rotating lights created patterns that are similar to the streaks and streams of light that seem to wander around the deep space of Matta's works of the early 1940s (see pl. 28). Kiesler's movable flaps resemble compositional details that can be observed in Matta paintings such as *A Grave Situation*; and the use of egglike womb shapes and the disintegration of the distinction between wall and floor, and finally the dispensing with the horizon line in Kiesler's architecture are exact parallels for the spatial character of Matta's work.

Although Le Corbusier's "purist" intentions were the antithesis of the Surrealist preoccupation with "organic"

Pl. 28. Matta, *War of Nerves*, 1940 (see p. 190)

Pl. 29. Arshile Gorky, *Carnival*, 1943 (see p. 152)

space, his interest in making man the module for architecture, and his propensity for defying design conventions with regard to the layering and organization of space and the assignment of its usage coincide with Matta's and Kiesler's ideas. Le Corbusier and Kiesler had met through Fernand Léger in the 1920s, and an interaction between the two architects has been acknowledged. An exhibition of Corbusier's collection of primitive and modern art, organized in his apartment by Louis Carré in 1935 under the rubric of a "museum without walls," does indeed indicate an anti-institutional bent that would have been appreciated by the Surrealists.[34] Here the space was broken up by partitions that moved, and the ramped areas and multilevel approach to space utilized by Le Corbusier in projects achieved during the period that Matta was apprenticed in his atelier (such as the Centre d'Esthétique Contemporain at the 1937 International Exposition in Paris) are certainly reflected in Matta's apartment project, with its split-level space through which a column passes,[35] and flexible walls that

seem able to conform to one's psychological fears. This brings full circle the discussion of Matta's "primitivistic" instinct.[36]

Wifredo Lam's relation to the New York school is elusive, but Roberto Matta has been recognized as a mentor and prime mover in the genesis of the Abstract Expressionist movement. From the time of his arrival in New York in 1939 until he returned to Europe in the late 1940s, Matta was an active and integral element in New York art society.[37] The influence of his horizonless spaces and anti-Cubist organization had a profound effect on the New York school. He is credited with revolutionizing the work of artists such as Arshile Gorky, William Baziotes, Gerome Kamrowski, Jackson Pollock, and Robert Motherwell through the exercises in automatism they engaged in together at Matta's studio in 1941.[38] His influence was particularly pronounced on Gorky in his work of the mid-1940s when the latter was still searching for his own style — one that would merge psycho-sexual aspects of Surrealism with landscape elements, and the

101

metamorphic aspects of automatism with the broad color fields of Miró, Tanguy, and Dali (see pls. 29, 30).

Both Lam and Matta are of interest for their approach to the morphology of painting. Lam's discrete splatterings and intricate juxtapositions of line and color were as germane to the formal issues of action painting as was Matta's exploitation of evocative surfaces achieved by wiping, thinning, and drawing in paint. Matta's adroit exploration of scale was also undoubtedly an important element in the transformation of the worldview of the New York artists. For the new band of "mythmakers," the monumentality of Matta's easel creations was certainly an important example, particularly for Pollock and even for Rothko and Still. Matta's evocation of Pre-Columbian and other "primitivist" mythic imagery had parallels in interpretations being explored by Gottlieb or Pollock. Such works as *Splitting the Ergo* and *Space and the Ego*, at a width of 15 feet, were only a few of the first giant canvases that virtually become standard in Matta's exhibitions from 1946 on.

In 1944 Roberto Matta created the cover design for the last issue of *VVV*, the Surrealist journal that was founded in America in 1942. Perhaps this fact is prophetic and summarizes the role that Matta and Lam played with regard to the New York school of artists. Essentially Matta and Lam may be said to have transformed Cubism and Surrealism into a new context, and, by means of this process, fulfilled and affirmed the Surrealist expectations of accommodating the coexistence of "primitive" and "civilized" worlds. In spite of their passionate admiration for and evocation of an integral world-view, the Surrealists were conscious of their ultimate lack of ability to step fully into a non-European mind-set. Even Max Ernst, who evolved the most elaborately "primitive" alter-ego, creating the alternative autobiographical personage "Loplop" (see pl. 31), who corresponded to his totemic identification with birds, was doomed to mere posturing. As Breton observed toward the end of his life:

> Unfortunately, ethnography was not able to take sufficiently great strides to reduce, despite our impatience, the distance which separates us from ancient Maya or the contemporary Aboriginal culture of Australia, because we remain largely ignorant of their aspirations and have only a very partial knowledge of their customs. The inspiration we were able to draw from their art remained ultimately

ineffective because of a lack of basic organic contact, leaving an impression of rootlessness.[39]

By the mid-1940s American artists had already been reaching beyond the psychological preoccupations of the Surrealists toward a world-view that was closely related to a specifically American archetypal tradition, and which reflected the cosmogony of the next decade. If Matta provided artists with a model for depicting a spatial arena that encompassed a state of mind as well as empirical sensibility, then the American artists would go one step beyond to create spaces that reflected the new extraterrestrial arena in which these interior and exterior, mental and physical areas, would be merged, opening up new vistas for painting. In addition, Matta's and Lam's explorations of heroic proportions in their work (seen in exhibitions in New York and Chicago in the early 1940s) provided yet another pictorial framework for artists already versed in mural-sized proportions through their employment by the WPA Federal Art Project and their contact with the Mexican muralists.

That Lam and Matta began to draw on mythic material that was not exclusively European, demonstrating an appreciation for such New World cultures as Pre-Columbian art, Amerindian philosophy, and Africa, made their work, along with that of Torres-García and Kahlo, prophecies of the increasing importance of the western and southern rims of the Atlantic basin. It is almost inevitable that American artists would gravitate toward the pictorial interests of Lam and Matta. Mark Rothko would write about "the small band of Myth Makers who have merged here during the war."[40] When he wrote about Clyfford Still, he wrote about them all:

> Bypassing the current preoccupation with genre and the nuances of formal arrangements, Still expresses the tragic-religious drama which is generic to all Myths at all times, no matter where they occur. He is creating new counterparts to replace the old mythological hybrids who have lost their pertinence in the intervening centuries.[41]

Lam and Matta indicated the way, and by the mid-1940s the Americans took up the baton, creating a new art that was unsurpassed not only in its audacity but in the grandeur and innovation of its vision. This then is the legacy of Lam and Matta and the situation of Surrealism in the New World.

Notes

1.
Hayden Herrera, *Frida: A Biography of Frida Kahlo* (New York: Harper and Row, 1983), p. 228.

2.
René Passeron, *Phaidon Encyclopedia of Surrealism*, trans. John Griffiths (New York: E.P. Dutton, 1978), p. 261.

3.
This map is reproduced in Evan Maurer, "Dada and Surrealism," in *"Primitivism" in 20th Century Art: Affinity of the Tribal and the Modern*, ed. William S. Rubin (New York: The Museum of Modern Art, 1984), II, p. 556.

4.
See M. Leiris, "L'Ile magique," *Documents* 5 (Oct. 1929), p. 334.

5.
See René Crevel, "Colonies," *Le Surréalisme au service de la révolution* 1 (July 1930), pp. 9-12; "Bobards et fariboles" also by Crevel on page 17 in number 2 (Oct. 1930) of the same periodical; and J.M. Monnerot, "A partir de quelques traits particuliers à la mentalité civilisée," on pages 35-37 in number 5 (May 1933).

6.
The psychological dimensions of the phenomenon have been treated at length in several sources; see, for example, Franz Fanon, *Black Skin, White Masks*, trans. Charles Lam Markmann (New York: Grove Press, Inc., 1967); and Albert Memmi, *The Colonizer and the Colonized*, trans. Howard Greenfield (New York: The Orion Press, 1965).

7.
Even a primary source such as Migene Gonzalez-Wippler's *Santeria: African Magic in Latin America* (New York: Anchor Books, 1975) fails to come up with a ready definition of Santeria. Essentially, it may be described as an African-American religious cult (based in Cuba) which is the result of a unique synthesis of various African belief systems and Catholicism. The word "santeria" is derived from the Spanish *santo* (saint), and the African name is "Lucumi" from the Yoruba *akumi*. Like Voudun in Haiti and Candombel in Brazil, Santeria consists of ritual ceremonies of song and dance which coincide with births, initiations into the religion, marriage, illness, death, and burial. Specific gods and goddesses — who have been identified with complementary Catholic saints — are associated with these various aspects of life, and they communicate with supplicants and devotees through dreams of possession. Possession and trance are integral parts of these ceremonies, and the aspect of these rituals that would have most interested the Surrealists. While in exile in the Americas in the 1940s, André Breton visited Haiti in the company of Wifredo Lam. There they attended several Voudun ceremonies.

8.
André Breton was very aware of the special relationship between Lam and Picasso, which he clearly elucidated in his essay on Lam in *Le Surréalisme et la peinture...* (New York: Brentano's, Inc., 1945).

9.
Roger Bastide, *The African Religions: Towards a Sociology of Interpenetrations of Civilizations*, trans. Helen Sebba (Baltimore: The Johns Hopkins Press, 1978), pp. 95-96.

10.
Michael Newman, "The Ribbon Around the Bomb," *Art in America* 71, 4 (Apr. 1983), p. 169.

11.
Ibid., p. 164.

12.
See Daniel Robbins, *Torres-García* (Providence: Museum of Art, Rhode Island School of Design, 1974).

13.
Marsden Hartley, "The Red Man," *Adventures in the Arts* (New York: Boni and Liveright, 1921), pp. 13-29.

14.
"Picassolamming," *Art Digest* 17 (Dec. 1, 1942), p. 7.

15.
André Breton, *Fata Morgana*, ill. Wifredo Lam (San Martin: Editions des Lettres Françaises, 1942).

16.
Pierre Mabille, "La Jungle," *Tropiques* 12 (Jan. 1945), pp. 173-86.

17.
Lam was one of three American artists (along with Robert Motherwell and Adolph Gottlieb) mentioned in a summer summation of the New York gallery scene by an unidentified reporter in *Newsweek*: "Wifredo Lam, 43, who has been called Picasso's only pupil, fills his canvases with strange winged creatures and voodoo gods which suggest rather than represent the mysteries of the jungles in his native Cuba" ("A Way to Kill Space," *Newsweek* 28 [Aug. 12, 1946], p. 108).

18.
Robert C. Hobbs and Gail Levin, *Abstract Expressionism: The Formative Years* (Ithaca, NY: Herbert F. Johnson Museum of Art, Cornell University, in Association with the Whitney Museum of American Art, New York, 1978), p. 18.

19.
Irving Sandler, *The Triumph of American Painting: A History of Abstract Expressionism* (New York: Praeger Publishers, 1970), p. 67.

20.
See Dore Ashton, *The New York School: A Cultural Reckoning* (New York: Viking Press, 1983); Barbara Rose, *American Art Since 1900: A Critical History* (New York: Frederick A. Praeger, 1967); William S. Rubin, *Dada, Surrealism, and Their Heritage* (New York: The Museum of Modern Art, 1968); Sandler (note 19); and Sidney Simon, "Concerning the Beginnings of the New York School: 1939-1943," *Art International* 11 (Summer 1967), pp. 17-23.

21.
Max-Pol Fouchet, *Wifredo Lam* (Barcelona: Ediciones Poligrafa, S.A., 1976), pp. 188-89.

22.
Nicolas Calas, *Matta: A Totemic World* (New York: Andrew Crispo Gallery, 1975), p. 1.

23.
Ibid., p. 2.

24.
Rubin (note 20), p. 166.

25.
Ibid., p. 169.

26.
See Roger Caillois, "Mimétisme et psychasthénie légendaire," *Minotaure* 7 (1935), pp. 5-10; Jacques Lacan, "Le Problème du style," *Minotaure* 1 (1933), pp. 68-69; and Pierre Mabille, "Miroirs," *Minotaure* 11 (1938), pp. 14-18.

27.
Maurer (note 3), pp. 577-78.

28.
Roger Hervé, "Sacrifices humains du Centre-Amérique," *Documents* 4 (1930), pp. 205-13.

29.
[Roberto] Matta Echaurren, "Mathématique sensible — architecture du temps," *Minotaure* 11 (1938), p. 43.

30.
Salvador Dali, "De La Beauté terrifiante et comestible, de l'architecture Modern Style," *Minotaure* 3-4 (1933), pp. 68-76; and Tristan Tzara, "D'Un Certain Automatisme du goût," *Minotaure* 1, 3-4 (1933), pp. 81-85.

31.
Cynthia Goodman, "Frederick Kiesler: Designs for Peggy Guggenheim's Art of This Century Gallery," *Arts Magazine* 51 (June 1977), p. 92.

32.
Ibid., p. 95.

33.
Ibid., p. 92.

34.
Le Corbusier and P. Jeanneret, *Oeuvre complète, 1934-1938* (Zurich: Editions Dr. H. Girsberger, 1939), p. 157.

35.
Ibid., p. 153.

36.
See F. Adama van Scheltema, "Le Centre feminin sacré," *Documents* 7 (1930), pp. 337-82.

37.
Simon (note 20).

38.
Dawn Ades, *Dada and Surrealism Reviewed* (London: Arts Council of Great Britain, 1978), p. 388. See also Simon (note 20).

39.
André Breton in Maurer (note 3), p. 584.

40.
Sandler (note 19), p. 67.

41.
Ibid.

Pl. 30. Arshile Gorky, *Scent of Apricots in the Fields*, 1944 (see p. 152)

Pl. 31. Max Ernst, *Loplop Introduces*, 1932 (see p. 146)

Pl. 32. André Breton, Man Ray, Max Morise, and Yves Tanguy, *Exquisite Corpse*, 1928 (see p. 228)

Acknowledgments

Chicago has been identified many times over with Surrealism — as a stronghold of collecting classic European works, and as a city that has given rise to a regional style with a Surrealist flavor. Offered as a truism, this was the starting point for the concept of this exhibition: to discover if and how Chicago had a special place in the field of Surrealism, and what impact this has had on the cultural life of the city. "Dada and Surrealism in Chicago Collections," while always planned as a major exhibition, became an even more extensive project as we found the number of Surrealist collectors and appropriate works to be far greater than even general knowledge in the community would have it. While spanning the years 1915 to 1966 with the work of over 50 artists, the exhibition, because it was based on Chicago connoisseurship, is not an historical survey of the period along academic lines; for instance, Duchamp is excluded except for his published works, while Surrealists of the 1940s to 1950s, like Matta and Lam, are seen in great number. Yet, the 400 works in the exhibition are a remarkably complete review.

The work of many enabled us to realize the full potential of this important exhibition. First of all, I would like to express my deepest thanks to Dennis Alan Nawrocki, associate curator for research and collection and coorganizer of this exhibition, for his exhaustive efforts in searching out works for the show and his assistance at every step of the way; his dedication has allowed us to accomplish an ambitious program of study and to mount this extensive exhibition. I would also like to acknowledge the assistance during the research phase of the following individuals: Dennis Adrian, Frances Beatty, Richard Born, Anselmo Carini, Alan Cohen, Richard Feigen, Allan Frumkin, Suzanne Ghez, Susan Glover Godlewski, Richard Gray, B.C. Holland, Katharine Kuh, Anne Rorimer, Patricia Scheidt, Esther Sparks, David Sylvester, David B. Travis, and Sarah Whitfield. Special thanks also go to Joseph and Jory Shapiro and to Edwin and Lindy Bergman who offered not only insight into their collecting and love of Surrealism, but also into the Chicago scene; their contributions served immeasurably to guide and inspire us as we moved forward through the various phases of this project.

This publication is intended to serve as a testament to and reference for Chicago's Surrealist heritage. Here again Mr. Nawrocki's scholarship has contributed greatly to the catalogue of the exhibition and his annotations in this section should be of particular interest to the reader. Many others have also been important to the production of this book. We are grateful to the authors whose research was first presented in the format of public talks during the exhibition, and then published here. Terry Ann R. Neff played a major role as planner of the Museum's adjunct symposium and lecture series and as editor of the publication. It was designed by Michael Glass, who with his staff, Anthony Porto and Mark Signorio, has given to the written and visual material an appropriate and handsome format that is an enhancement to the information contained within. We would also like to thank Nancy Grubb of Abbeville Press who helped to make the collaborative publication of this major book possible.

The efforts of others at the Museum of Contemporary Art were essential to the research and execution of this exhibition. Jacqueline Small worked for months patiently cataloguing works, checking sources and references, and typing much of the voluminous preliminary information compiled. Robert M. Tilendis, executive secretary, as proof reader and typist, also played a major role in finalizing this manuscript; while Mary Anne Wolff, curatorial secretary, assisted with the utmost efficiency as tasks relating to this exhibition mounted in the months preceding its opening. Lynne Warren, associate curator of exhibitions, was of great assistance with the exhibition's complex installation, which was executed through the tireless dedication and sense of perfection demonstrated by the Museum's crew under the supervision of Geoffrey Grove and Ian Edwards with the assistance of Dennis O'Shea. Careful coordination of all loans, from 56 lenders, was expertly arranged and supervised by Debi Purden, registrar, and carried out by her and Lela Hersh, assistant registrar, and Museum Interns Connie Arismendi and Ann Bundy.

In addition, Steven Correll, Brigid Finucane, Rebecca Frankel, Andrew Ignarski, Charlotte Moser, Elizabeth Newman, Carrie Przybilla, Bonnie Rubenstein, and Fan

Warren, Museum interns and volunteers, all assisted in various phases of the project, and their help is gratefully acknowledged. Other members of the Museum staff also played important parts in bringing about this major exhibition in the planning over the last two years; for their continued support and effort I would like to thank Russell Willis Barnes, Phil Berkman, Nancy Cook, Chris DerDerian, Helen Dunbeck, Naomi Vine, Alice Piron, Charlie Scheips, Ronna Issacs, and Larry Thall.

The Museum of Contemporary Art could not have undertaken such a major effort had it not been for the encouragement and interest of Helyn D. Goldenberg, president, and the Museum's Board of Trustees; and William J. Hokin, chairman, and the other members of the Exhibition Committee.

Finally, it is to the owners of these works — the collectors themselves (see p. 108) — that we must offer our most sincere gratitude for collaborating with us to make this exhibition of "Dada and Surrealism in Chicago Collections" and this book, *In the Mind's Eye: Dada and Surrealism,* an in-depth review of this, the most important area of Chicago connoisseurship in modern art.

Mary Jane Jacob, *Chief Curator*

Lenders to the Exhibition

Alice Adam
The Art Institute of Chicago
The Arts Club of Chicago
Mr. and Mrs. E.A. Bergman
Robert H. Bergman
Cambridge Associates Collection
Douglas and Carol Cohen
Paolo Colombo
Arnold H. Crane
Mr. and Mrs. Thomas H. Dittmer
Stefan T. Edlis
Dr. and Mrs. Philip Falk
Lillian H. Florsheim Foundation for Fine Arts
Marshall Frankel
Mr. and Mrs. Stanley M. Freehling
Mr. and Mrs. Maurice Fulton
Dr. and Mrs. Martin L. Gecht
Mrs. Oscar L. Gerber
Mr. and Mrs. Bertrand Goldberg
Richard and Mary L. Gray
Mrs. Eugene Grosman
Irving B. and Joan W. Harris
Dr. and Mrs. Jerome H. Hirschmann
William J. Hokin
Ruth Horwich
Mrs. Harvey Kaplan
Renée Logan

Mrs. Henry A. Markus
Mrs. Robert B. Mayer
Morton G. Neumann Family Collection
Mr. and Mrs. Kenneth Newberger
Dr. and Mrs. Edward A. Newman
Muriel Kallis Newman
Mr. and Mrs. Marshall Padorr
Mr. and Mrs. Henry D. Paschen
Drs. William and Martha Heineman Pieper
The Ratner Family Collection
Mr. and Mrs. Albert Robin
Mr. and Mrs. David C. Ruttenberg,
 Courtesy of the Ruttenberg Arts Foundation
The Sandor Family Collection
Katharine S. Schamberg
Donn Shapiro
Joseph and Jory Shapiro
Mr. and Mrs. Leo S. Singer
Victor Skrebneski
The David and Alfred Smart Gallery,
 The University of Chicago
Dr. Eugene A. Solow
Dr. Paul and Dorie Sternberg
Mrs. Harold E. Strauss
Mr. and Mrs. Howard A. Weiss
Claire Zeisler
and other private collectors

Catalogue of the Exhibition

"Dada and Surrealism in Chicago Collections"

Museum of Contemporary Art, Chicago

Manuel Alvarez Bravo
Mexican, b. 1902

Manuel Alvarez Bravo
Optic Parable, 1931
Silver gelatin print
24.8 x 18.7 cm
Mr. and Mrs David C. Ruttenberg,
Courtesy of the Ruttenberg Arts
Foundation

Manuel Alvarez Bravo
Riding Equipment, 1931
Silver gelatin print
19.1 x 18.7 cm
The Art Institute of Chicago,
The Julien Levy Collection, Gift of
Jean and Julien Levy

Manuel Alvarez Bravo
Skins of Pulque, n.d.
Silver gelatin print
15.9 x 23.9 cm
The Art Institute of Chicago,
The Julien Levy Collection, Gift of
Jean and Julien Levy

Jean (Hans) Arp
French, 1886-1966

Jean (Hans) Arp
Automatic Drawing, 1918
Ink on paper
33 x 25.4 cm
Morton G. Neumann Family Collection

Jean (Hans) Arp
Calligraphy of Navels, 1928
Painted wood relief
29.9 x 38.8 cm
Morton G. Neumann Family Collection

In 1925 I exhibited at the first Surrealist group show and contributed to their magazines. They encouraged me to ferret out the dream, the idea behind my plastic work, and to give it a name. For many years, roughly from the end of 1919 to 1931, I interpreted most of my works. Often the interpretation was more important for me than the work itself. Often it was hard to render the content in rational words.
— Jean Arp, 1958

Jean (Hans) Arp

Jean (Hans) Arp
Constellation of White Forms on Gray, 1929
Painted wood relief
59.7 x 74.9 cm
Morton G. Neumann Family Collection

Jean (Hans) Arp
Constellation of Black Forms on Gray, 1937
Painted wood relief
80 x 60.3 cm
Mr. and Mrs. E.A. Bergman

Jean (Hans) Arp
Constellation of Yellow Forms on Green Background, 1933
Painted wood relief
54.5 x 55.5 cm
Mrs. Harold E. Straus

Jean (Hans) Arp
Untitled, 1942
Collage
35.3 x 28.6 cm
Mr. and Mrs. Bertrand Goldberg

Jean (Hans) Arp
Constellation, 1955
Paper collage
49.5 x 31.8 cm
Mrs. Eugene M. Grosman

Jean (Hans) Arp
Constellation, 1956
Painted wood relief
69.2 x 66.7 cm
Lillian H. Florsheim Foundation
for Fine Arts

113

Jean (Hans) Arp

Eugène Atget
French, 1857-1927

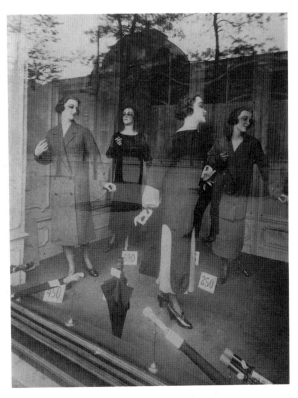

Jean (Hans) Arp
Concretion on Oval Base (Nativity of the Saurian), 1957
Bronze
H. 62.9 cm
Irving B. and Joan W. Harris

We don't want to copy nature. We don't want
to reproduce, we want to produce. We want
to produce like a plant that produces a fruit,
and not reproduce. We want to produce
directly and not by way of any intermediary.
Since this art doesn't have the slightest trace
of abstraction, we name it a concrete art.
— Jean Arp, 1944

Eugène Atget
Avenue des Gobelines/82, n.d.
Gelatin printing-out paper print from dry-
plate negative
22.5 x 17.8 cm
The Art Institute of Chicago,
The Julien Levy Collection, Gift of
Jean and Julien Levy

Jean (Hans) Arp
Quitting the System of Ladders (Quittant
l'Echelonnement), 1959
Painted wood relief
104.8 x 85.1 cm
Katharine S. Schamberg

Herbert Bayer
Self-Portrait, 1900
Silver gelatin print
34.3 x 24.8 cm
Drs. William and Martha Heineman
Pieper

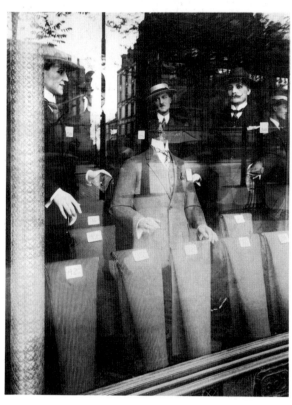

Eugène Atget
Avenue des Gobelines/85, n.d.
Gelatin printing-out paper print from dry-
plate negative
22.5 x 17.8 cm
The Art Institute of Chicago,
The Julien Levy Collection, Gift of
Jean and Julien Levy

Late 19th-century photographer Eugène
Atget was claimed by the Surrealists, who
published his photographs in their
periodical *La Révolution surréaliste* (three
in June and one in December 1926).

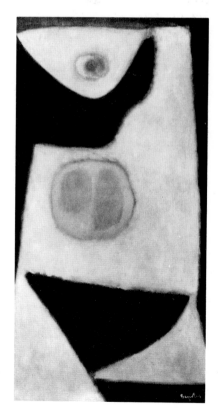

William Baziotes
The Sleepwalker, 1949
101.6 x 56.2 cm
Museum of Contemporary Art, Promised
Gift of the Mary and Earle Ludgin
Collection (PG81.5)

William Baziotes

Hans Bellmer
German, 1902-1975

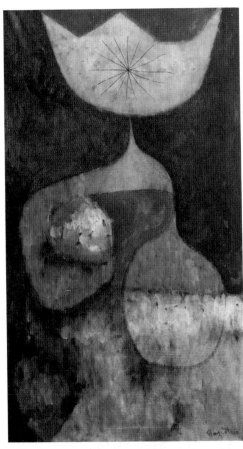

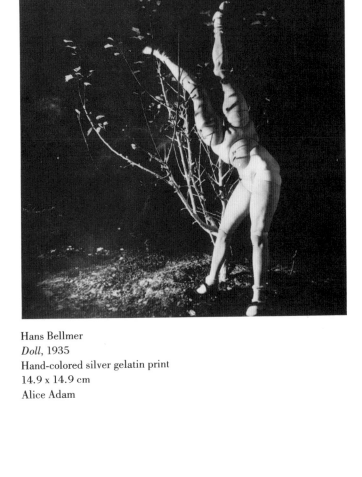

Hans Bellmer
Doll, 1935
Hand-colored silver gelatin print
14.9 x 14.9 cm
Alice Adam

William Baziotes
Cat, 1950
Oil on canvas
101.9 x 55.9 cm
Museum of Contemporary Art, Promised
Gift of Joseph and Jory Shapiro (PG83.9)

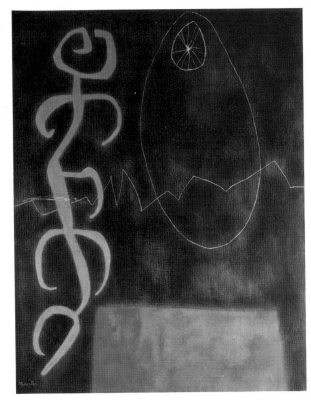

William Baziotes
The Specter, 1953
Oil on canvas
88.8 x 61 cm
Mr. and Mrs. Marshall Padorr

There is always a subject in my mind that
is more important than anything else.
Sometimes I am aware of it, sometimes not.
I keep working on my canvas until I think
it is finished. The subject matter may be
revealed to me in the middle of the work, or
I may not recognize it until a long time
afterward.
— William Baziotes, 1944

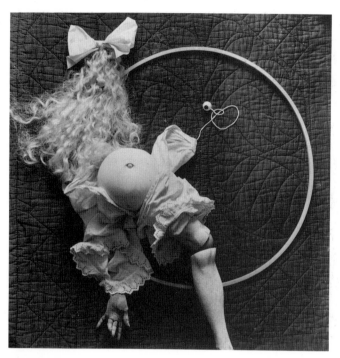

Hans Bellmer
Doll, 1935
Silver gelatin print
14 x 13.3 cm
Mr. and Mrs. David C. Ruttenberg,
Courtesy of the Ruttenberg Arts
Foundation

I shall construct an artificial girl whose
anatomy will make it possible physically to
re-create the dizzy heights of passion and to
do so to the extent of inventing new desires.
— Hans Bellmer, date unknown

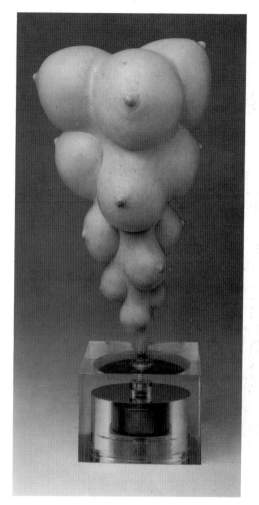

Hans Bellmer
The Top, 1938
Painted bronze
H. 33 cm
Joseph and Jory Shapiro

Bellmer's obsession with female anatomy
reaches a kind of apogee here in a revolving
sculpture of a cluster of breasts. These
endless and multiplying breasts evoke
fertility fetishes or even an organic
emanation exhaled from an invisible
source. The title, however, rather
perversely refers to a children's toy that
has been metamorphosed into an erotic
plaything. Bellmer's sculptures are
relatively rare, for after 1940, he devoted
most of his creative energies to drawing
and painting.

Hans Bellmer
Doll, c. 1935
Silver gelatin print
23.8 x 23.8 cm
Alice Adam

Hans Bellmer
Child and Seeing Hands, 1950
Ink and watercolor on paper
29.2 x 24.1 cm
Joseph and Jory Shapiro
Reproduced p. 119.

Hans Bellmer
Untitled (Hands), 1951
Pencil on paper
34.3 x 25.4 cm
Mr. and Mrs. E.A. Bergman

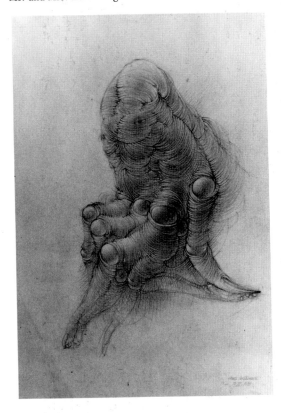

Hans Bellmer
The Top, 1956
Gouache on board
65 x 65 cm
The Ratner Family Collection

Hans Bellmer
Untitled, 1964
Pencil on paper
55.9 x 48.3 cm
The Ratner Family Collection

Pl. 33. Hans Bellmer, *Child and Seeing Hands*, 1950 (see p. 118)

Brassaï (Gyula Halász)
French, b. Hungary, 1899-1984

Brassaï (Gyula Halász)
The Temptation of Saint Anthony (from
Transmutations), 1934-35/67
Cliché-verre print
17.8 x 23.8 cm
The Art Institute of Chicago, Gift of Mr.
and Mrs. Gaylord Donnelley and Mr. and
Mrs. Ralph J. Mills

Brassaï (Gyula Halász)
Odalisque (from *Transmutations*),
1934-35/67
Cliché-verre print
23.8 x 17.8 cm
The Art Institute of Chicago, Gift of Mr.
and Mrs. Gaylord Donnelley and Mr. and
Mrs. Ralph J. Mills

*The engravings collected in this album were
done in 1934-35. What impulse did I obey,
what temptation overcame me, when I seized
several glass plates to engrave them?
Respectful of the image printed by the sun,
hostile to any "intervention," had I, in spite
of myself, come under the influence of the
Surrealists I was seeing so frequently at that
time? Who knows?...Nevertheless, that
which attracted me in this adventure was
not the process itself, but the possibility to
introduce something indefinable to me
which belongs only to photography....
Photography became the raw material, the
point of departure for the mutations and
transmutations and which then had nothing
more to do with it....*
— Brassaï, 1967

Brassaï (Gyula Halász)
Woman-Amphora (from *Transmutations*),
1934-35/67
Cliché-verre print
23.8 x 17.8 cm
The Art Institute of Chicago, Gift of Mr.
and Mrs. Gaylord Donnelley and Mr. and
Mrs. Ralph J. Mills

Victor Brauner
Romanian, 1903-1966

Victor Brauner
Christopher Columbus, 1938
Oil on canvas
50.2 x 65.1 cm
Mr. and Mrs. Albert Robin

Isn't the dream to have an apparatus that automatically and economically provides the means to think without great effort, all of the time? This apparatus exists, and it is "the tandem-hat to incubate ideas in the tandem-egg."...The tandem-hat is basically comprised of an interior reservoir of two joined eggs and an exterior covering, hats of different forms also joined by a tandem bar.
— Victor Brauner, 1938

Victor Brauner
Turning Point of Thirst, 1934
Oil on canvas with painted frame
50.8 x 59 cm
Claire Zeisler
Reproduced p. 122.

Representing this personage in withered tatters expresses unremitting solitude and should pound the senses.
— Victor Brauner, 1959

Victor Brauner
Gemini, 1938
Oil on canvas
45.7 x 54.3 cm
Mr. and Mrs. Albert Robin
Reproduced p. 123.

Victor Brauner
The Object That Dreams II, 1938
Oil on canvas
80.6 x 65.1 cm
Museum of Contemporary Art, Promised Gift of Joseph and Jory Shapiro (PG83.10)

A daydream in honor of Woman, shown as a moving flame—Life. The frog is a mutation of the great humid depths, which gives to mortal existence the immortality of thought; thus, in her turn, Woman becomes the great initiator.
— Victor Brauner, 1959

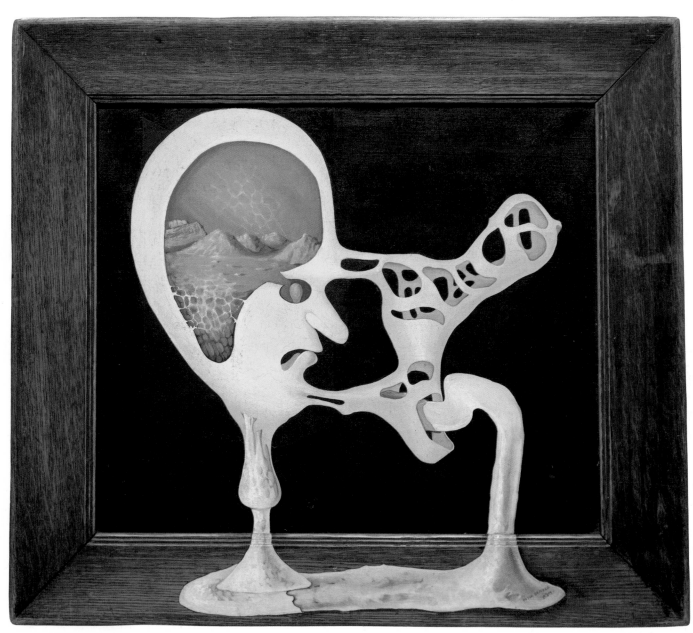

Pl. 34. Victor Brauner, *Turning Point of Thirst*, 1934 (see p. 121)

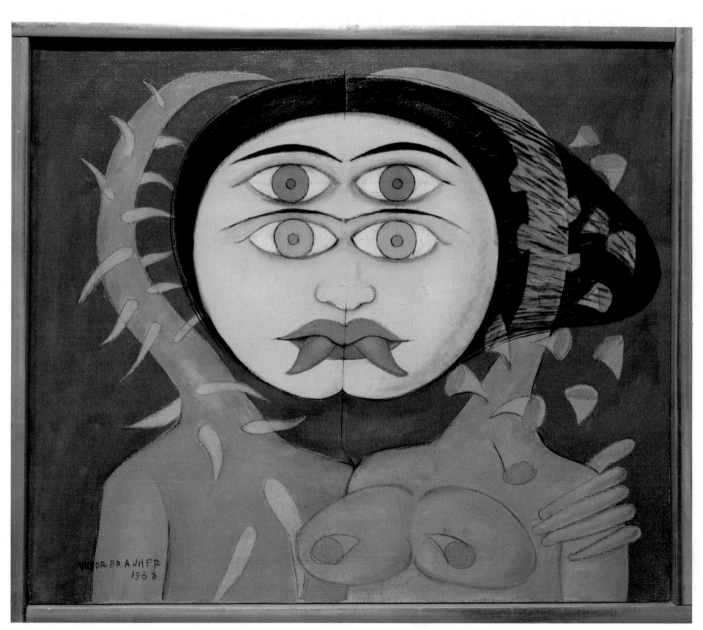

Pl. 35. Victor Brauner, *Gemini*, 1938 (see p. 121)

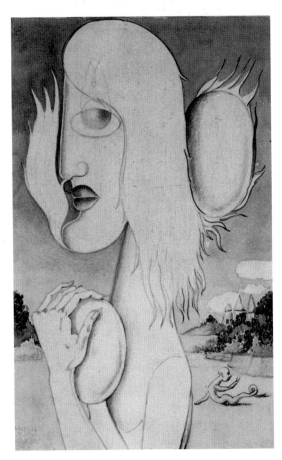

Victor Brauner
Air-bel, 1941
Ink and watercolor on paper
22.9 x 14.6 cm
Joseph and Jory Shapiro

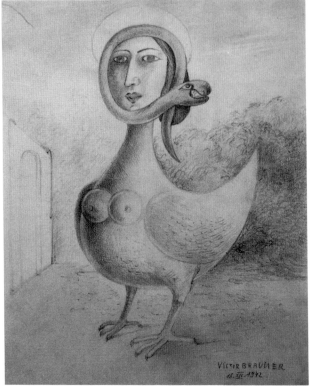

Victor Brauner
Chicken, Female, and Serpent, 1942
Pencil on paper
25.7 x 21 cm
Joseph and Jory Shapiro

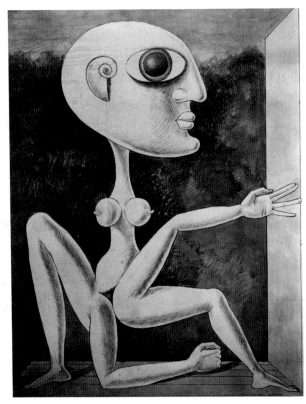

Victor Brauner
Drawing for Monumental Sculpture, 1943
Ink on paper
61.6 x 48.9 cm
Victor Skrebneski

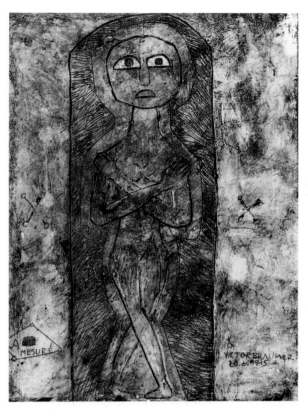

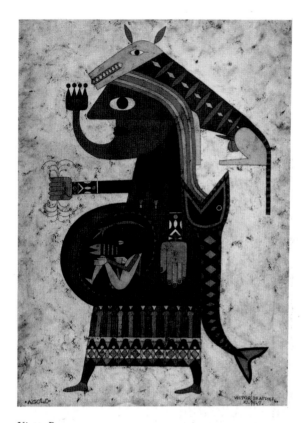

Victor Brauner
The Measure, 1945
Encaustic on board
64.8 x 50.8 cm
Joseph and Jory Shapiro

Victor Brauner
Agolo, 1949
Encaustic on paper
74.6 x 54.6 cm
Mr. and Mrs. E.A. Bergman

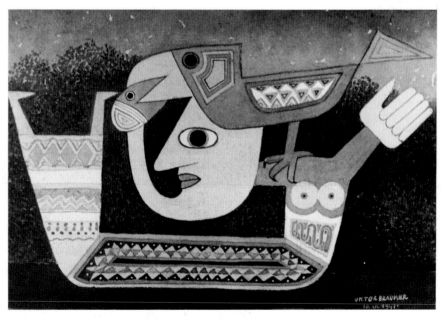

Victor Brauner
Reclining Figure with Crow, 1947
Watercolor on paper
17.8 x 26.7 cm
Joseph and Jory Shapiro

Victor Brauner

André Breton
French, 1896-1966

André Breton
For Jacqueline, 1937
Mixed media in wood frame
39.4 x 30.5 x 3.8 cm
Mr. and Mrs. E.A. Bergman
Reproduced p. 22.

Breton, who first exhibited his "object-poems" in 1929, described them as "compositions which combine the resources of poetry and plastic art, and thus speculate on the capacity of these two elements to excite each other mutually." *For Jacqueline* is dedicated to Jacqueline Lamba, Breton's wife at that time.

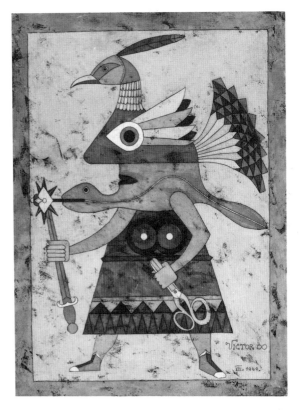

Victor Brauner
The Knight, 1949
Encaustic on board
79.4 x 58.4 cm
Joseph and Jory Shapiro

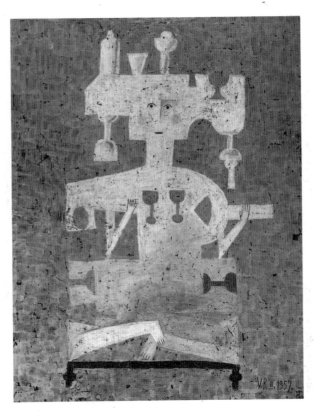

Victor Brauner
Metasign, 1958
Encaustic on board
55.2 x 75.6 cm
Ruth Horwich

Victor Brauner
The Feast, 1957
Encaustic on board
90.2 x 72.4 cm
Donn Shapiro

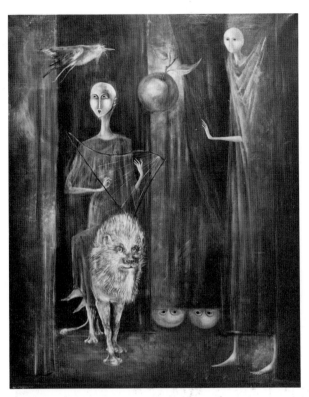

Leonora Carrington
Peek-a-Boo, 1961
Oil on canvas
99.1 x 81.3 cm
Dr. Eugene A. Solow

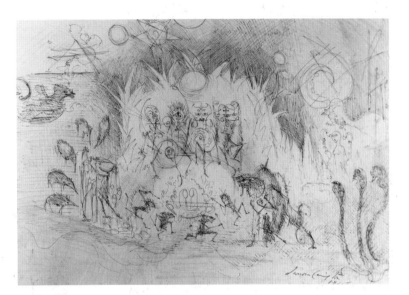

Leonora Carrington
Mundo Magico de los Mayas (Magical World of the Mayas), 1965
Pencil on paper
33 x 45.7 cm
Dr. Eugene A. Solow

Joseph Cornell
Monsieur Claude, 1930s
Collage
12.2 x 14.4 cm
Mr. and Mrs. E.A. Bergman

In 1931 Cornell, one of the first American artists to be influenced by Surrealism, began to make collages, inspired by Ernst's collage novel, *The 100 Headless Woman* (created 1927; published 1929). Here, in the characteristic Surrealist mode of improbable juxtaposition, an unperturbed Monsieur Claude, riding in a conventional railroad car, seems blissfully unaware of the unlikely and peculiar accouterments of his surroundings.

Joseph Cornell

Joseph Cornell
La Bourboule, c. 1933
Construction
36.2 x 31 x 5.9 cm
Mr. and Mrs. E.A. Bergman
Reproduced p. 16.

Joseph Cornell
Lobster Ballet, 1943
Construction
26.7 x 45.8 x 15.2 cm
Mr. and Mrs. E.A. Bergman

Joseph Cornell
Soap Bubble Set, 1939
Construction
35.6 x 22.9 x 6.4 cm
Mr. and Mrs. E.A. Bergman

Shadow boxes become poetic theatres or settings wherein are metamorphosed the elements of childhood pastime. The fragile, shimmering globules become the shimmering but more enduring planets — a connotation of moon and tides — the association of water less subtle, as when driftwood pieces make up a proscenium to set off the dazzling white of sea-foam and billowy cloud crystallized in a pipe of fancy.
— Joseph Cornell, 1948

Joseph Cornell
Untitled (Cork or *Varia Box)*, 1943
Construction
6.3 x 43.5 x 26.4 cm
Mr. and Mrs. E.A. Bergman

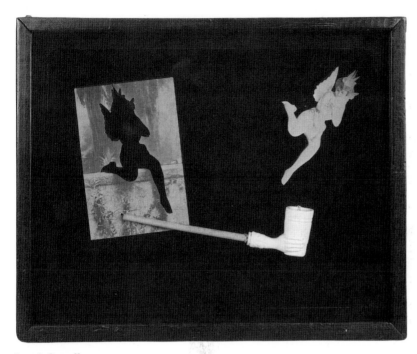

Joseph Cornell
Untitled, 1945
Construction
27 x 33.3 x 5.1 cm
Mr. and Mrs. E.A. Bergman

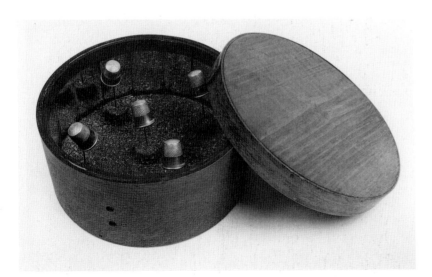

Joseph Cornell
Beehive (Thimble Forest), 1948
Construction
H. 9.4; dia. 19.5 cm
Mr. and Mrs. E.A. Bergman

Into a world of looking-glasses where one
feels like Alice shrunk to the size of an
insect.
— Joseph Cornell, 1948

Joseph Cornell
Rose Castle (Pink Castle), c. 1948
Construction
25.7 x 41 x 14 cm
Mr. and Mrs. E.A. Bergman
Reproduced p. 16.

Joseph Cornell
The Caliph of Bagdad, c. 1954
Construction
52 x 33.7 x 11.4 cm
Mr. and Mrs. E.A. Bergman

The sap of Surrealism rises, too, from the
great roots of dreamlife to nourish the
paintings of Richard Oelze and Paul
Delvaux, the constructions of Hans Bellmer
and Joseph Cornell.... At the extreme limits
of stereoptic and anaglyphic perspective and
of stereotyped vision, Cornell has evolved
an experiment that completely reverses the
conventional usage to which objects are
put.
— André Breton, 1942

Joseph Cornell
Mica Magritte, 1963
Postcard and collage mounted on panel
27.9 x 21 cm
The Art Institute of Chicago, Gift of Mr.
and Mrs. Edwin A. Bergman in memory of
Joseph Cornell

Joseph Cornell
Le Petite Fumeuse de chocolat, c. 1965
Collage
29.2 x 22.9 cm
Mr. and Mrs. E.A. Bergman

Joseph Cornell
Spoken to Sister Angel, n.d.
Collage with coins
30.2 x 22.9 cm
Mr. and Mrs. E.A. Bergman

Pl. 36. Salvador Dali, *A Chemist Lifting with Extreme Precaution the Cuticle of a Grand Piano*, 1936 (see p. 132)

Salvador Dali
Spanish, b. 1904

Salvador Dali
The Red Tower, 1930
Pastel on paper
64.8 x 50.2 cm
Mr. and Mrs. E.A. Bergman
Reproduced p. 26.

One of the objectives of the Surrealists was
to acknowledge frankly the presence and
force of sexuality. The blatant phallic
imagery of *The Red Tower* is one instance
of the erotic symbolism that often informs
the works of the Surrealists. The tower itself
recalls the frequent presence of similar
structures in the metaphysical paintings of
de Chirico, the early canvases of Tanguy,
and some of Man Ray's sculpture.

Salvador Dali
*A Chemist Lifting with Extreme Precaution
the Cuticle of a Grand Piano*, 1936
Oil on canvas
50.2 x 65.1 cm
Joseph and Jory Shapiro
Reproduced p. 131.

The "chemist" as protagonist appears in
several of Dali's paintings in 1936. Attired
in a three-piece suit, he is typically shown
with head bent down, absorbed in exploring
or examining something — or nothing at
all. In fact, he is the ridiculous academic
who seems blind to the panorama around
him, so engrossed is he in his own pursuits.
Here he is shown examining a soft piano
as if to discover the secret of the universe,
while those around him go on with their
everyday affairs. The seated figure in the
center foreground is a portrait of the
composer Richard Wagner.

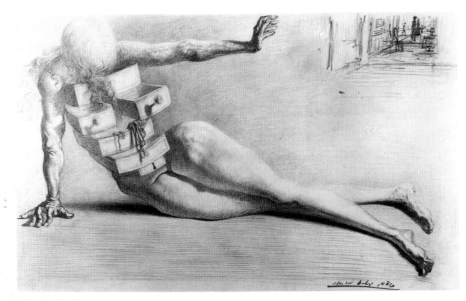

Salvador Dali
City of Drawers, 1936
Pencil on paper
26.5 x 43.5 cm
The Art Institute of Chicago, Gift of Frank
B. Hubachek

*My sole pictorial ambition is to materialize
by means of the most imperialist rage of
precision the images of concrete
irrationality.*
— Salvador Dali, 1935

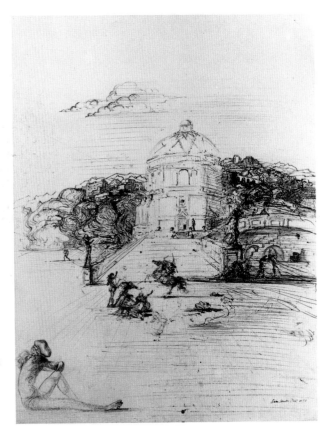

Salvador Dali
*Untitled (Self-Portrait Hidden in a
Landscape)*, 1936
Ink on paper
54.6 x 44.5 cm
Joseph and Jory Shapiro

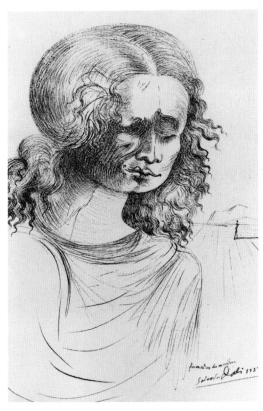

Salvador Dali
Formation of Monsters, 1937
Ink on paper
24.1 x 15.9 cm
Mr. and Mrs. E.A. Bergman

Salvador Dali
Vision of Eternity, 1936/37
Oil on canvas
208.3 x 118.1 cm
Joseph and Jory Shapiro

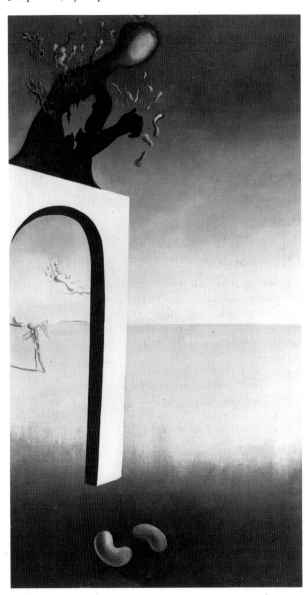

Salvador Dali
*Imaginary Portrait of Lautréamont at Age
19 Obtained by the Paranoic-Critical
Method*, 1937
Pencil on paper
48.3 x 34.3 cm
Mr. and Mrs. E.A. Bergman

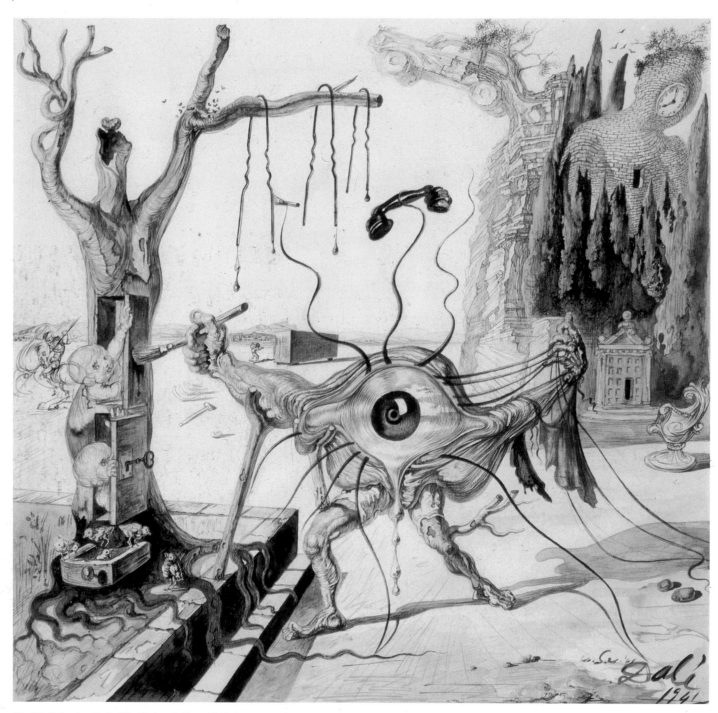

Pl. 37. Salvador Dali, *The Painter's Eye*, 1941 (see p. 135)

Salvador Dali
The Image Disappears (Self-Portrait),
1938
Ink on paper
64.7 x 50.8 cm
Mr. and Mrs. E.A. Bergman

Salvador Dali
The Painter's Eye, 1941
Watercolor and ink on paper
25.4 x 26.7 cm
Joseph and Jory Shapiro
Reproduced p. 134.

The eye is one of the pervasive images of
Surrealism, a symbol not only of retinal
vision but also of penetrating insight. Here
Dali presented the artist (and himself) as a
cyclopean eye surveying a universe of
fantastic diversity.

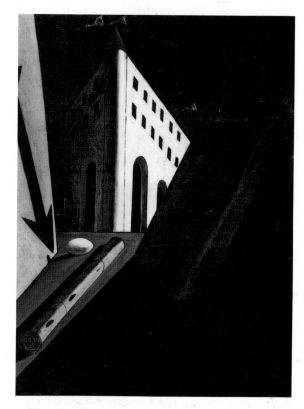

Giorgio de Chirico
Holiday, 1914
Oil on canvas
77.5 x 60.3 cm
Morton G. Neumann Family Collection

Salvador Dali
Three Points of Eze Village, 1938
Gouache, ink, and photograph on paper
26 x 23.5 cm
Mrs. Oscar L. Gerber

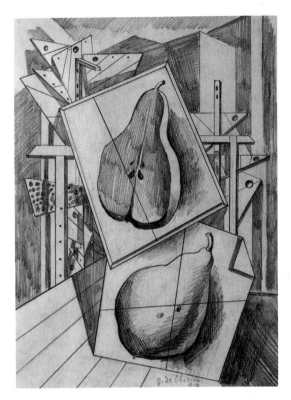

Giorgio de Chirico
Autumnal Still Life, 1917
Pencil on paper
30.1 x 22.2 cm
The Art Institute of Chicago, William
McCallin McKee Fund

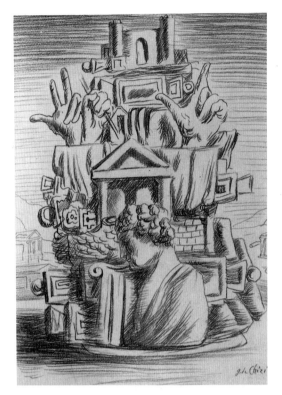

Giorgio de Chirico
Untitled (Figure Among the Ruins),
1925/26
Pencil on paper
32.4 x 25.4 cm
Mr. and Mrs. E.A. Bergman

Giorgio de Chirico
Le Mystère laïc (The Lay Mystery), 1928
Book with text by Jean Cocteau, illustrated
by de Chirico
19.7 x 14.9 cm
Paolo Colombo

Giorgio de Chirico
Hebdomeros, 1929
Book with text and illustrations
by de Chirico
19.7 x 17.5 cm
Paolo Colombo

Giorgio de Chirico

Paul Delvaux
Belgian, b. 1897

Paul Delvaux
Nude Among the Ruins, 1937
Ink and watercolor on paper
46.4 x 62.9 cm
Joseph and Jory Shapiro

Giorgio de Chirico
Mechanical, n.d.
Oil on canvas
62.2 x 49.5 cm
Mrs. Harvey Kaplan

*He is actually the first painter to have
thought of making painting speak of
something other than painting.*
— René Magritte, 1959

Giorgio de Chirico
Piazza d'Italia, n.d.
Oil on canvas
69.8 x 92.7 cm
Mrs. Robert B. Mayer

Paul Delvaux
Water Nymphs (The Sirens), 1937
Oil on canvas
102.9 x 120 cm
Joseph and Jory Shapiro

Paul Delvaux
Echo, 1943
Oil on canvas
105.4 x 129.5 cm
Marshall Frankel
Reproduced p. 139.

Like his fellow Belgian Magritte, Delvaux
employed a meticulous, detailed technique
to depict impossible occurrences. Here the
Surrealist love of confounding expectations
is readily apparent in the representation of
echoing female nudes diminishing in size
as a substitution for repetitive, ebbing
sounds.

Paul Delvaux
Penelope, 1945
Oil on board
121.9 x 121.9 cm
Joseph and Jory Shapiro
Reproduced p. 8.

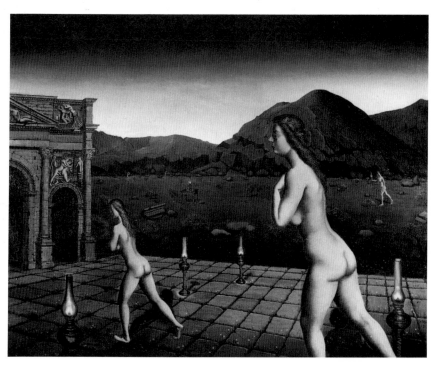

Paul Delvaux
Women with Lamps, 1937
Oil on canvas
102.9 x 129.5 cm
Mr. and Mrs. E.A. Bergman

Pl. 38. Paul Delvaux, *Echo*, 1943 (see p. 138)

Paul Delvaux

Oscar Dominguez
Spanish, 1906-1958

Marcel Duchamp
American, b. France, 1887-1968

Paul Delvaux
The Elysian Fields, 1966
Ink and watercolor on paper
62.5 x 100.3 cm
Joseph and Jory Shapiro

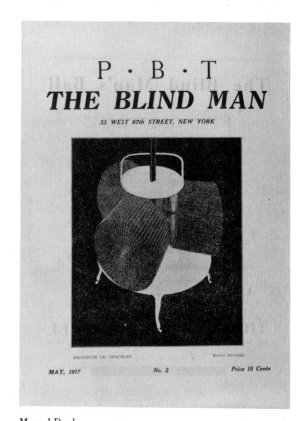

Marcel Duchamp
The Blind Man, 1917
Booklet edited by Duchamp
27.9 x 20.6 cm
Arnold H. Crane

Oscar Dominguez
Untitled, 1938
Oil on canvas
50.3 x 73 cm
Museum of Contemporary Art, Promised
Gift of Joseph and Jory Shapiro (PG83.19)

Marcel Duchamp
Boîte-en-valise (Box in a Suitcase), 1941
Sixty-eight reproductions in cardboard box
Closed: 8.9 x 37.8 x 38.8 cm
Museum of Contemporary Art, Gift of Mr.
and Mrs. E.A. Bergman (79.18)

Boîte-en-valise, filled with reproductions
of Duchamp's own art, is a portable
museum. When it is open, the illustrations
provide a miniature retrospective of
Duchamp's revolutionary career. Duchamp
was first of all a painter, most notably of
the famous *Nude Descending a Staircase*
(1912); then a Dada provocateur who
designated selected, mass-produced,
utilitarian objects as works of art — dubbed
"readymades"; and later, in the 1930s, a
friend and mentor of the Surrealists.

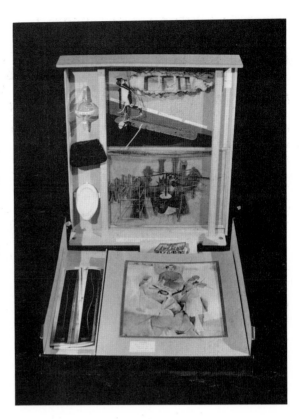

Marcel Duchamp
New York Dada, 1921/69
Broadsheet edited by Duchamp and Man
Ray, altered by Man Ray
36.5 x 25.4 cm
Arnold H. Crane

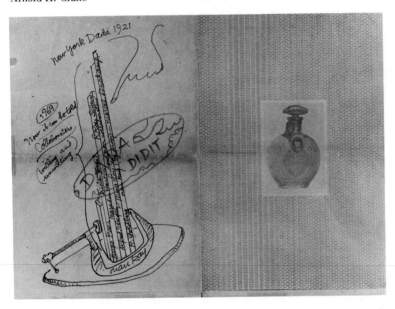

Marcel Duchamp
Prière de Toucher (Please Touch), 1947
Book cover by Duchamp and Enrico Donati
for *Le Surréalisme en 1947*; foam rubber,
paint, and velvet on paperboard
24.8 x 21.3 cm
Arnold H. Crane

*Historically, this is how it happened. Marcel
Duchamp had been requested by André
Breton to make the cover for the Paris
Maeght exhibition* Thirty Years of
Surrealism, *and came to see me. He wanted
to reproduce a breast on the cover. He
presented me with a plaster model and gave
me the problem of how to make 1,000
reproductions.*

*I went to work on the subject, and I found
that if we took a foam rubber "falsie" we
could flatten it out and paste it on
cardboard. So I went ahead molding over
1,000 pieces. However, the breast looked
too naked when pasted on the cover of the
book, so I cut out a piece of black velvet and
made it appear as if it was protruding from
a dress. Marcel Duchamp and I colored,
one by one, the 1,000 and more nipples in
my studio. Then I added "Prière de
Toucher."*
— Enrico Donati, 1983

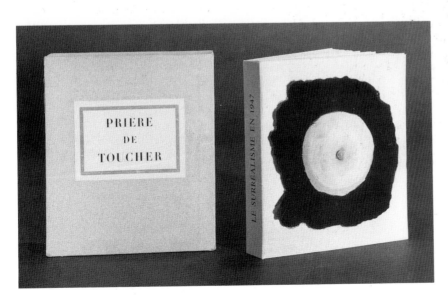

Max Ernst
German-French, 1891-1976

Max Ernst
Self-Constructed Small Machine, 1919
Printer's proof altered with ink
46.7 x 31.4 cm
Mr. and Mrs. E.A. Bergman

As Max Ernst noted facetiously in German
and French at the bottom of the sheet, this
image is a "little machine constructed by
himself where he mixes the ocean salad
the sperm of iron the bitter perisperm on
one side we see the development from the
other the anatomy this costs 2 *sous* more."

Max Ernst
Dada Gauguin, 1920
Gouache and paper collage on cardboard
27.9 x 40 cm
Mr. and Mrs. Maurice Fulton
Reproduced p. 27.

In *Dada Gauguin*, human figures appear
to be growing within or emerging from the
interiors of seed forms. In a landscape rife
with exotic, germinating vegetation,
Gauguin is invoked as the symbol of
sensuality and escape from repressive
tradition. A work entitled *Dada Degas*
dates from the same year.

Max Ernst
The Massacre of the Innocents, 1920
Photomontage, watercolor, ink, and pastel
on paper
21.3 x 28.9 cm
Mr. and Mrs. E.A. Bergman
Reproduced p. 27.

Max Ernst
Trophy Hypertrophied, 1919
Printer's proof altered with ink
36.5 x 24.5 cm
Morton G. Neumann Family Collection

Max Ernst
The Planet Sheds Its Leaves, 1925
Pencil frottage on paper
22.2 x 16.5 cm
Private Collection

According to Ernst, the invention of
frottage (literally, "rubbing," from *frotter*,
"to rub") occurred rather unexpectedly:
"On the tenth of August, 1925... finding
myself one rainy evening in a seaside inn,
I was struck by the obsession that showed
to my excited gaze the floorboards upon
which a thousand scrubbings had deepened
the grooves.... I made from the boards a
series of drawings by placing on them, at
random, sheets of paper which I undertook
to rub with black lead.... My curiosity
awakened and astonished, I began to
experiment indifferently... with all sorts of
materials to be found in my visual field:
leaves and their veins, the ragged edges of
a bit of linen, the brushstrokes of a 'modern'
painting, the unwound thread from a spool,
etc."

Max Ernst
Landscape with Sun, c. 1926
Oil on canvas
60.3 x 49.5 cm
Claire Zeisler

Max Ernst
*Marceline et Marie (d'une seule voix): "Il
me semble que le ciel descend dans mon
coeur..."* (Marceline and Marie [of one
voice]: "It seems to me the sky is falling into
my heart...") (from *A Little Girl Dreams of
Taking the Veil*), 1929/30
Collaged engravings on paper
22.9 x 14.6 cm
Mr. and Mrs. E. A. Bergman

Max Ernst

Max Ernst
Les Naufragés en choeur: "Et le jour n'existe nulle part." (The chorus of the shipwrecked: "And the day doesn't exist at all.") (from A Little Girl Dreams of Taking the Veil),
1929/30
Collaged engravings on paper
22.2 x 17.8 cm
Joseph and Jory Shapiro

Max Ernst
Loplop Introducing a Bird, 1929/57
Plaster, oil, and wood
102.2 x 123.2 cm
Museum of Contemporary Art, Promised
Gift of Joseph and Jory Shapiro (PG83.17)

*You want to know a little family secret? It's
the kind a brewmaster passes on to his son
in the business. Everybody always wants to
know who and what Loplop is and they write
marvelous stories about him. Well, when
you were still much too small to sit on one
without help, some idiot gave you a present
of a wooden rocking horse instead of buying
one of my paintings. It was a dreadful bore
to hold you on it and to sing to you:
"Gallopp... gallopp... gallopp." You loved
your Loplop. I hated it. You'd wake up
during the night and scream that you
wanted your Loplop. When I made up that
creature-device as the presenter of smaller
things in a larger composition, Paul Eluard
said it needed a name and I remembered
your damned Loplop. Never mind that mine
was more of a bird than a horse. Whenever
I was asked, I told them all kinds of stories
— but never that it was your Schaukelpferd.
I guess I had too much fun to see how much
of a myth they could invent themselves. Yes,
Loplop is your rocking horse.*
— Max Ernst to Jimmy Ernst, *A Not-So-
Still Life,* 1984

Max Ernst
*Pie XI: "La calvitie vous guette, mon enfant!
Au premier coup de feu vos cheveaux
s'envoleront avec vos dents et vos ongles.
Tout cela ne doit servir qu'à ma très invisible
parure." (Pius XI: "Baldness awaits you,
my child. At the first shot your hair will fly
away with your teeth and your nails. That
serves only my very invisible vestments.")
(from A Little Girl Dreams of Taking the
Veil),* 1929/30
Collaged engravings on paper
25.4 x 12.7 cm
Joseph and Jory Shapiro

Max Ernst
Mr. Knife Miss Fork, 1931
Book with text by René Crevel, illustrated
by Ernst
18.4 x 12.7 cm
Arnold H. Crane

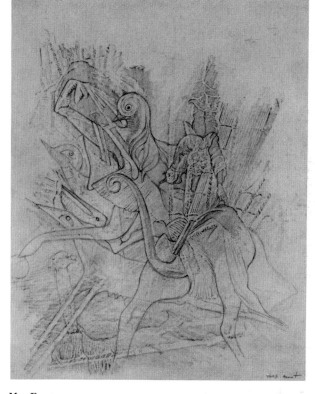

Max Ernst
Stallion, 1931
Pencil frottage on paper
30.5 x 25.4 cm
Joseph and Jory Shapiro

Max Ernst
Caresse Crosby, 1932
Gouache and pencil on wood
22.9 x 19 cm
Mr. and Mrs. Marshall Padorr

Through their Black Sun Press, Caresse
and Harry Crosby helped to bring the art
and literature of the Surrealists to public
attention. Notable among these
publications were Julien Levy's *Surrealism*
(1936), and *Mr. Knife Miss Fork* (1931) by
René Crevel, with illustrations by Max
Ernst.

Max Ernst
Loplop Introduces, 1932
Pasted paper, color engraving, and pencil
on paper
61.6 x 47.6 cm
Mr. and Mrs. E. A. Bergman

Max Ernst
*Mobile Object Recommended for Family
Use*, 1936/70
Wood and flax
H. 101 cm
Douglas and Carol Cohen

Max Ernst
Loplop Introduces, 1932
Pencil, crayon, paint, marbleized paper,
and photograph and frottage pasted on
paper
49.2 x 64.8 cm
Mr. and Mrs. E. A. Bergman
Reproduced p. 104.

Loplop became Ernst's alter ego in
numerous works in different media; he
frequently presents or introduces pictures
within pictures.

Max Ernst
Garden Airplane Trap, 1935
Oil on canvas
122.9 x 71.4 cm
Mr. and Mrs. E. A. Bergman
Reproduced p. 64.

Ernst painted several similar depictions of
this subject, which he described as
"voracious gardens devoured by a
vegetation springing from the debris of
trapped airplanes."

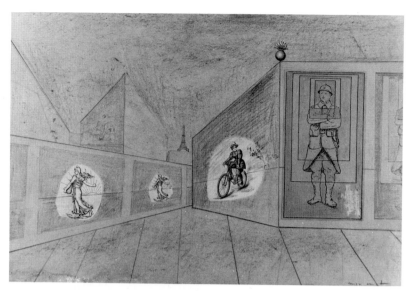

Max Ernst
How We Are in France (from *Ubu enchaîné*),
1937
Collaged engravings, crayon, and pencil
on paper
24.1 x 35.2 cm
Joseph and Jory Shapiro

Max Ernst
Spanish Physician, 1940
Oil on canvas
38.1 x 54.9 cm
Joseph and Jory Shapiro
Reproduced p. 11.

Ernst was interned twice by the Germans
in France during 1940. Nonetheless, he
managed to paint several canvases before
immigrating to the United States in 1941.
In *Spanish Physician*, the course of events
appears irrational: at the right, a screaming
young woman in a torn dress flees from the
"Spanish Physician." The physician and
an enormous beast, symbolically linked
by an identical covering of thick, shaggy
hair, stand strangely immobile and
uninterested. Perhaps prompted by the
brutal, dictatorial regime of Francisco
Franco, the painting is also an exposé of
the corruption of those trained to succor
humankind.

Max Ernst
La Sclavonie (from *Ubu enchaîné*), 1937
Collaged engravings, crayon, and pencil
on paper
24.1 x 33.3 cm
Joseph and Jory Shapiro

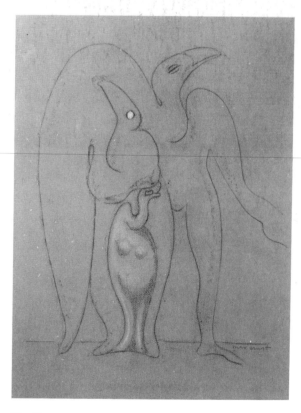

Max Ernst
Study for "Surrealism and Painting,"
1942
Crayon and pastel on colored paper
45 x 34.9 cm
Mr. and Mrs. E. A. Bergman

Max Ernst

Max Ernst
The King Playing with the Queen,
1944/54
Bronze
H. 99 cm
Joseph and Jory Shapiro

Max Ernst
Moonmad, 1944/56
Bronze
H. 93.3 cm
Mr. and Mrs. E.A. Bergman

Max Ernst
Young Man with Beating Heart, 1944/56
Bronze
H. 64.8 cm
Victor Skrebneski

Max Ernst
An Anxious Friend, 1944/57
Bronze
H. 67.3 cm
Mr. and Mrs. E.A. Bergman

We drove out to Great River [Long Island,
New York], *a drive of about two and one-
half hours. Max had become completely
diverted from painting. He was making a
chess set and a large sculpture he called* The
King Playing with the Queen.... *Max had
taken over the garage as a studio and there
he poured his plaster of Paris into ingenious
molds. His molds were of the most startling
simplicity and originality — shapes found
among old tools in the garage plus utensils
from the kitchen.... One evening he picked
up a spoon from the table, sat looking at it
with that abstracted, distant sharpness one
finds in the eyes of poets, artists, and
aviators. He carefully carried it to his
garage. It would be the mold for the mouth
of his sculpture,* An Anxious Friend.
— Julien Levy, *Memoir of an
 Art Gallery*, 1977

Max Ernst
Red Owl, 1951/52
Oil on canvas
106.7 x 122 cm
Joseph and Jory Shapiro

Max Ernst
Solar Heads, 1953
Oil on canvas
116.2 x 81.3 cm
Mr. and Mrs. Thomas H. Dittmer

Max Ernst
Study for "A Tissue of Lies," 1958
Oil on board
27.3 x 21.3 cm
Mr. and Mrs. Henry D. Paschen

Max Ernst
Venus Seen from the Earth, 1962
Oil on canvas
44.5 x 36.8 cm
Mr. and Mrs. Henry D. Paschen

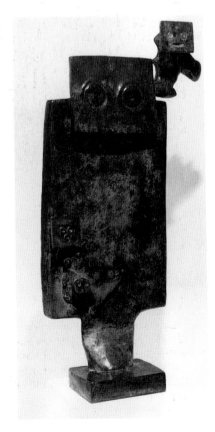

Max Ernst
In the Streets of Athens, 1960
Bronze
H. 98.1 cm
Mr. and Mrs. Henry D. Paschen

Estéban Francès
Spanish, 1914-1976

Arshile Gorky (Vosdanig Manoog Adoian)
American, b. Armenia, 1904-1948

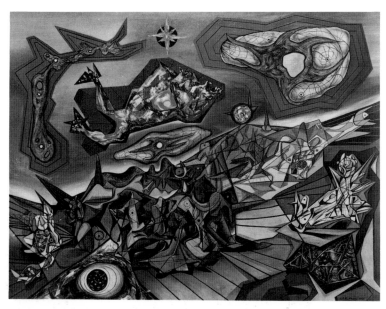

Estéban Francès
Untitled, 1943
Oil on canvas
78.1 x 102.9 cm
Mr. and Mrs. Henry D. Paschen

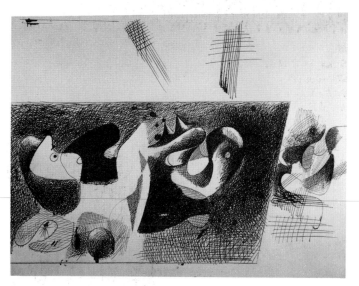

Arshile Gorky (Vosdanig Manoog Adoian)
Nighttime, Enigma, and Nostalgia,
c. 1931/32
Ink on paper
48.3 x 63.5 cm
Dr. and Mrs. Martin L. Gecht

This drawing is one of a score of similarly titled works, many of them executed in 1931 and 1932. For the most part, these variations on a theme delineate a cluster of erotic organic forms grouped on a flat surface in the foreground. The title recalls the evocative titles de Chirico employed for some of his metaphysical paintings of 1912-19.

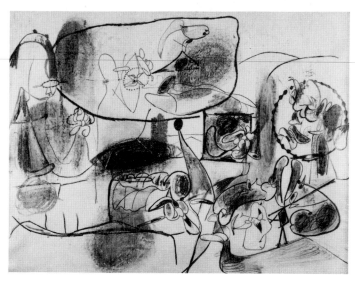

Arshile Gorky (Vosdanig Manoog Adoian)
Virginia Landscape, 1943
Pencil and crayon on paper
43.2 x 55.9 cm
Muriel Kallis Newman

Arshile Gorky (Vosdanig Manoog Adoian)

George Grosz
German, 1893-1959

Arshile Gorky (Vosdanig Manoog Adoian)
Carnival, 1943
Pencil, oil, and crayon on paper
57.2 x 73.3 cm
Mr. and Mrs. E. A. Bergman
Reproduced p. 101.

Arshile Gorky (Vosdanig Manoog Adoian)
Scent of Apricots on the Fields, 1944
Oil on canvas
78.7 x 111.8 cm
Joseph and Jory Shapiro
Reproduced p. 104.

Gorky was the last major artist André
Breton invited to join the Surrealists.
Writing about his work in 1945, Breton
declared: "Gorky is, of all the Surrealist
artists, the only one who maintains direct
contact with nature — sits down to paint
before her."

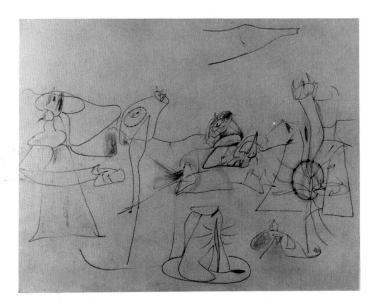

Arshile Gorky (Vosdanig Manoog Adoian)
Untitled, 1947
Charcoal and crayon on paper
47.6 x 60.3 cm
Joseph and Jory Shapiro

Arshile Gorky (Vosdanig Manoog Adoian)
Study for "The Betrothal," 1945/46
Ink, oil, and crayon on brown paper
70.5 x 35.6 cm
Mr. and Mrs. E. A. Bergman

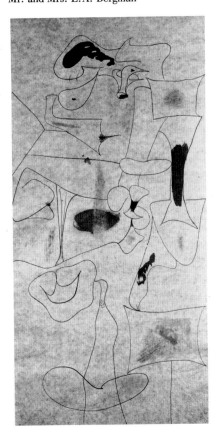

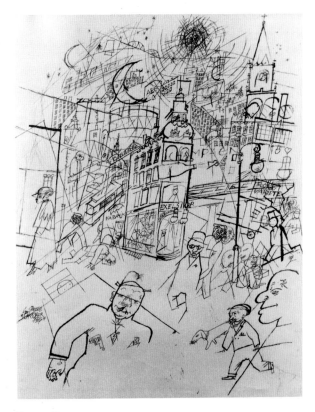

George Grosz
Street Scene, 1916
Ink on paper
76.2 x 63.5 cm
Mr. and Mrs. Stanley M. Freehling

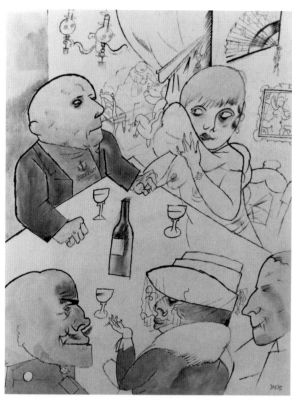

George Grosz
Café Neptun, 1919
Ink, watercolor, and pencil on paper
50 x 33.8 cm
The Art Institute of Chicago, Olivia Shaler
Swan Fund

George Grosz
Self-Portrait with Vincent van Gogh,
c.1956
Collage on cardboard
18.5 x 17.2 cm
Alice Adam

George Grosz
Construction 22: Amalie, 1922
Gouache, ink, and graphite on paper
52.7 x 41.3 cm
The David and Alfred Smart Gallery, The
University of Chicago, The Joel Starrels,
Jr. Memorial Collection

Amalie is one of a series of costume
sketches Grosz executed for Yvan Goll's
Methusalem, a play that pits Methusalem,
the perpetual bourgeois, against Student,
the revolutionary. Grosz's costume design
for Amalie, Methusalem's wife, envisions
a mechanical woman constructed from
diverse utilitarian elements, who rolls
swiftly and efficiently like a locomotive
from place to place. Unfortunately, the
proposed designs were never realized.

John Heartfield
German, 1891-1968

Hannah Höch
German, 1889-1978

Georges Hugnet
French, 1906-1974

Georges Hugnet
Untitled, c. 1934
Paper collage
13 x 11.1 cm
Drs. William and Martha Heineman
Pieper
Reproduced p. 42.

Georges Hugnet
Untitled (Undeceived Words), 1936
Collaged newspaper and magazine
clippings on paper
32 x 24.5 cm
The Art Institute of Chicago, Gift of Frank
B. Hubachek and Department Purchase
Funds

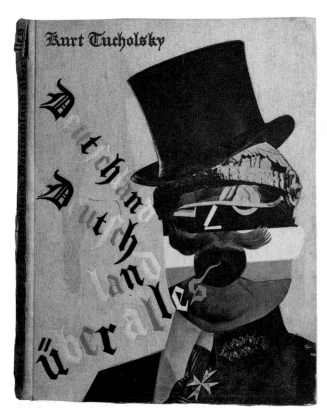

John Heartfield
Deutschland, Deutschland über Alles, 1929
Book with text by Kurt Tucholsky, cover
design by Heartfield
24.1 x 19.4 cm
Arnold H. Crane

Hannah Höch
Collage, 1920
Collaged magazine and newspaper
clippings on paper
34.9 x 29.9 cm
Morton G. Neumann Family Collection

Marcel Jean
French, b. 1900

György Kepes
American, b. Hungary, 1906

Marcel Jean
Tree-Woman, 1935
Ink on paper
29.2 x 21 cm
Morton G. Neumann Family Collection

György Kepes
Julia with One Peacock-Feather Eye, 1938
Silver gelatin print
22.2 x 16.2 cm
Drs. William and Martha Heineman
Pieper

Marcel Jean
The Specter of the Gardenia, 1936/72
Plaster, flocking, zippers, filmstrip, and
staple on plaster head with leather and
wood base
H. 36 cm
Morton G. Neumann Family Collection
Reproduced p. 13.

The Specter of the Gardenia was first shown
at the "Exposition Surréaliste d'objets" in
Paris in 1936. Later, writing in *Cahiers
d'Art* about the significance of the
exhibition, Jean asserted that "However
unpretentious is the part that man assigns
to 'useful' objects of his creation, they
participate intimately in his life and
possess a double meaning: all have a latent
sexual content besides their practical role,
and our dreams, with the greatest sureness,
do not fail to endow them with the values
we unconsciously gave them when they
were created during the waking state...."

Marcel Jean
The Horoscope, 1937
Painted dressmaker's dummy
H. 71.1 cm
Morton G. Neumann Family Collection

155

György Kepes

André Kertész
American, b. Hungary, 1894

András Kertész
Distortion #41, 1933
Silver gelatin print
17.5 x 23.8 cm
Private Collection, Courtesy Edwynn Houk
Gallery

György Kepes
Eyes, 1941
Silver gelatin print
22.2 x 16.2 cm
Drs. William and Martha Heineman
Pieper

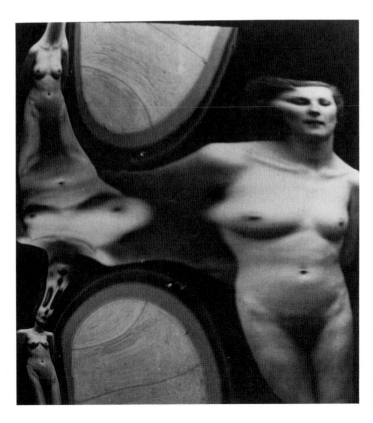

André Kertész
Distortion #86, 1933
Silver gelatin print
17.8 x 16.2 cm
Private Collection, Courtesy Edwynn Houk
Gallery

André Kertész **Edmund Kesting** **Paul Klee**
 German, 1892-1970 Swiss, 1879-1940

André Kertész
Distortion #141, 1933
Silver gelatin print
24.5 x 26 cm
The Sandor Family Collection

Distortions consists of a series of over 100
photographs taken in 1933. Kertész used
funhouse mirrors to create dreamlike
"distortions" of the female nude at once
erotic and surreal.

Paul Klee
Death in the Garden (Legend), 1919
Oil on canvas mounted on board
27 x 25.1 cm
Joseph and Jory Shapiro

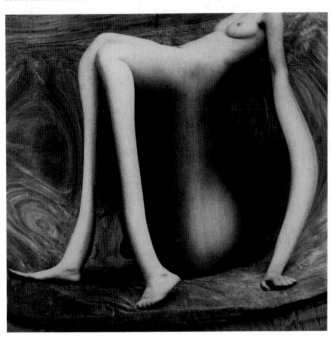

Edmund Kesting
Self-Portrait, 1954
Silver gelatin print
29.8 x 23.8 cm
Drs. William and Martha Heineman
Pieper

157

Paul Klee
Dance with Violins, Cymbals, and Oboe,
1929
Watercolor on paper mounted on paper
30.5 x 45.4 cm
Joseph and Jory Shapiro

Paul Klee
Physiognomies of Cross Sections, 1930
Watercolor on paper mounted on
cardboard
47.6 x 61.9 cm
Morton G. Neumann Family Collection
Reproduced p. 159.

Paul Klee
History, 1930
Colored inks on paper
42 x 57.2 cm
The Ratner Family Collection

Paul Klee
Woman in the Process of Becoming,
c. 1932/33
Gouache on paper
30.5 x 47.3 cm
Private Collection

Pl. 39. Paul Klee, *Physiognomies of Cross Sections*, 1930 (see p. 158)

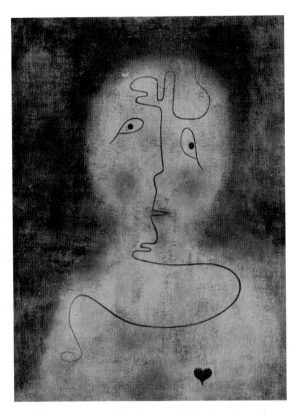

Paul Klee
Magic Mirror with Heart, 1934
Oil on canvas
68.6 x 50.8 cm
Claire Zeisler

Klee was included in the first Surrealist
exhibition in Paris in 1925. His affinity
with the Surrealist sensibility stemmed in
part from his reliance on intuitive and
subconscious processes as a springboard
for the creative act. His famous assertion
that "Art does not render the visible; rather
it makes visible" complements the anti-
illusionistic stance of the Surrealists as
well. An instructor at the Bauhaus for many
years, Klee painted *Magic Mirror* in Bern
where he moved after the closing of the
Bauhaus in 1933.

Paul Klee
Leaf from the Memories of an Old Woman,
1939
Watercolor on paper
29.2 x 20.8 cm
The Art Institute of Chicago, Gift of Mr.
and Mrs. Walter Paepcke

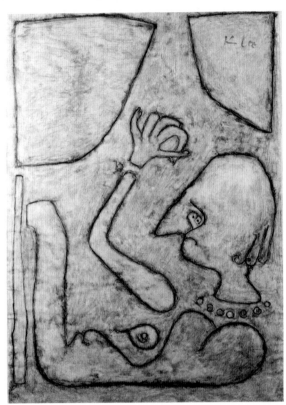

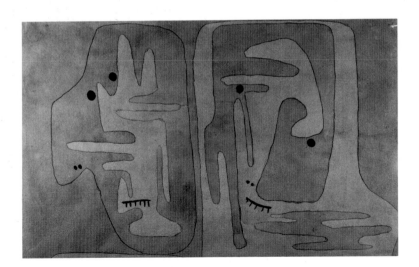

Paul Klee
Two Heads, 1940
Watercolor on paper
30.5 x 48.3 cm
Mr. and Mrs. Bertrand Goldberg

Wifredo Lam
Cuban, 1902-1982

Wifredo Lam
Anamu, 1942
Oil on canvas
152.4 x 127 cm
Museum of Contemporary Art, Promised
Gift of Joseph and Jory Shapiro (PG83.25)
Reproduced p. 93.

Wifredo Lam
The Jungle (Personage with Scissors),
1942
Watercolor, gouache, and pastel on paper
175.9 x 120.3 cm
Mr. and Mrs. E.A. Bergman
Reproduced p. 15.

Lam's particular subjects and style of
Surrealism are rooted in the exotic imagery
of his native land where Caribbean and
African cultures were fused. His mystical
figures are inspired by Haitian voodoo
spirits as well as pure African sources, as
exemplified in *The Jungle*.

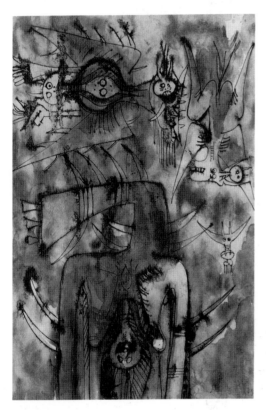

Wifredo Lam
Untitled, 1941
Watercolor and ink on paper
47.4 x 31.1 cm
Mr. and Mrs. E.A. Bergman

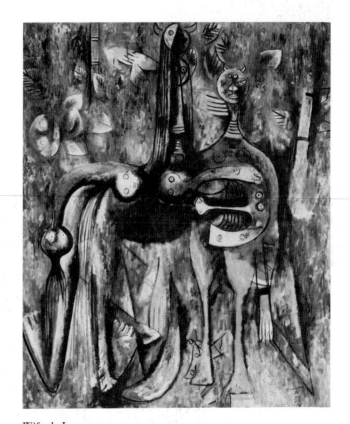

Wifredo Lam
Malembo, God of the Crossroads, 1943
Oil on canvas
153 x 126.4 cm
Joseph and Jory Shapiro

161

Wifredo Lam

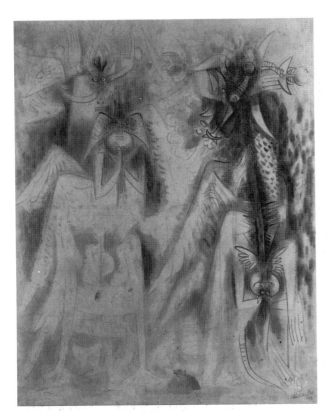

Wifredo Lam
Annunciation, 1944
Oil on canvas
154.3 x 127.6 cm
Museum of Contemporary Art, Gift of Mr.
and Mrs. E.A. Bergman (77.28)

Even in his *Annunciation*, a conventional
religious subject with a venerable history,
Lam has peopled the narrative with
fantastical figures. The Archangel Gabriel
on the right is a totally otherworldly
creature; the figure of the Virgin on the left
is equally indistinct. Around these central
characters is a heavenly host of nonhumans
whose angelic nature is expressed by
fragmented, angled forms of wings.

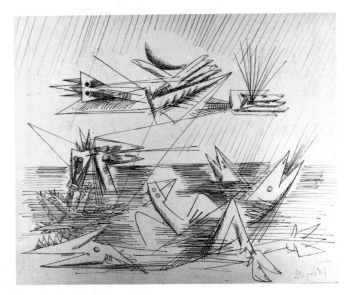

Wifredo Lam
Untitled, 1946
Ink on paper
52.1 x 63.5 cm
Joseph and Jory Shapiro

Wifredo Lam
Noncombustible, 1950
Oil on canvas
90.2 x 108 cm
Robert H. Bergman

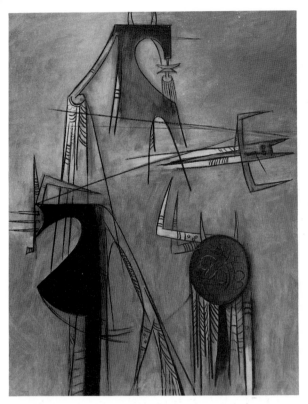

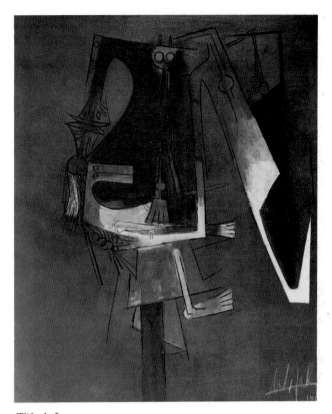

Wifredo Lam
Untitled, c. 1957
Oil on canvas
97.8 x 77.5 cm
Douglas and Carol Cohen

Wifredo Lam
Untitled, 1964
Oil on canvas
126.1 x 109.2 cm
Dr. and Mrs. J.H. Hirschmann

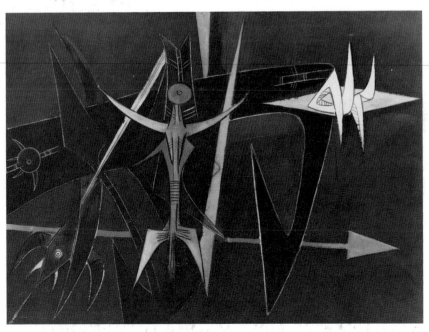

Wifredo Lam
Untitled, c. 1965
Oil on canvas
106.7 x 152.4 cm
Ruth Horwich

Clarence John Laughlin
American, 1905-1985

Nathan Lerner
American, b. 1915

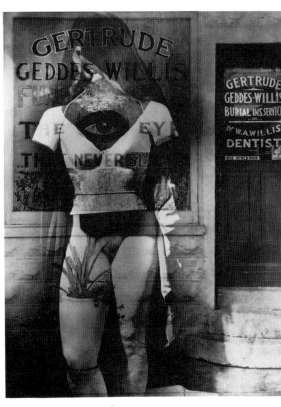

Clarence John Laughlin
The Eye That Never Sleeps, 1946
Silver gelatin print
30.5 x 22.5 cm
Mr. and Mrs. David C. Ruttenberg,
Courtesy of the Ruttenberg Arts
Foundation

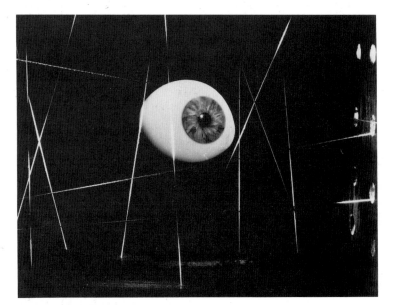

Nathan Lerner
Eye and String, 1939
Silver gelatin print
38.1 x 48.3 cm
Mr. and Mrs. David C. Ruttenberg,
Courtesy of the Ruttenberg Arts
Foundation

Nathan Lerner
Eye and Barbed Wire, 1939
Silver gelatin print
40.5 x 50.5 cm
Museum of Contemporary Art, Gift of
Arnold M. Gilbert (74.17)

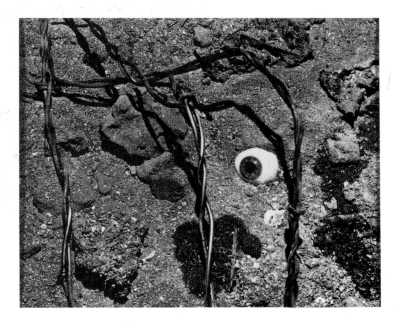

George Platt Lynes
American, 1907-1955

René Magritte
Belgian, 1898-1967

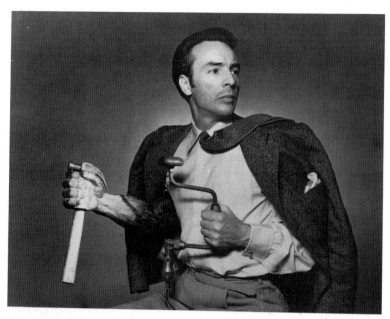

George Platt Lynes
George Balanchine, 1941
Silver gelatin print
19.3 x 24.2 cm
The Art Institute of Chicago, Photography
Expense Fund

René Magritte
The Age of Marvels, 1926
Oil on canvas
116 x 81 cm
The Ratner Family Collection
Reproduced p. 65.

*The marvelous is always beautiful; anything
marvelous is beautiful; only the marvelous
is beautiful.*
— André Breton, *Manifesto of Surrealism*,
1924

George Platt Lynes
Paul Cadmus, 1945
Silver gelatin print
24.2 x 19.3 cm
The Art Institute of Chicago, Photography
Expense Fund

René Magritte

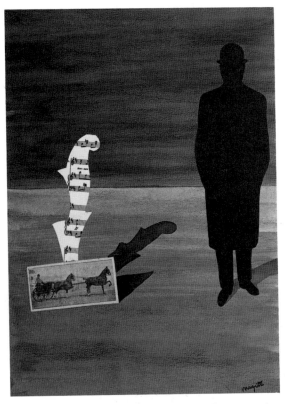

René Magritte
The Beauty of the Night (Torso at Window),
1932/33
Oil on canvas
81.3 x 114.3 cm
Joseph and Jory Shapiro

René Magritte
Untitled (Reveries of the Solitary Walker),
1926
Watercolor, India ink, charcoal, and
collage on paper
54.8 x 39.5 cm
Museum of Contemporary Art, Promised
Gift of Joseph and Jory Shapiro (PG84.1)

This is one of the earliest renderings of the
bowler-hatted, topcoat-attired Everyman
who recurs over and over in Magritte's
oeuvre, most notably in numerous oils from
the 1950s and 1960s. In his first one-
person show in Brussels in 1927, Magritte
exhibited a number of these collages,
several of which feature images cut from
sheet music combined with gouache and
ink. Although the fact that Magritte
occasionally had himself photographed in
a bowler and black overcoat, sometimes
with his face hidden, suggests that these
figures are self-portraits, their anonymity
contradicts the notion of portraiture.

René Magritte
The Palace of Curtains II, 1928/29
Oil on canvas
73 x 54 cm
Museum of Contemporary Art, Gift of Mr.
and Mrs. Kenneth Newberger (80.69)
Reproduced p. 66.

René Magritte
When the Bell Tolls, 1932/33
Oil on canvas
114.3 x 87.6 cm
Ruth Horwich

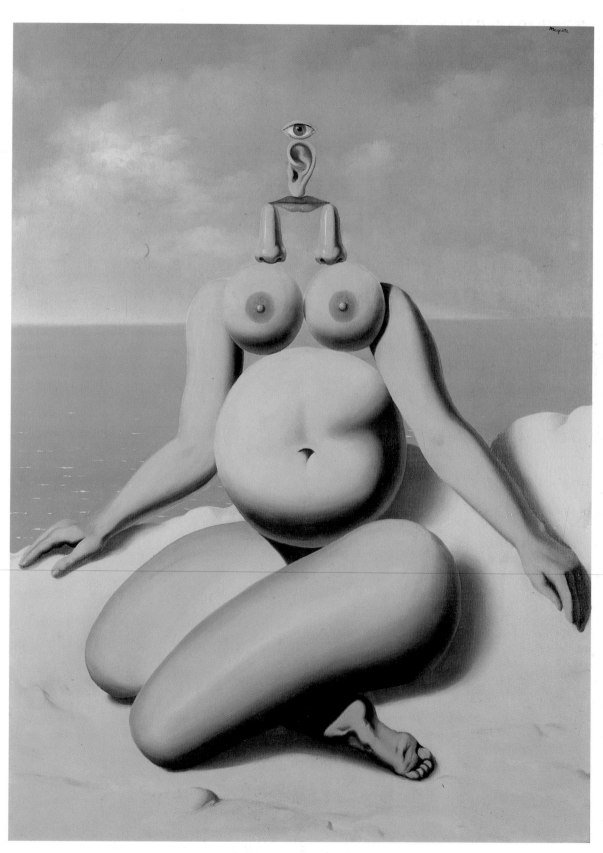

Pl. 40. René Magritte, *The White Race*, 1937 (see p. 168)

René Magritte

René Magritte
Subterranean Fire, 1935
Oil on canvas
53.3 x 72.1 cm
Morton G. Neumann Family Collection

René Magritte
The White Race, 1937
Oil on canvas
81.3 x 60.3
Ruth Horwich
Reproduced p. 167.

René Magritte
Scheherazade, 1944
Gouache on paper
34.3 x 26.7 cm
Mrs. Robert B. Mayer

René Magritte
Sentimental Education, 1946
Gouache on paper
47 x 34.3 cm
Mrs. Robert B. Mayer

René Magritte
Untitled (Bottle Nude), c. 1946/49
Oil on glass
H. 27.9 cm
Joseph and Jory Shapiro

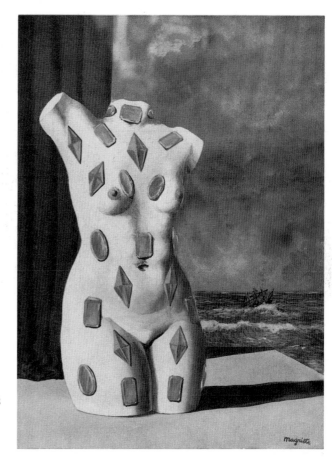

René Magritte
The Drop of Water, 1948
Gouache on paper
35.6 x 26.7 cm
Mrs. Robert B. Mayer

René Magritte
The Flavor of Tears, c. 1948
Gouache on paper
45.7 x 35.6 cm
Joseph and Jory Shapiro
Reproduced p. 12.

René Magritte
The Balcony (after Manet), c. 1949/50
Crayon on paper
44.5 x 34.3 cm
Joseph and Jory Shapiro

René Magritte
Song of Love, c. 1950/51
Oil on canvas
77.5 x 98.1 cm
Museum of Contemporary Art, Partial Gift
of Joseph and Jory Shapiro (82.48)
Reproduced p.68.

René Magritte
The Banquet, 1958
Oil on canvas
96.2 x 128.6 cm
Mr. and Mrs. E.A. Bergman
Reproduced p. 171.

A sun or moon hovering implausibly in
front of rather than behind a stand of trees
is a recurring image in several related
Magritte paintings between 1956 and
1958. Though identically titled, they vary
in size of sun, configuration of trees, and
appearance or absence of balustrade.
Reversing one's usual expectations,
Magritte brought the setting sun into the
foreground, a device that, according to the
artist, coincidentally illustrates the truism
"The sun shines for all."

René Magritte
The Legend of the Centuries, 1952
Ink and pencil on paper
26.7 x 17.8 cm
Mr. and Mrs. Howard A. Weiss

*Beautiful title. I took the liberty of finding
it myself....A stone table has less thought
than an ordinary wood table. It has no
thought; it thinks of the absolute.*
— René Magritte, 1965

René Magritte
The Tower, 1954
Red chalk and pencil on paper
35.6 x 43.2 cm
Private Collection

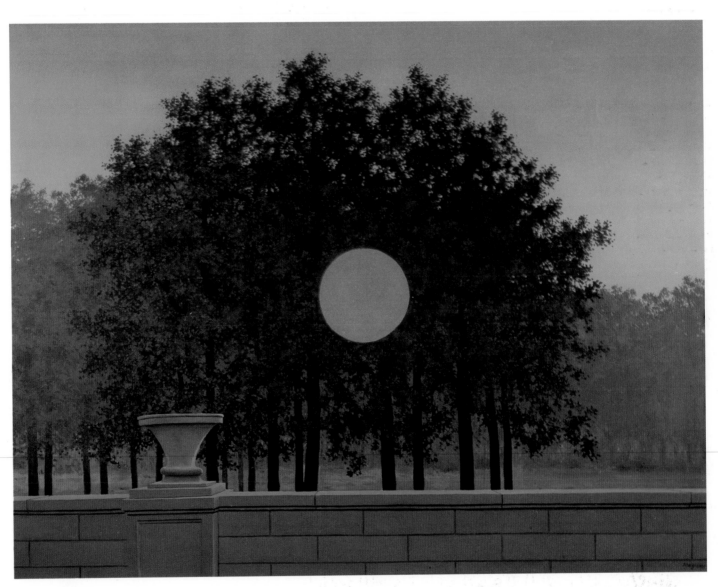

Pl. 41. René Magritte, *The Banquet*, 1958 (see p. 170)

René Magritte

René Magritte
The Air and the Song, 1964
Gouache on paper
35.6 x 54.3 cm
Mr. and Mrs. E.A. Bergman
Reproduced p. 85.

The famous pipe. How people reproached
me for it! And yet, could you stuff my pipe?
No, it's just a representation, is it not? So if
I had written on my picture "This is a pipe,"
I'd have been lying.
— René Magritte, 1966

René Magritte
The Familiar World, 1958
Oil on canvas
48.9 x 59.1 cm
Mr. and Mrs. Henry D. Paschen

René Magritte
Untitled (Delusions of Grandeur), n.d.
Ink and watercolor on paper
25.4 x 17.8 cm
The Ratner Family Collection

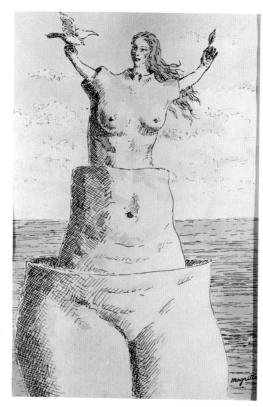

René Magritte
The Museum of the King, 1966
Oil on canvas
130 x 89 cm
Stefan T. Edlis

Man Ray
American, 1890-1976

Man Ray
Revolving Doors: The Meeting, 1915
Ink on paper
50.5 x 33 cm
Morton G. Neumann Family Collection

Man Ray
The Ridgefield Gazook, 1915
Broadsheet
Closed: 22.5 x 16.5 cm
Arnold H. Crane

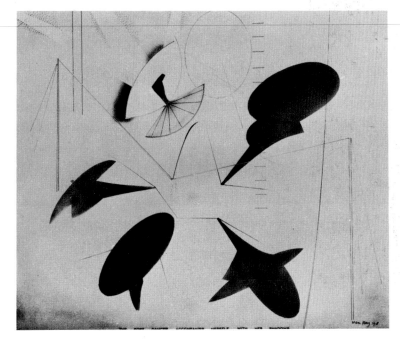

Man Ray
The Rope Dancer Accompanies Herself with Her Shadows, 1918
Airbrush and tempera on paper
39.7 x 44.5 cm
Morton G. Neumann Family Collection

I was planning something entirely new, had no need of an easel, brushes and the other paraphernalia of the traditional painter. ...I became quite adept in the use of the airbrush ...it was thrilling to paint a picture, hardly touching the surface — a purely cerebral act, as it were.
— Man Ray, 1963

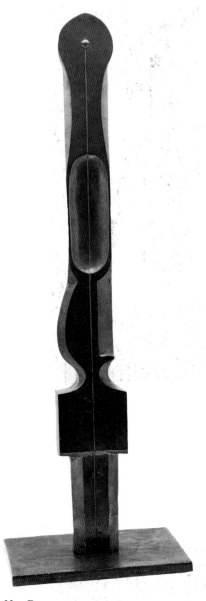

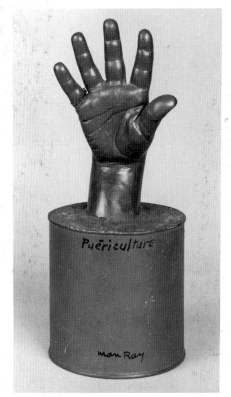

Man Ray
Child Rearing, 1920
Painted metal and plaster
H. 26.7 cm
The Art Institute of Chicago, Bequest of
Florence S. McCormick

*I dreamed once that as I walked on the street
hands came out from the road and that I
had to make my way through the hands.*
— Man Ray, 1972

Man Ray
By Itself II, 1918/66
Bronze
H. 55.9 cm
Victor Skrebneski

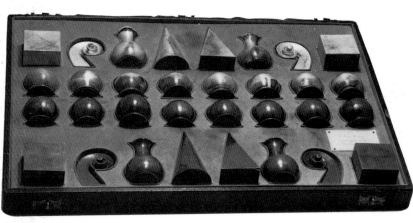

Man Ray
Chess Set, 1920/26
Silver and wood box
5.4 x 38.1 x 52.1 cm
William J. Hokin

Man Ray
Gift, 1921/63
Flatiron with tacks
H. 16.2 cm
Morton G. Neumann Family Collection

You can tear a dress to ribbons with it. I did it once, and asked a beautiful eighteen-year-old coloured girl to wear it as she danced. Her body showed through as she moved around, it was like a bronze in movement. It was really beautiful.
— Man Ray, date unknown

Man Ray
Untitled (Plate IV from *Champs Délicieux [Sweet Fields]*), 1922
Rayograph
22.2 x 17 cm
The Art Institute of Chicago, The Julien Levy Collection, Special Photography Acquisition Fund

Man Ray
Untitled (Plate VII from *Champs Délicieux [Sweet Fields]*), 1922
Rayograph
22.6 x 16.9 cm
The Art Institute of Chicago, The Julien Levy Collection, Special Photography Acquisition Fund

175

Man Ray
Untitled, 1923
Rayograph
30.5 x 22.9 cm
Morton G. Neumann Family Collection

Man Ray christened his cameraless photographs "Rayographs" in 1925. Recounting their discovery by accident in the darkroom in 1921, he wrote: "I mechanically placed a small glass funnel, the graduate and the thermometer in the tray on the wetted paper. I turned on the light; before my eyes an image began to form, not quite a simple silhouette of the objects as in a straight photograph, but distorted and refracted by the glass more or less in contact with the paper and standing out against a black background, the part directly exposed to the lightI was trying to do with photography what painters were doing, but with light and chemicals, instead of pigment, and without the optical help of the camera."

Man Ray
Untitled, 1923
Rayograph
24 x 17 cm
The Art Institute of Chicago, The Julien Levy Collection, Special Photography Acquisition Fund

Man Ray
Untitled, 1923
Rayograph
23.4 x 17.7 cm
The Art Institute of Chicago, The Julien Levy Collection, Special Photography Acquisition Fund
Reproduced p. 56.

Man Ray
Indestructible Object, 1923/58
Metronome with photograph and paperclip
H. 22.2 cm
Morton G. Neumann Family Collection
Reproduced p. 13.

Originally titled *Object of Destruction* in 1923, the famous metronome with cut-out eye was destroyed in 1957. Subsequently issued in an edition of 100 in 1958, it was ironically retitled *Indestructible Object* by Man Ray, who observed, "It would be very difficult to destroy all hundred metronomes now."

Man Ray
Breath (from the portfolio *Electricity*),
1931
Photogravure
26 x 20.5 cm
The Sandor Family Collection

Man Ray
Electricity (from the portfolio *Electricity*),
1931
Photogravure
26 x 20.5 cm
The Sandor Family Collection

Man Ray
Electricity (from the portfolio *Electricity*),
1931
Photogravure
26 x 20.5 cm
The Sandor Family Collection

Man Ray
The World (from the portfolio *Electricity*),
1931
Photogravure
26 x 20.5 cm
The Sandor Family Collection

Man Ray
Object of Destruction, 1932
Ink on paper
25.4 x 15.2 cm
Morton G. Neumann Family Collection

This 1932 drawing and the "directions"
Man Ray wrote on the verso furnish both
illustration and instructions for making
one's own Surrealist object: "Cut out the
eye from a photograph of one who has been
loved but is not seen anymore. Attach the
eye to the pendulum of a metronome and
regulate the weight to suit the tempo
desired. Keep going to the limit of
endurance. With a hammer well-aimed,
try to destroy the whole with a single
blow."

Man Ray
Marquis de Sade (drawing for *Les Mains libres*), 1936
Ink on paper
34.9 x 25.1 cm
Joseph and Jory Shapiro

Because of his notorious ideas about
sexual, personal, political, and religious
liberty, the Marquis de Sade (1740-1814)
was revered by the Surrealists and his
writings were published in their journals.
Here, the Bastille, in which de Sade was
imprisoned, is consumed by fire while his
monumental visage, built out of stone,
endures. No likeness of de Sade exists, but
this imaginary portrait bears more than a
passing resemblance to André Breton. Two
oil paintings of the same subject followed
(1938 and 1940).

Man Ray
The Adventure (drawing for *Les Mains libres*), 1937
Ink on paper
35.6 x 27.9 cm
Katharine S. Schamberg

Man Ray
Portable Woman (drawing for *Les Mains libres*), 1937
Ink on paper
35.5 x 25.3 cm
Arnold H. Crane

Man Ray
Les Mains libres (Free Hands), 1937
Book with text by Paul Eluard, illustrations
by Man Ray
27.9 x 21.9 cm
Katharine S. Schamberg

*I always have by my bed a notebook with
pen and ink. Even when I travel….At night,
before falling asleep, if an idea occurs to
me I immediately make a drawing. And in
the morning when I wake up, if I have
dreamed I sketch my dream immediately.
Many of the* Mains libres *drawings are
drawing of dreams.*
— Man Ray, 1972

Man Ray

Man Ray
Repainted Mask, 1941
Painted cloth over papier-mâché, and cigar
box
18.7 x 15.2 x 8.6 cm
Morton G. Neumann Family Collection

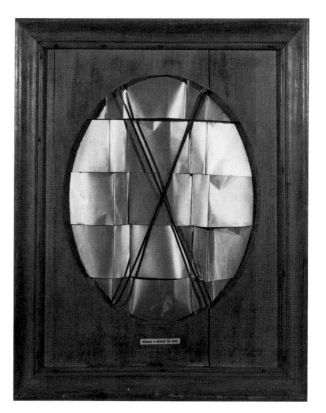

Man Ray
Mirror to Die of Laughter, 1952
Wood, metal, tin, transparent tape, and
paper
52.1 x 43.2 cm
Morton G. Neumann Family Collection

Man Ray
*L'Aventure Dada (1916-1922) (The Dada
Adventure [1916-1922])*, 1957/68
Book with text by Georges Hugnet, altered
by Man Ray
24.5 x 16.5 cm
Arnold H. Crane

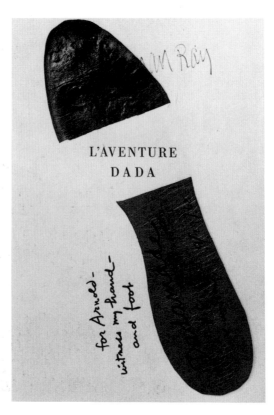

Man Ray
Architexture, 1958
Wood and metal
H. 26.7 cm
Morton G. Neumann Family Collection

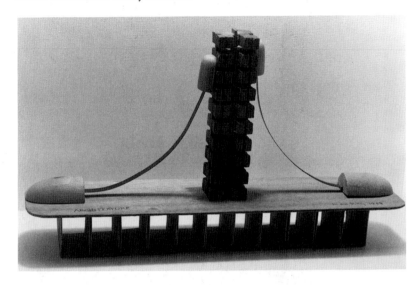

Man Ray
Self-Portrait, 1962
Metal
44.8 x 34 cm
Morton G. Neumann Family Collection

Man Ray
Smoking Device, 1959
Wooden pipe rack, plastic tubing, and
marbles
H. 18.4 cm
Morton G. Neumann Family Collection
Reproduced p. 14.

Man Ray
It's Springtime, 1961
Metal springs and wood
H. 27.9 cm
Morton G. Neumann Family Collection

Man Ray

André Masson
French, b. 1896

André Masson
Figure, 1924
Oil on canvas
63.5 x 48.3 cm
Ruth Horwich

André Masson
Man, 1924/25
Oil on canvas
100.3 x 65.4 cm
Museum of Contemporary Art, Promised
Gift of Joseph and Jory Shapiro (PG83.29)
Reproduced p. 28.

Man was shown in the first Surrealist
exhibition in Paris in 1925 and
subsequently purchased by actor and writer
Antonin Artaud, who wrote of the painting:
"A soft belly. A belly of fine and illusory
powder; at the foot of the belly a burst
pomegranate./The Pomegranate sends
forth a circulation of floccules that rise like
tongues of fire, a cold fire. The circulation
takes the belly and turns it inside out. But
the belly doesn't turn..../There are veins
of winy blood and blood mixed with saffron
and sulfur, but a sulfur diluted with water./
Visible above the belly are breasts. Higher,
and deeper, but on another mental plane
a sun burns, in such a way though that it
makes one think that it's the breast that
burns..../The sun seems to be looking....
Its gaze is a cone that upturns itself on the
sun. And all the air is like fixed music,
but a vast, profound music, well built and
secret, and full of frozen ramifications..../
The canvas is hollow and stratified. The
painting is well confined on the canvas. It
is like a closed circle, a kind of abyss that
turns, and splits into two down the
middle...."

Man Ray
*Portrait of Mary Reynolds and Marcel
Duchamp*, n.d.
Silver gelatin print
15 x 14.9 cm
The Art Institute of Chicago, Gift of Frank
B. Hubachek

André Masson
The Helmet's Dream, 1925
Ink on paper
29.5 x 23.5 cm
Mr. and Mrs. E.A. Bergman

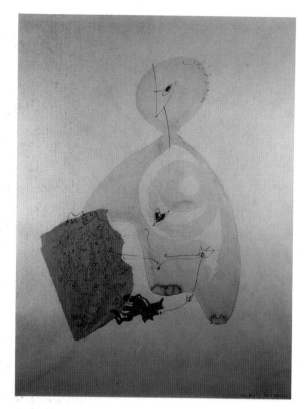

André Masson
Blue Personage/Child Looking at a
Drawing, 1927
Gouache, ink, and paper collage on paper
61 x 50.8 cm
The Art Institute of Chicago, Gift of Mr.
and Mrs. Edwin A. Bergman

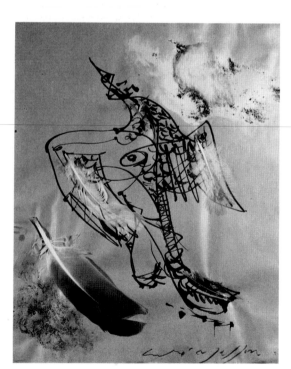

André Masson
Untitled, 1925
Ink, feathers, cotton, and gouache on
brown paper
24.8 x 20.7 cm
Mr. and Mrs. E.A. Bergman

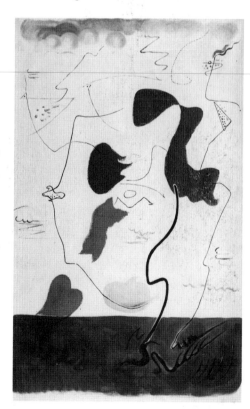

André Masson
The Chase, 1927
Oil on canvas
90.8 x 59.4 cm
Dr. and Mrs. J.H. Hirschmann

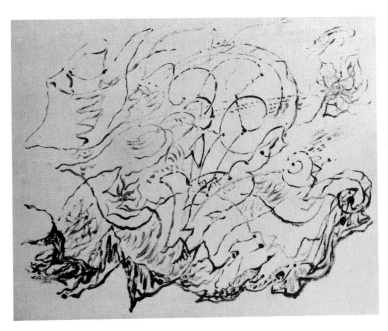

André Masson
Death's Head, 1927
Oil on canvas
38.1 x 46 cm
Morton G. Neumann Family Collection

André Masson
The Nasty Experience, 1930
Oil on canvas
26.4 x 20.9 cm
Dr. and Mrs. J.H. Hirschmann

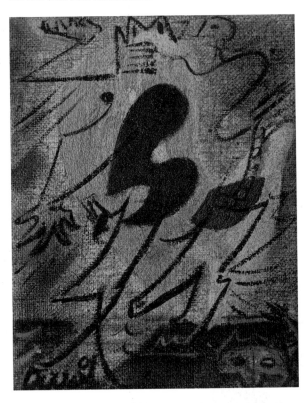

André Masson
Two Death's-Heads, 1927
Oil and sand on canvas
14.4 x 24.2 cm
Mr. and Mrs. E.A. Bergman

1927: First sand pictures. I realized the need for them, when I saw the gap between my drawings and my oil paintings — the gap between the spontaneity and lightning rapidity of the former and the thought that inevitably went into the latter. I suddenly hit on the solution while I was at the seaside, gazing at the beauty of the sand with its myriads of nuances and infinite variations from the dull to the sparkling. As soon as I got home, I laid out an unprimed canvas on the floor of my room and poured streams of glue over it; then I covered the whole thing with sand brought in from the beach....However, as in my ink drawings, the emergence of a figure was solicited, and this unorthodox kind of picture was worked out with the help of a brushstroke and sometimes a patch of pure color.
— André Masson, 1961

André Masson
Louis XVI Armchair, 1938/39
Oil on canvas
71.1 x 57.5 cm
Mrs. Henry A. Markus
Reproduced p. 185.

Pl. 42. André Masson, *Louis XVI Armchair*, 1938/39 (see p. 184)

André Masson
Battle of Birds, 1941
Pastel on paper
63.8 x 48.6 cm
Mr. and Mrs. E.A. Bergman

André Masson
Pasiphaë, 1943
Oil and tempera on canvas
101 x 127 cm
Dr. and Mrs. J.H. Hirschmann
Reproduced p. 19.

*Impressed by the art and legends of
American Indians, Masson turned to totemic
subjects and to Indian as well as classical
mythology.... The myth of Pasiphaë, wife
of Minos, the ruler of Crete, and her passion
for a great white bull fascinated many
artists — most especially the Surrealists,
who saw its symbolic possibilities.... The
union between Pasiphaë and the bull was
interpreted by Surrealists as a rejoining of
man and nature.*
— Edward B. Henning, *The Spirit of
 Surrealism*, 1979

André Masson
The Feast, 1958
Pastel on paper
61 x 45.7 cm
Dr. and Mrs. Philip Falk

Matta (Roberto Matta Echaurren)
Chilean-French, b. 1911

Matta (Roberto Matta Echaurren)
Horoscope, 1937
Crayon and pencil on paper
31.4 x 49.2 cm
Mr. and Mrs. E.A. Bergman

Trained as an architect with Le Corbusier in the early 1930s, Matta joined the Surrealist circle in Paris in 1937, the same year he made his first drawings.

Matta (Roberto Matta Echaurren)
Untitled, 1937
Crayon and pencil on paper
31.1 x 48.9 cm
Mr. and Mrs. Albert Robin

Matta (Roberto Matta Echaurren)
Psychological Morphology, 1938
Oil on canvas
73 x 92.7 cm
Donn Shapiro

Matta painted his first canvases in 1938. Titled *Psychological Morphologies*, these oils of 1938-40 evoke, in their depiction of boundless space, the hidden recesses of the psyche as well as the veiled mysteries of the universe. Matta also referred to them as "Inscapes" while André Breton described them as "four-dimensional universe[s]."

Matta (Roberto Matta Echaurren)
Untitled, 1938/39
Pencil and crayon on paper
48.3 x 63.5 cm
Joseph and Jory Shapiro

Matta (Roberto Matta Echaurren)
Psychological Morphology (Inscape), 1939
Oil on canvas
72.4 x 91.5 cm
Mr. and Mrs. E.A. Bergman
Reproduced p. 189.

Matta (Roberto Matta Echaurren)
Untitled, 1939
Pencil and crayon on paper
32.4 x 49.5 cm
Joseph and Jory Shapiro

Matta (Roberto Matta Echaurren)
Untitled, 1938/39
Pencil and crayon on paper
49.5 x 64.8 cm
Mr. and Mrs. E.A. Bergman
Reproduced p. 97.

Matta (Roberto Matta Echaurren)
Rain on the King and Counsellors, 1940
Pencil and crayon on paper
37.8 x 56.2 cm
Mr. and Mrs. E.A. Bergman

Pl. 43. Matta, *Psychological Morphology (Inscape)*, 1939 (see p. 188)

Matta (Roberto Matta Echaurren)

Matta (Roberto Matta Echaurren)
War of Nerves, 1940
Pencil and crayon on paper
37.8 x 56.2
Mr. and Mrs. E.A. Bergman
Reproduced p.100.

Matta (Roberto Matta Echaurren)
Untitled, 1941
Pencil and crayon on paper
49.8 x 64.8 cm
Muriel Kallis Newman

Matta (Roberto Matta Echaurren)
Galaxies (Mysticism of Infinity), 1940/44
Oil on canvas
92.1 x 73 cm
Joseph and Jory Shapiro

Matta (Roberto Matta Echaurren)
The Earth Is a Man, 1942
Oil on canvas
182.9 x 243 cm
Joseph and Jory Shapiro
Reproduced p. 18.

Matta's... painting The Earth Is a Man *was precisely what it implied — cosmic nebula in breathing bursts of detonation and implosion. It was a visceral interior as vast as any imaginable universe. With a surgical curiosity bordering on mania, Matta had invaded one of Yves Tanguy's enigmatic flesh machines and had discovered a cosmic totality that was, indeed, both man and earth.*
— Jimmy Ernst, 1984

Matta (Roberto Matta Echaurren)
After Life, 1942
Pencil and crayon on paper
57.5 x 72.7 cm
Mr. and Mrs. E.A. Bergman

Matta (Roberto Matta Echaurren)
Untitled, 1942
Pencil and crayon on paper
57.1 x 72.4 cm
The Ratner Family Collection

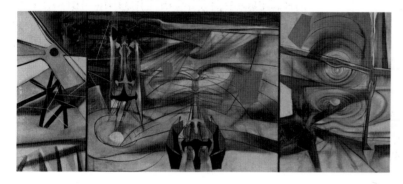

Matta (Roberto Matta Echaurren)
Redness of Lead, 1943
Oil on canvas
75.6 x 183.5 cm
Morton G. Neumann Family Collection

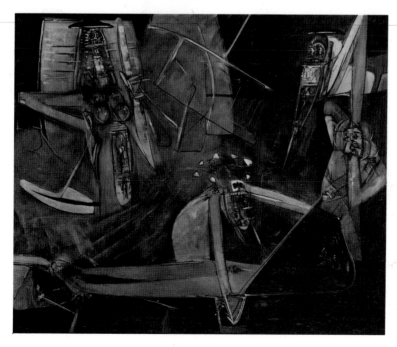

Matta (Roberto Matta Echaurren)
Let's Phosphoresce by Intellection #1,
1950
Oil on canvas
148.6 x 179.1 cm
Museum of Contemporary Art, Gift of Mr.
and Mrs. E.A. Bergman (76.45)

The group of people of the Northwest Coast,
for example, when they make a totem it has
to do with animals in the forest, with trees
and with some of their ancestors. The totem
is a representation of social life, or life in
common. I used to say that this
representation of society today would be
transparent. Most of the things that affect
us are not things we see, like in the case of
primitive people, but they are things that
come from forces like the psyche. So I
painted several pictures in those days, some
of them very large, which I called "les
vitreurs" or "men made of glass."
— Matta, 1982

191

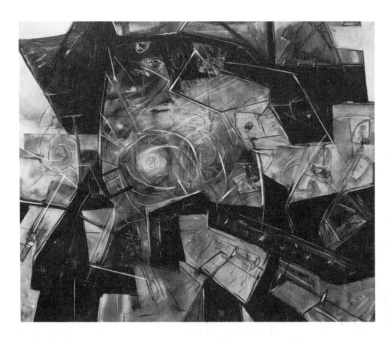

Matta (Roberto Matta Echaurren)
Let's Phosphoresce by Intellection #2,
1950
Oil on canvas
149.9 x 177.8 cm
Mr. and Mrs. Kenneth Newberger

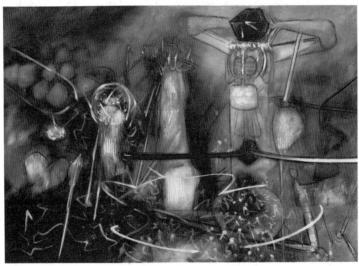

Matta (Roberto Matta Echaurren)
I Go in Search, 1952
Oil on canvas
116.8 x 165.1 cm
Donn Shapiro

Matta (Roberto Matta Echaurren)
Untitled, 1952
Pastel on paper
99.1 x 147 cm
Douglas and Carol Cohen

Matta (Roberto Matta Echaurren)
The Three Worlds, 1957
Bronze
H. 71.1 cm
Museum of Contemporary Art, Promised
Gift of Joseph and Jory Shapiro (PG83.30)

It was in 1957 that Matta executed his first bronze sculpture, a single figure. Shortly thereafter, he began work on The Three Worlds *in which the possibilities of his inventiveness in three-dimensional form became clear. Upon seeing this piece for the first time I was so impressed that I urged Matta to explore sculpture further and proposed that he attempt an extensive series of bronzes.... Matta worked intensively in plaster through 1959 and into 1960, but the realization of his sculpture in bronze was delayed by the extreme complexity and delicacy of the forms. Finally, Mme. Susse of Susse Frères of Arcueil agreed to attempt to cast the plasters with the collaboration of the artist.*
— Allan Frumkin, 1964

Matta (Roberto Matta Echaurren)
Couple I, 1959/60
Bronze and wood
H. 74.9 cm
The David and Alfred Smart Gallery, The
University of Chicago, Gift of Mr. Allan
Frumkin

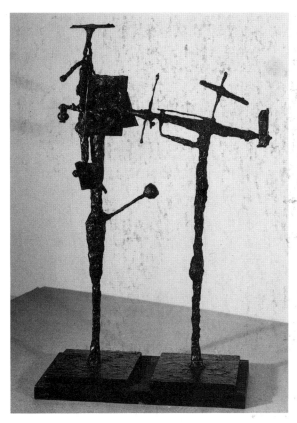

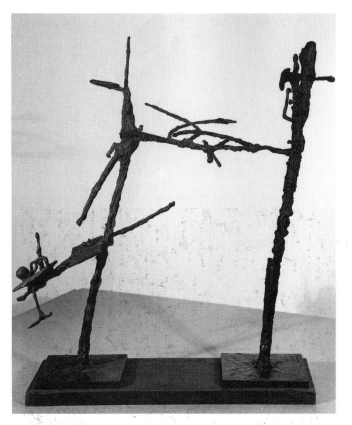

Matta (Roberto Matta Echaurren)
Couple II, 1959/60
Bronze and wood
H. 76.2 cm
Mr. and Mrs. Stanley M. Freehling

Matta (Roberto Matta Echaurren)
Couple III, 1959/60
Bronze and wood
H. 73.7 cm
Private Collection

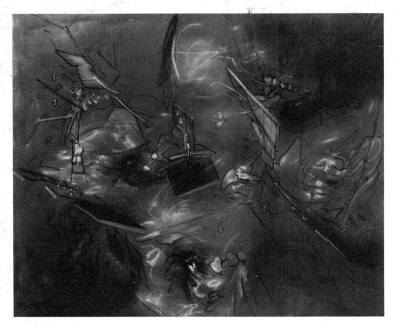

Matta (Roberto Matta Echaurren)
*Passage from Art to Chess: Homage to
Marcel Duchamp*, 1966
Oil on canvas
113.7 x 146.7 cm
Mr. and Mrs. Leo S. Singer

Lee Miller
American, 1907-1978

Lee Miller
Hand, 1931
Silver gelatin print
23.1 x 22.2 cm
The Art Institute of Chicago, The Julien
Levy Collection, Gift of Jean and Julien
Levy

Lee Miller
Untitled, 1930
Silver gelatin print
19.5 x 17 cm
The Art Institute of Chicago, The Julien
Levy Collection, Gift of Jean and Julien
Levy

Lee Miller
Untitled, 1931
Silver gelatin print
21.7 x 17.4 cm
The Art Institute of Chicago, The Julien
Levy Collection, Gift of Jean and Julien
Levy

Joan Miró
Spanish, 1893-1983

Joan Miró
Pastorale, 1923/24
Oil and charcoal on canvas
65 x 91.5 cm
Stefan T. Edlis
Reproduced p. 25.

During the early 1920s, Miró developed
the engagingly idiosyncratic vocabulary of
forms, both naturalistic and seemingly
abstract, that populate his paintings. As
he himself claimed, however, "For me a
form is never something abstract; it is
always a sign of something. It is always a
man, a bird, or something else. For me
painting is never form for form's sake."

Joan Miró
Spanish Flag, 1925
Oil on canvas
114.3 x 144.8 cm
Joseph and Jory Shapiro
Reproduced p.96.

In 1925, I was drawing almost entirely from
hallucinations. At the time I was living on
a few figs a day. I was too proud to ask my
colleagues for help. Hunger was a great
source of these hallucinations. I would sit
for long periods looking at the bare walls of
my studio trying to capture these shapes on
paper or burlap.
— Joan Miró, 1948

Joan Miró
Automaton, 1924
Pencil and crayon on paper
45.7 x 61 cm
Morton G. Neumann Family Collection

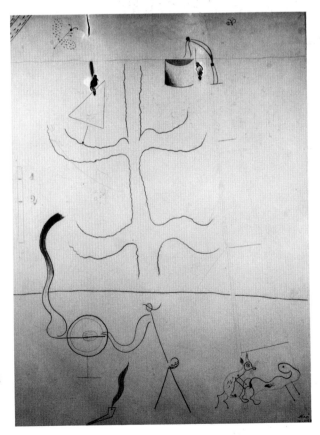

Joan Miró
Untitled, 1924
Charcoal, graphite, watercolor, and
colored pencil on paper
62.9 x 48.3 cm
Mr. and Mrs. E.A. Bergman

Joan Miró
The Lovers, 1928
Charcoal and gouache on granulated
paper
72.7 x 109.2 cm
Stefan T. Edlis

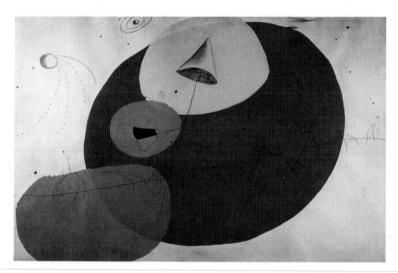

Joan Miró
Summer, 1929
Pencil, ink, and collage on paper
63.5 x 98 cm
Richard and Mary L. Gray

Joan Miró
Composition, 1933
Collaged asphalt paper, paper, postcards,
and pencil on paper
105.4 x 70.5 cm
Mr. and Mrs. E.A. Bergman
Reproduced p. 198.

*Little by little I turned from dependence on
hallucinations to forms suggested by
physical elements, but still quite apart from
realism. In 1933, for example, I used to tear
newspapers into rough shapes and paste
them on cardboards. Day after day I would
accumulate the shapes. After the collages
were finished they served me as points of
departure for paintings. I did not copy the
collages. I merely let them suggest shapes
to me.*
— Joan Miró, 1948

Joan Miró
Drawing-Collage, 1933
Pencil and collaged papers on paper
61.6 x 45.7 cm
Morton G. Neumann Family Collection

197

Pl. 44. Joan Miró, *Composition*, 1933 (see p. 197)

Joan Miró
Drawing-Collage, 1933
Conté crayon and collaged paper on tan
paper
106.7 x 69.9 cm
Morton G. Neumann Family Collection

Joan Miró
Drawing-Collage, 1933
Conté crayon and collaged engravings and
postcards on paper
62.2 x 46.7 cm
Private Collection

Joan Miró
Woman, 1934
Pastel on paper
106.1 x 71.1 cm
Mr. and Mrs. E.A. Bergman
Reproduced p. 202.

Joan Miró
Metamorphosis, 1936
Watercolor, gouache, and collage on
paper
48.6 x 63.8 cm
Claire Zeisler

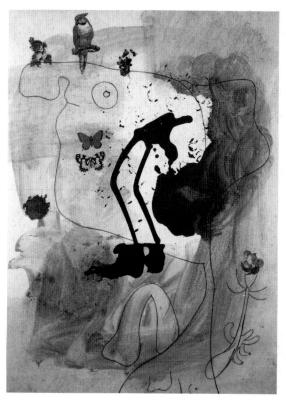

Joan Miró
Metamorphosis, 1936
Watercolor, ink, and collaged photograph
on paper
63.5 x 48.2 cm
Mrs. Oscar L. Gerber

Joan Miró
Standing Woman, 1937
Oil on paper
75 x 56 cm
Mr. and Mrs. E. A. Bergman

Joan Miró
Persons Haunted by a Bird, 1938
Watercolor, ink, and colored pencil on
paper
41.1 x 33 cm
The Art Institute of Chicago, Peter B.
Bensinger Charitable Trust

*Between the years 1937 and 1940 I once
again became interested in realism. Perhaps
the interest began as early as 1937 in* Still
Life with Old Shoe [The Museum of Modern
Art, New York]. *Perhaps the events of the
day, particularly the drama of the war in
Spain, made me feel that I ought to soak
myself in reality. I used to go every day to
the Grande Chaumière to work from a
model. At the time I felt a need to control
things by reality.*
— Joan Miró, 1948

Joan Miró

Roger Parry
French, 1905-1977

Roland Penrose
English, 1900-1984

Joan Miró
Woman, Bird, and Stars, 1942
Watercolor and pastel on paper
66 x 45.7 cm
Dr. and Mrs. Paul Sternberg

*I produced a great deal at this time [1942-
44], working very quickly. And just as I
worked very carefully in the Palma series
which had immediately preceded these,
"controlling" everything, now I worked with
the least control possible — at any rate in
the first phase, the drawing.... The rest was
carefully calculated. The broad initial
drawing, generally in grease crayon, served
as the point of departure. I even used some
spilled blackberry jam in one case as a
beginning; I drew carefully around the
stains and made them the center of the
composition. The slightest thing served me
as a jumping off place in this period.*
— Joan Miró, 1948

Roger Parry
Untitled, c. 1930
Silver gelatin print
22.4 x 16.6 cm
The Art Institute of Chicago, The Julien
Levy Collection, Gift of Jean and Julien Levy

Roland Penrose
Camera Obscura, 1937
Collaged postcards, paper, and
cardboard, with paint and charcoal
on board
76.2 x 101.6 cm
Mr. and Mrs. E.A. Bergman

*Attracted by the vivid colour of the picture
postcards on sale everywhere [in Mougins,
France, 1937], I began to experiment with
them in collages. Sometimes I found the
repetitive clusters could take the effect of a
spread of feathers or a single image cut out
and set at a peculiar angle could transform
completely its original meaning.*
— Roland Penrose, 1981

Pl. 45. Joan Miró, *Woman*, 1934 (see p. 199)

Francis Picabia
French, 1879-1953

Francis Picabia
This Thing Is Made to Perpetuate My Memory, 1915
Oil and metallic paint on cardboard
99 x 101.6 cm
The Arts Club of Chicago, Arthur Heun Purchase Fund, 1955

Picabia's choice of image here — gramophone records — is one manifestation of the Dadaist aversion to painting traditional subjects, and interest in modern-day items, especially industrial mechanical forms. Here, five symmetrically placed discs arranged like a boldly colored heraldic crest are intended, as the title declares, "to perpetuate [Picabia's] memory." The image looks like a device impersonally drawn by an engineer that, if realized, could in fact mechanically perpetuate Picabia's memory. Picabia, Marcel Duchamp, and Man Ray were the chief provocateurs of the Dada movement in New York. Picabia's machinist style of 1915-19 was inspired in part by his exhilarating visits to New York: "Almost immediately upon coming to America it flashed on me that the genius of the modern world is in machinery and that through machinery art ought to find a most vivid expression."

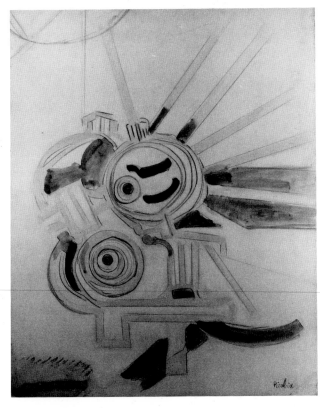

Francis Picabia
Machine, 1915/19
Crayon and watercolor on paper
57.7 x 46.3 cm
The Art Institute of Chicago, Gift of Edward Voynow, Jr. and Ann Voynow Blumenthal

Francis Picabia
Immobile Machine, 1916
Ink, watercolor, gouache, and collage on paper
73.7 x 54.6 cm
Ruth Horwich

Francis Picabia

Francis Picabia
Amorous Parade, 1917
Oil on board
95.6 x 72.7 cm
Morton G. Neumann Family Collection
Reproduced p. 35.

*The machine has become more than a mere
adjunct of life. It is really a part of human
life — perhaps the very soul. In seeking
forms through which to interpret ideas or
by which to expose human characteristics I
have come at length upon the form which
appears most brilliantly plastic and fraught
with symbolism. I have enlisted the
machinery of the modern world, and
introduced it into my studio.... Of course, I
have only begun to work out this newest
stage of evolution. I don't know what
possibilities may be in store. I mean to
simply work on and on until I attain the
pinnacle of mechanical symbolism.*
— Francis Picabia, 1915

Francis Picabia
Mechanical Drawing, 1917
Watercolor and ink on paper
25 x 27.3 cm
Mr. and Mrs. E.A. Bergman

Francis Picabia
Apparatus, 1919
Collage, ink, and watercolor on paper
50.2 x 38.7 cm
Mr. and Mrs. E.A. Bergman

Francis Picabia
Rotation of Naïveté, 1919
Ink on paper
33 x 23.2 cm
Morton G. Neumann Family Collection

Francis Picabia
Woman with Matches, 1920
Oil and mixed media on canvas board
92 x 73.3 cm
Mr. and Mrs. E. A. Bergman
Reproduced p. 206.

Picabia's abandonment of his machinist
style and return to figuration in the 1920s
is heralded by this work of 1920 (part of a
series of matchstick women). The inclusion
from 1922 to 1928 of such commonplace
items as wooden matches, coins, buttons,
feathers, combs, and toothpicks to
animate — and subvert — traditional
pictorial representation is anticipated in
this assemblage.

Francis Picabia
Rémy/Hébrides, 1922
Ink on paper
43.2 x 35.6 cm
Private Collection

Francis Picabia
DADAphone, 7, 1920
Book with text by Tristan Tzara, cover
design by Picabia
27.9 x 20.3 cm
Arnold H. Crane

Francis Picabia
Painting of Madame X, 1927
Oil on canvas
81.3 x 64.8 cm
Ruth Horwich
Reproduced p. 207.

Francis Picabia
Salary Is the Reason for Work, 1949
Oil on panel
54 x 35.6 cm
The David and Alfred Smart Gallery, The
University of Chicago, Gift of Stanley G.
Harris, Jr.

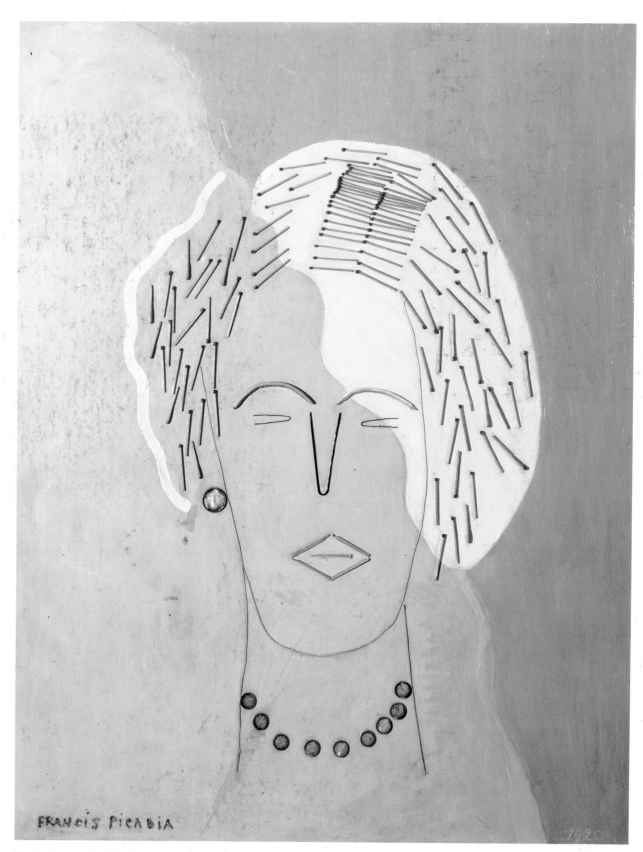

Pl. 46. Francis Picabia, *Woman with Matches*, 1920 (see p. 205)

Werner Rohde
German, b. 1906

Kay Sage
American, 1898-1963

Kurt Schwitters
German, 1887-1948

Kurt Schwitters
Proclamation (Aufruf), 1919
Collage and ink on paper
18.1 x 14.6 cm
The Art Institute of Chicago, Gift of Mr.
and Mrs. Maurice E. Culberg

Werner Rohde
Untitled, 1930
Silver gelatin print
22.9 x 16.2 cm
Drs. William and Martha Heineman
Pieper

Kay Sage
In the Third Sleep, 1944
Oil on canvas
101.6 x 152.4 cm
The Art Institute of Chicago, Friends of
American Art Collection and Watson F.
Blair Prize Fund

American artist Kay Sage lived in Italy from
1918 to 1937 before moving to Paris, where
she met the Surrealists, including Yves
Tanguy, whom she subsequently married.
Purchased by The Art Institute of Chicago
from its 56th American Exhibition, *In the
Third Sleep* depicts a vast, silent,
unpeopled space that appears to extend to
infinity.

Kurt Schwitters
Der Sturm, 1919
Collage with newspaper clippings, rice
paper, and ink on paper
22.2 x 17.5 cm
Morton G. Neumann Family Collection

In 1918 Schwitters declared that "It is my
ultimate object to combine art and nonart…
to make use of snatches of prose in poetry,
of rubbishy images in my paintings,
deliberately to choose inferior or bad
material in creating works of art." *Der
Sturm (The Storm)* was the name of both a
gallery and periodical which featured and
espoused the cause of the avant-garde;
Schwitters exhibited at the gallery and
published his poetry and reproductions of
his work in the journal.

Kurt Schwitters
Collage, 1922
Collage on paper
27.9 x 23.5 cm
Morton G. Neumann Family Collection

Kurt Schwitters
Untitled, 1926
Paper and cloth on cardboard
13.3 x 10.3 cm
Mrs. Eugene M. Grosman

Kurt Schwitters
Trein, 1934
Collage on paper
43.8 x 32.4 cm
Joseph and Jory Shapiro
Reproduced p. 214.

*The work of art originates through judgment
of the art value of its elements. I only know
how I do it. I only know my material from
which I take, I do not know for what purpose.
The material is unimportant, as I am myself.
Important are the forms. Because the
material is unimportant I use any material
which the picture may demand. Since I use
various materials to place in adaptation to
each other, I have in contrast to oil paintings
a plus, for I have besides color against color,
line against line, form against form, still
another element, material against material,
a wood against sackcloth in value.... It must
be granted to every artist to create a picture,
using only blotting paper if he can create
with it. The reproduction of elements of
nature is not of necessity a work of art.*
— Kurt Schwitters, 1921

Kurt Schwitters
Untitled, 1940
Collage on board
16.8 x 14.9 cm
Richard and Mary L. Gray

Kurt Schwitters
Player's, 1934
Collage
15.9 x 12.7 cm
Private Collection
Reproduced p. 215.

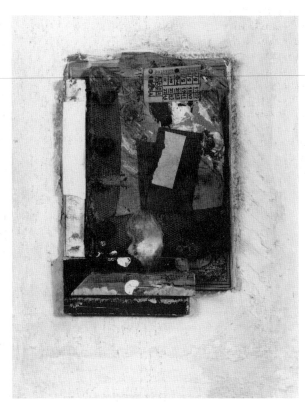

Kurt Schwitters
Untitled (Construction), 1946
Collage on board
29.8 x 22.8 cm
Mr. and Mrs. E.A. Bergman

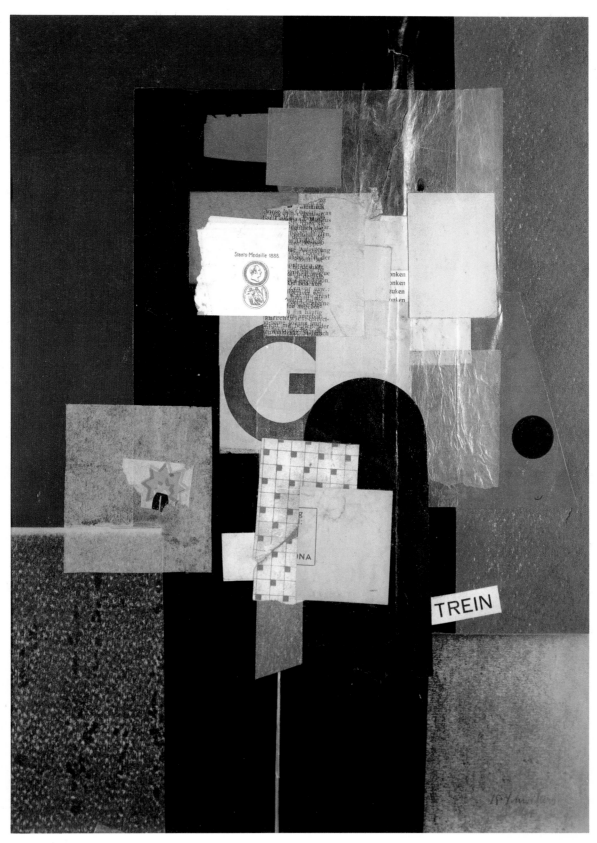

Pl. 48. Kurt Schwitters, *Trein*, 1934 (see p. 213)

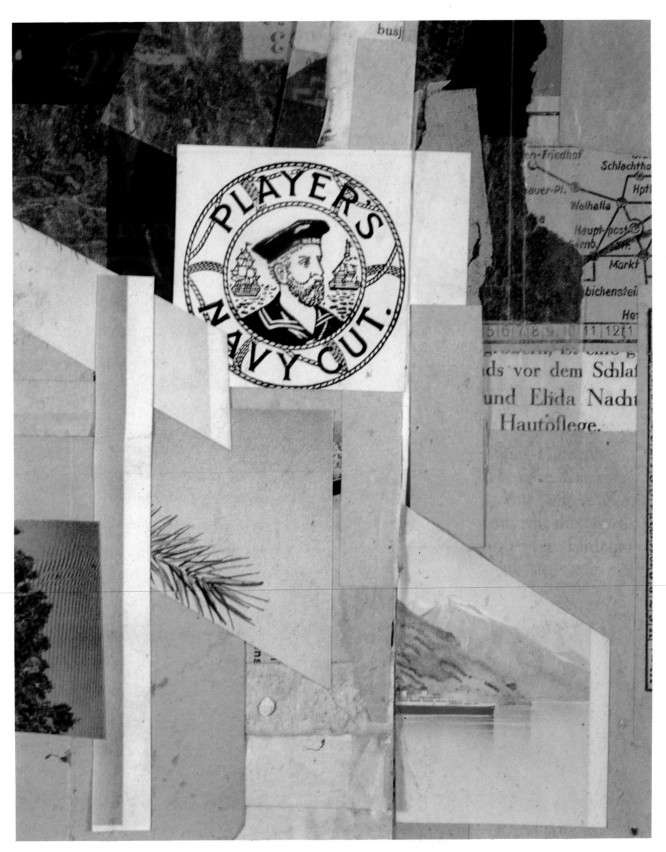

Pl. 49. Kurt Schwitters, *Player's,* 1934 (see p. 213)

Kurt Schwitters

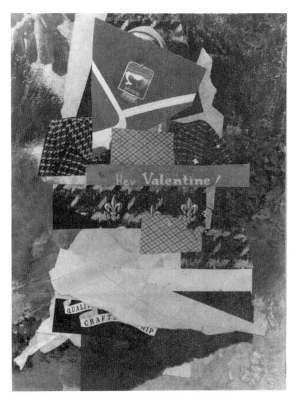

Kurt Schwitters
Hey Valentine, 1947
Watercolor, oil, and collaged paper on cardboard
24.4 x 18.4 cm
The Art Institute of Chicago, Gift of Mr.
and Mrs. Maurice E. Culberg

Kurt Schwitters
Nuin, 1947
Collage on paper
48.3 x 38.4 cm
Morton G. Neumann Family Collection

Kurt Schwitters
Light Blue Collage, 1947
Collage on board
29.2 x 24.1 cm
Morton G. Neumann Family Collection

Kurt Seligmann
American, b. Switzerland, 1900-1962

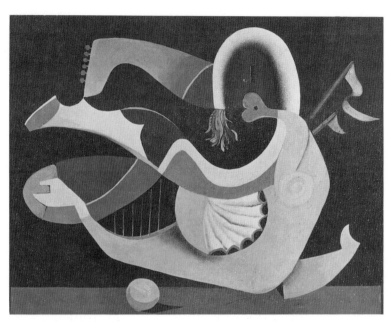

Kurt Seligmann
Harp Player, 1933
Oil on board
81.9 x 104.7 cm
The David and Alfred Smart Gallery, The
University of Chicago, The Mary and Earle
Ludgin Collection

Kurt Seligmann
The Round Dance, 1940-41
Oil on board
136 x 165.6 cm
Museum of Contemporary Art, Promised
Gift of the Mary and Earle Ludgin
Collection (PG81.21)

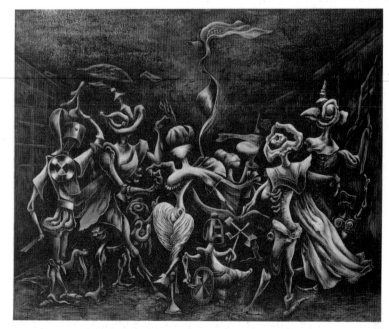

After living in Paris from 1929 to 1939,
Seligmann settled in New York. *The Round
Dance* was painted the year after his
arrival. Later, responding to a query about
that period, Seligmann disclosed: "As for
influences which life here may have
exerted on my work, it is hard to say.
Perhaps the light has had an effect.
Perhaps in my work there have been certain
changes of proportion since my arrival
here; perhaps a tendency to use elongated
shapes in my anthropomorphic forms.
Perhaps the color has become brighter.
Perhaps, a greater emphasis on drawing.
But one thing is certain, I have always been
able to work well here. We Europeans all
began our stay here with complaints against
the severity of the climate and the hectic
life of Manhattan. But eventually we all
found the climate good for us, especially
from the point of view of work."

Kurt Seligmann
Cave of the Echoes, 1943
Ink and watercolor on layered paper
64.8 x 48.3 cm
Museum of Contemporary Art, Gift of
Katharine Kuh (84.62)

Kurt Seligmann
Romantic Feud, 1947
Oil on canvas
55.9 x 106.7 cm
Mr. and Mrs. Maurice Fulton

Kurt Seligmann
Baphomet, 1948
Oil on canvas
122.6 x 147.6 cm
Museum of Contemporary Art, Promised
Gift of Joseph and Jory Shapiro (PG83.35)

Maurice Tabard
French, 1897-1984

Yves Tanguy
French, 1900-1955

Maurice Tabard
Untitled, 1930
Collage with silver gelatin prints and
paper
31.4 x 24 cm
Cambridge Associates Collection, David
Kudish, Managing Director
Reproduced p. 60.

Maurice Tabard
Untitled, 1933
Silver gelatin print
24.1 x 17.8 cm
Drs. William and Martha Heineman
Pieper

Maurice Tabard
Untitled, 1932
Photomontage of silver gelatin prints
22.2 x 16.5 cm
The Art Institute of Chicago,
The Julien Levy Collection, Gift of Jean
and Julien Levy

Yves Tanguy
Untitled, 1926
Ink on paper
29.2 x 21.6 cm
Mr. and Mrs. E.A. Bergman

219

Yves Tanguy
The Certitude of the Never Seen, 1933
Oil on board with feathers and carved
wood
19.4 x 23.4 cm
Mr. and Mrs. E.A. Bergman
Reproduced p. 6.

This small object is something of an
anomaly in the career of Tanguy, a
Surrealist known principally for his
paintings. Merging painted surface and
sculpted forms, the artist's familiar
biomorphic shapes appear not only in the
depicted scene, but also in the contoured
frame and five small elements that rest on
or emerge from a protruding platform that
functions like a three-dimensional
equivalent of a painted foreground.

Yves Tanguy
From the Other Side of the Bridge, 1936
Painted wood and stuffed cloth
14.7 x 48.3 x 22.3 cm
Morton G. Neumann Family Collection
Reproduced p. 222.

Created at the height of the Surrealist
interest in objects (whether found,
readymade, or assembled), *From the Other
Side of the Bridge* was shown in 1936 at
both the "Exposition Surréaliste d'objets"
at the Galerie Charles Ratton, Paris, and
in New York in The Museum of Modern
Art's exhibition "Fantastic Art, Dada,
Surrealism."

Yves Tanguy
Untitled, 1930
Oil on canvas
99.7 x 80.6 cm
Joseph and Jory Shapiro

Yves Tanguy
The Extermination of the Species, 1936
Oil on canvas
34 x 26
Dr. and Mrs. J.H. Hirschmann

Yves Tanguy

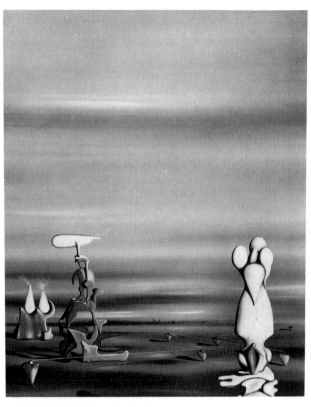

Yves Tanguy
Untitled, 1937
Oil on canvas
72.7 x 59.7 cm
Dr. and Mrs. J.H. Hirschmann

André Breton: "What is painting?"
Tanguy: "It is a little white twist of
smoke."

Yves Tanguy
Palace of Windowed Rocks, 1942
Oil on paper
30.2 x 24.2 cm
Mr. and Mrs. E.A. Bergman

Yves Tanguy
Untitled, 1940
Oil on canvas
91.5 x 98.4 cm
Mr. and Mrs. E.A. Bergman
Reproduced p. 97

Identified in *The Abridged Dictionary of
Surrealism* (written by fellow Surrealists)
as "the guide from the age of mistletoe
druids," Tanguy had begun by 1927 to
animate an illusionistic, yet indeterminate,
space (desert or ocean floor?) with
biomorphic forms. By the early 1930s, the
organic forms gave way to rock- or bonelike
formations, recalling the menhirs and
boulders found along the coast of Brittany
where Tanguy spent summers during his
childhood.

Yves Tanguy
Untitled, 1945
Gouache, pencil, and ink on paper
45.7 x 31.8 cm
Joseph and Jory Shapiro

Pl. 50. Yves Tanguy, *From the Other Side of the Bridge*, 1936 (see p. 220)

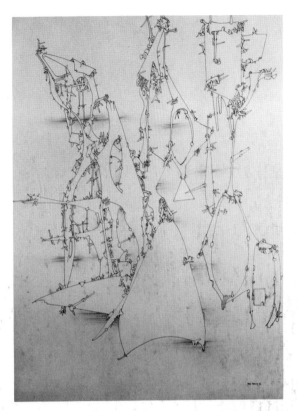

Yves Tanguy
Untitled, 1949
Ink, pencil, and gouache on paper
50.5 x 37.5 cm
Mr. and Mrs. E.A. Bergman

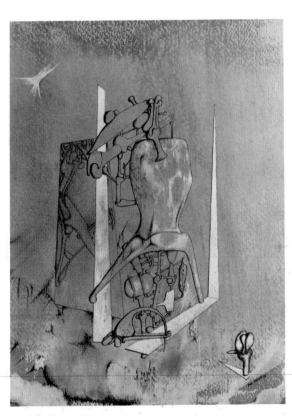

Yves Tanguy
Untitled, 1949
Gouache on paper
32 x 24 cm
Stefan T. Edlis

Yves Tanguy
Untitled, 1949
Ink and pencil on paper
50.8 x 55.9 cm
Joseph and Jory Shapiro

Dorothea Tanning
American, b. 1910

Pavel Tchelitchew
American, b. Russia, 1898-1957

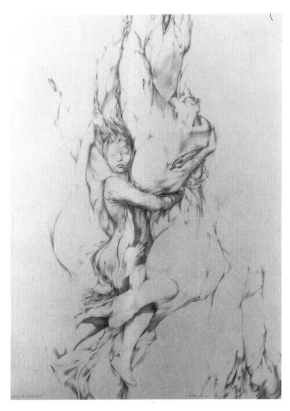

Dorothea Tanning
Drawing for Midnight, 1951
Pencil on paper
73.6 x 58.8 cm
The Art Institute of Chicago, Harriett A.
Fox Fund

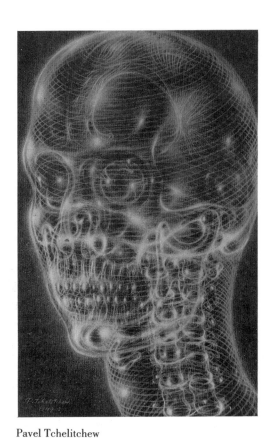

Pavel Tchelitchew
Interior Landscape, 1949
Chalk on paper
49.8 x 32.5 cm
Joseph and Jory Shapiro

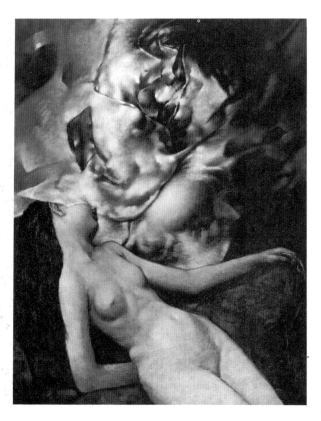

Dorothea Tanning
Sleeping Nude, 1954
Oil on canvas
61 x 49.9 cm
Museum of Contemporary Art, Gift of an
Anonymous Donor (84.23)

Illinois-born Tanning has described her
life and art as: "She has been around for
some time, firmly planted somewhere
between the immediate past and a hazy
future, between the inner eye and the other
side of the door, between what was painted
yesterday and what will be painted
tomorrow."

Marie Cernisova Toyen
Czechoslovakian, 1902-1980

Umbo (Otto Umbehr)
German, 1902-1980

Marie Cernisova Toyen
War, Hide Yourself! (Câche-toi Guerre!),
1944
Ink on paper
41 x 58.6 cm
The Art Institute of Chicago, Gift of
Margaret Fisher

Pavel Tchelitchew
Spiral Head, 1952
Colored chalk on black paper
50.8 x 34.9 cm
Mr. and Mrs. E.A. Bergman

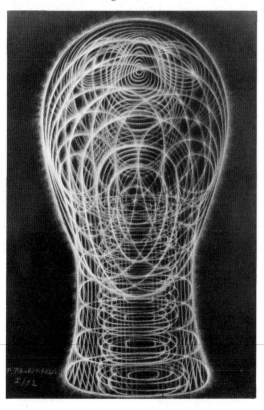

Umbo (Otto Umbehr)
Untitled, 1928
Silver gelatin print
29.3 x 21.4 cm
The Art Institute of Chicago,
The Julien Levy Collection, Gift of
Jean and Julien Levy

225

Umbo (Otto Umbehr)

Wols (Alfred Otto Wolfgang Schulze-Battmann)
German, 1913-1951

Wols (Alfred Otto Wolfgang Schulze-Battmann)
Untitled, 1940/41
Watercolor and ink on paper
24.1 x 31.1 cm
Muriel Kallis Newman

Umbo (Otto Umbehr)
Untitled, 1928
Silver gelatin print
28.3 x 22.7 cm
The Art Institute of Chicago,
The Julien Levy Collection, Gift of
Jean and Julien Levy

Umbo (Otto Umbehr)
Untitled, 1928
Silver gelatin print
23.8 x 17.8 cm
Mr. and Mrs. David C. Ruttenberg,
Courtesy of the Ruttenberg Arts
Foundation

The mannequin, with its haunting
conjunction of the real and the artificial,
became a familiar motif for Surrealists, as
can be seen here in the work of Bayer,
Bellmer, Dali, de Chirico, Jean, Man Ray,
Miller, and Rohde.

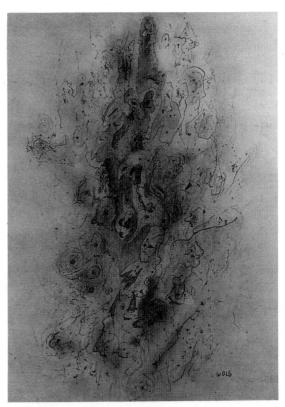

Wols (Alfred Otto Wolfgang Schulze-Battmann)
Constellation (Crowded Place), n.d.
Ink and watercolor on paper
34.9 x 26 cm
Joseph and Jory Shapiro

Wols (Alfred Otto Wolfgang Schulze-Battmann)
Surrealist Composition/Fantastic Head,
n.d.
Watercolor on paper
30.5 x 36.8 cm
Claire Zeisler

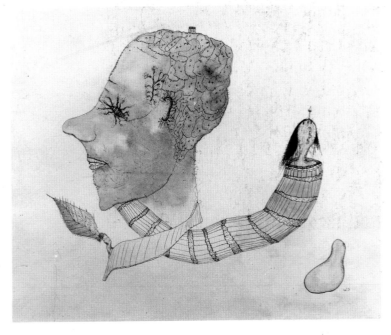

Wols (Alfred Otto Wolfgang Schulze-Battmann)
Strange Boat, n.d.
Ink and watercolor on paper
33.3 x 26.4 cm
Joseph and Jory Shapiro

German-born Wols moved to Paris in 1932 where he met and was influenced by the Surrealists. In the late 1930s, he began the delicate, lyrical drawings and watercolors that record, like a diary, the private thoughts and dreams of a fecund and sometimes disturbing psychic life.

Collaborative Objects

The Bearded Heart (Le Cœur à barbe),
1922
Broadsheet by Paul Eluard, Th. Fraenkel,
Vincent Huidobro, Matthew Josephson,
Benjamin Péret, Georges Ribemont-
Dessaignes, Erik Satie, Serner, Rrose
Sélavy, Philippe Soupault, and Tristan
Tzara
22.9 x 14 cm
Arnold H. Crane

Max Ernst, André Masson, and Max
Morise
Exquisite Corpse, 1927
Pencil and crayon on paper
19.4 x 14.6 cm
Mr. and Mrs. E. A. Bergman

André Breton, Man Ray, Max Morise, and
Yves Tanguy
Exquisite Corpse, 1928
Ink and watercolor on paper
30.5 x 19.1 cm
Private Collection
Reproduced p. 105.

André Breton, Man Ray, Max Morise, and
Yves Tanguy
Exquisite Corpse, 1928
Ink and watercolor on paper
29.8 x 19.4 cm
Mr. and Mrs. E. A. Bergman

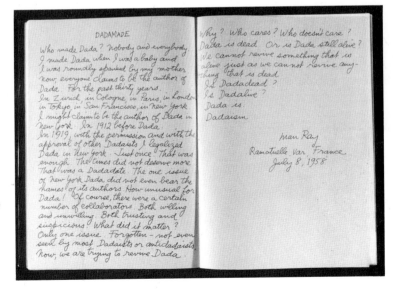

André Breton, Valentine Hugo, Greta
Knutson, and Tristan Tzara
Exquisite Corpse, c. 1930
Ink on board
23.5 x 31.1 cm
Morton G. Neumann Family Collection

The first Surrealist game invented was the
"Exquisite Corpse," which is defined in
The Abridged Dictionary of Surrealism
(written by various Surrealists and published
in 1938): "Game of folded paper that
consists in having a sentence or a drawing
composed by several persons, each ignorant
of the preceding collaboration. The
example that has become a classic and gave

its name to the game is the first sentence
obtained by those means: 'The exquisite/
corpse/will drink/the new/wine.' " Breton
summarized its importance as follows:
"What exalted us in these productions was
indeed the conviction that, come what
might, they bore the mark of something that
could not be begotten by one mind alone
and that they were endowed, in a much
greater measure, with a power of *drift* that
poetry cannot value too highly. With the
Exquisite Corpse we had at our disposal —
at last — an infallible means of tempor-
arily dismissing the critical mind and of
fully freeing metaphorical activity."

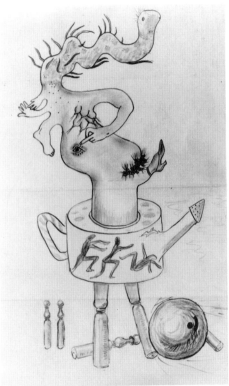

André Breton, Man Ray, Max Morise, and
Yves Tanguy
Exquisite Corpse, 1928
Ink and watercolor on paper
29.2 x 17.5 cm
Mr. and Mrs. E.A. Bergman

Dada: Dokumente einer Bewegung, 1958
Book published by the Kunstverein für die
Rheinlande und Westfalen, Düsseldorf
Kunsthalle, with facsimile letter by Man
Ray
26.7 x 19.4 cm
Arnold H. Crane

In 1919, after the death of her husband, Mary Reynolds moved from her native Chicago to France where she lived (except for the war years from about 1943 to 1946 spent in the United States) until her death in 1950. In 1956 her extensive collection of approximately 900 Dada and Surrealist books and periodicals was given to The Art Institute of Chicago by her brother, Frank B. Hubachek. As friend, confidante, and generous supporter of many writers and artists of the period, in particular Marcel Duchamp, Mary Reynolds collected the numerous catalogues, books, periodicals, and ephemera (pamphlets and exhibition announcements) that represent and illuminate the fecund literary activities and collaborations of the Dada and Surrealist era. Moreover, as a result of her involvement with the writers and artists of the period, Reynolds learned the art of bookbinding in order to produce books designed both by herself and others.

In 1956, on the occasion of the Art Institute's inaugural exhibition of The Mary Reynolds Collection, Marcel Duchamp wrote this affectionate remembrance of his devoted friend:

> The assembling of these books, albums, magazines, catalogues of exhibitions, pamphlets was not premeditated as is the case of a formal library. It is more like a diary: the art and letters diary of Mary Louise Reynolds' thirty year life in Paris.
>
> From the time she made her home in Paris in the early 20's Mary Reynolds took part in the literary and artistic life which was resurrected in France after having been dormant for the four years of the First World War.
>
> If the various art movements of the beginning of the Century, Fauves,

Cubism, Futurism, which were in full activity, were not yet accepted by the general public, they received full recognition immediately after 1918 when new forms of rebellion were beginning to take shape.

> Mary Reynolds was an eye-witness of the Dadaist manifestations and on the birth of Surrealism in 1924 she was among the supporters of the new ideas.
>
> In a close friendship with André Breton, Raymond Queneau, Jean Cocteau, Djuna Barnes, James Joyce, Alexander Calder, Miró, Jacques Villon, and many other important figures of the epoch, she found the incentive to become an artist herself. She decided to apply her talents to the art of bookbinding.
>
> After the necessary technical training in a bookbinder's atelier, she produced a number of very original bindings, completely divorced from the classical teachings and marked by a decidedly surrealistic approach and an unpredictable fantasy.
>
> The Second World War found Mary in Paris, ready to fight, and she fought in her brave own way by joining the ranks of the "Resistance" in 1941. In 1943 she barely escaped the Gestapo by actually walking over the Pyrenees into Spain.
>
> A great figure in her modest ways.

For this exhibition, fifty-five items from The Mary Reynolds Collection were on view, of which the six illustrated here are representative.

391 5, 1917
Cover by Francis Picabia, editor
Periodical
37.3 x 27 cm

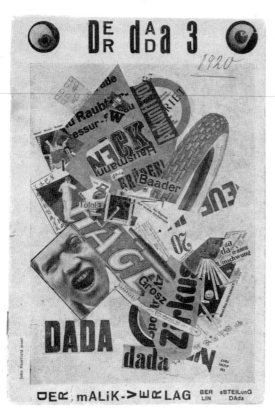

André Breton
Qu'est-ce que le Surréalisme? (What Is Surrealism?), 1934
Cover by René Magritte
Booklet
24.6 x 15.7 cm

Der Dada 3, 1920
Cover by John Heartfield
Periodical
23.1 x 15.7 cm

André Breton
Bulletin International du Surréalisme 3,
1935
Cover by René Magritte
Periodical
28.9 x 20.7 cm

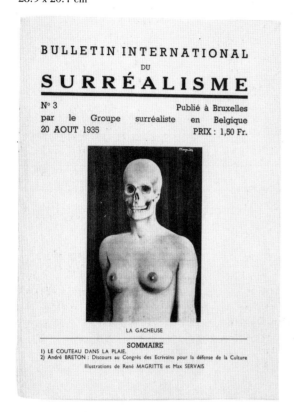

Julien Levy
Surrealism, 1936
Cover by Joseph Cornell
Book
24.7 x 19.5 cm

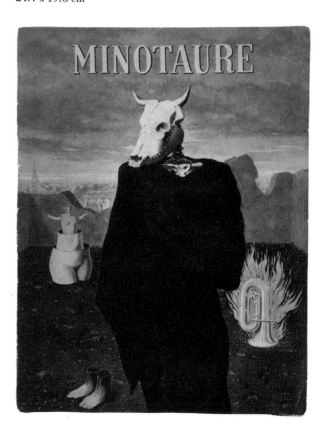

Julien Levy
Minotaure 10, 1937
Cover by René Magritte
Periodical
31.5 x 24.5 cm

We would like to thank the members of the Museum of Contemporary Art's Contemporary Art Circle for their support of the exhibition "Dada and Surrealism in Chicago Collections," which provided the occasion for this publication.

Index

Photography Credits

Jonas Dovydenas: Delvaux, Water Nymphs (The Sirens), 1937
Eeva: Masson, Battle of Birds, 1941
Michael Tropea: Arp, Automatic Drawing, 1918; de Chirico, Holiday, 1914; Ernst, Trophy Hypertrophied, 1919; Ernst, An Anxious Friend, 1957; Höch, Collage, 1920; Hugnet, Untitled, c. 1934; Klee, Physiognomies of Cross Sections, 1930; Magritte, Subterranean Fire, 1935; Man Ray, Revolving Doors: The Meeting, 1915; Man Ray, Rayograph, 1923; Man Ray, Object of Destruction, 1932; Man Ray, Unpainted Mask, 1941; Man Ray, Mirror to Die of Laughter, 1952; Man Ray, Self-Portrait, 1962; Matta, Redness of Lead, 1943; Miró, Automaton, 1924; Miró, Drawing-Collage, 1933; Miró, Drawing-Collage, 1933; Picabia, Rotation of Naïveté, 1919; Schwitters, Der Sturm, 1919; Schwitters, Collage, 1922; Tabard, Untitled, 1930; Tanguy, From the Other Side of the Bridge, 1936; Exquisite Corpse, 1930
Tom Van Eynde: Lam, Annunciation, 1944